U0069151

映像蘭嶼

Images of Orchid Island

歲月的情懷與見證

推薦序 / 張照堂

在有關以蘭嶼為主體的影像檔案中，遠自張才的《蘭嶼採風》（1948 - 49）、林全助的《島嶼獵影》（1955）、王信的《蘭嶼再見》（1974 - 75）、關曉榮的《尊嚴與屈辱》（1987 - 88），近至潘小俠的《蘭嶼記事》（1980 - 2005）。不同世代的台灣攝影家，對這個飛魚與木舟的神話小島都有各自的解讀與觀察，而在這個記錄時序中，獨缺六〇年代。2008 年，謝震隆的《蘭嶼情懷》（1964）在四十餘年後再度顯影，相當難得而珍貴地，接續架構起這一系列有關田野誌、影像錄、民族史、人類學的跨世代「蘭嶼報告」。

六〇年代的蘭嶼仍屬神祕的化外之地，當時的台灣政府與漢人勢力尚未入侵，沒有國民住宅，沒有觀光客，更沒有核廢料，無水無電，是片沒有污染的「淨土」。謝震隆隨著《蘭嶼之歌》外景隊抵達蘭嶼，他在這裡待了五十八天，職務是電影劇照師。當時謝震隆三十出頭，攝影事業剛起步不久，對他來說，這趟蘭嶼之旅是意外的挑戰與冒險。每當電影攝製空隙或收工後，謝震隆即迫不及待地抓起相機四處獵影。海洋、木舟、聚落、家屋、婦孺、勇士、起居、勞動、舞蹈、祭儀等各種自然景觀與生活面向，一一入鏡。由於拍照時間不是很充裕，不見得每一面向都能全面與深入地觸及，但影像普遍表達出來的自然、沉著與力度，令人刮目相看。在六〇年代的台灣攝影時潮中，專題報導的認知與實踐尚未普及與推展，紀實攝影甚至時遭忽視與排擠之際，謝震隆在田野紀實的嘗試與努力，在今天看來，是個範例與座標。這些遲到的歸位與彌補的再現，見證了攝影家當年的睿智與堅持，而這些稟賦及毅力，都得追溯至謝震隆的家教環境與成長演練。

1933 年謝震隆出生於苗栗，是謝家五兄弟中的老二，個性務實、木訥，自幼常被稱為是個「做得多，說得少」的小伙子。他的父親謝錦傳早年在日本留學，專攻攝影，返台後就在家鄉開設「雲峰寫真館」。兄弟中，謝震隆最早接觸並沉迷於攝影，小學時代就時常窩在暗房裡沖洗藥罐，幫忙生計；國小四年級時，便拿著相機至學校拍風景與紀念照；他對素描也有天分，每年代表學校參加繪畫比賽都名列前茅。這些對構圖與美感的基礎與培養，成為他掌握相機取景的優勢。中學時代的謝震隆如影隨形地跟著父親學習影藝，累積經驗，還在醫院中兼差沖洗 X 光片以賺取生活雜費，大大小小的歷練，確立了他日後的攝影之路。

1961 至 1963 年間是謝震隆創作的旺盛期，當時他已在北部的攝影行業裡磨練、打拼多年，返回台南開辦自己的攝影社。為了證明實力以召聲譽與生意，他勤快地在農村鄉野間守候與奔走，也記錄許多純樸、動人的民風變貌，並贏得多次日本攝影月賽的最高獎勵。因為務實與勇於嘗試，在一次意外的電影劇照試拍中，他為潘壘導演所看中，就此展開 1964 年這趟難忘的蘭嶼之旅。

謝震隆每談及他的攝影理念，總憶起父親訓導的三個基本觀：（一）看好、看穩再拍。（二）控制相機，不是相機控制你。（三）心中先要有一個「主意」，拍甚麼？為甚麼這樣拍？這三個觀念其實簡單易明，但得經過不斷實作與演練的過程，才會無形地存印在攝影者的腦海中，再本能地投射在按快門的手上。謝震隆的《映像蘭嶼》反應這樣的自覺，同時也表現下列幾個特色：

一、他不刻意去「構圖」，因而影像顯得自然、親和而不匠氣。他自謙個性與能力上缺少組織能力，沒有「設計」的長處，而這樣的性格運用在紀實風格的攝影上，反而是種助力與優點。島嶼上的母子相依、孩童戲耍、家居聚會或漁獵勞動等取景，呈現了隨機又凡常的觀照角度；坐在屋簷下的婦人們嘻笑地看著行過的小山豬、羞怯的少女、相互理髮或爭著圍觀相機的島民等鏡頭，顯現了達悟族人罕見的輕鬆與幽默。因為瞬間速寫，因為沒有刻意雕琢，更顯現出客觀與真實的生活觀照。

二、對光線明暗的掌握與處理，他有獨到的分寸。晨昏的山色、逆光的海面、族人的特寫與側顏，因為光線對比的襯托，呈現主題與景觀的立體感和縱深度，也彰顯出一種凝聚的情感與韻味。

三、對「動」與「靜」之間的剎那取捨，他有敏銳而明快的掌控能力。當達悟族人新船下水前、進行示威儀式時，兩組人馬激狂、亢奮地對陣呼叫之際，謝震隆身揹三個不同焦距的相機，高低左右取景，緊緊扣住了祭儀中最直截、憾動的一幕。誠如謝震隆所說，相片中每個人的神情都是最真實與誠懇的，也能夠看見上一輩族人的樣貌與靈魂。影像裡，若靜若動的氛圍、緊迫的構圖，再現源源的生命張力，加上特寫、中景與遠景的交互運用，逐建構起十分生動、完整的祭儀意象。在過往的相關影檔中，謝震隆的這組作品，尤顯傑出、優異，與四○年代末的張才系列，共具代表性。

每一個年代都有每一個年代的臉孔與姿態，都有它獨特的生態、空氣與土壤。達悟族人傳承世代的精神與力氣，他們的規律與勤奮，四十年前被年輕的謝震隆記錄下來。儘管交會只是瞬間，但在他們彼此的眼神閃爍中，我們似乎都讀到一種對生命與大海的尊重與禮讚。

六○年代的攝影家與六○年代的蘭嶼子民，在這裡共同為我們留下了歲月的年輪與斑痕。大自然的粗曠與美，生命的深邃、勇毅、苦楚與光彩俱在這寫下光影見證。感謝他們讓我們重新看見另一個世代與另一片土地，體會一種意志與性情，並在時光迴廊中，留下「人性」與「真實」的深遠詮釋與寫照。

推薦者簡介

張照堂
現任：台南藝術大學音像紀錄研究所專任教授
學歷：台灣大學土木系畢業。
曾任：中國電視公司新聞部攝影記者、行政院新聞局多媒體策劃、公共電視籌委會製作人、超級電視台製作人等。

Sentiment and Testimony of Time

Recommendation by Chang Chao-Tang

Over the years there have been quite a few photographic publications featuring Orchid Island: Chang Tsai's *Medley of Orchid Island* (1948-49), Lin Chuan-Chu's *Images of the Island* (1955), Wang Hsin's *Farewell to Orchid Island* (1974-75), Kuan Hsiao-Jung's *Dignity and Humiliation* (1987-88), and the more recent *The Photographic Reportage of Orchid Island* by Pan Hsiao-Hsia (1980-2005). Different Taiwanese photographers of different generations have produced unique interpretation and observation on the mystical island of flying fish and wooden canoes. Among the chronicles, the only period absent was the sixties. Now in 2008, after forty years, the publication of Hsieh's *Images of Orchid Island* (1964) was priceless. It is the missing link that completes the "Orchid Island Report" - a comprehensive cross-generation ethnographical, ethnohistorical, anthropological and visual memoir of the island.

In the sixties, Orchid Island was a mysterious Shangri-La. There was no influence of the Taiwanese government or Han Chinese. No housing projects, no tourists, no nuclear waste, no running water or electricity. It was a pollution free virgin land. Hsieh went there as a still photographer with the film crew of *Song of Orchid Island* and worked there for fifty-eight days. He was in his early thirties and his photography career just took off; this journey to Orchid Island was an unanticipated challenge and adventure. During shooting breaks or after hours, Hsieh picked up his cameras and took pictures of everything everywhere: ocean, canoes, villages, houses, women, children, warriors, daily routines, work, dance, rituals - all aspects of natural sceneries and human activities. With limited time, he could not cover his subjects thoroughly, but the spontaneity, the composure and the power of the images are extraordinary. The photographical movements in Taiwan in the sixties did not embrace or advocate the understanding and practice of topical reporting. In retrospect, Hsieh's undertaking and effort in ethnographical photography were truly exemplary and admirable. This belated positioning and acknowledgement only illustrates Hsieh's pioneering insight and resolve at a time when documentary photography was even ignored or discriminated against. And such gift and tenacity can be attributed to his family upbringing and discipline.

Hsieh was born in Miaoli in 1933. As the second among five boys, he was practical and taciturn, known to be a kid whose action spoke louder than words. His father Hsieh Chin-Chuan studied photography in Japan and ran the "Yun-Feng Photo Studio" in his hometown after returning Taiwan. The first one of the boys to get introduced to photography, Hsieh became enthralled with the art. He stayed in the darkroom cleaning tools and helped the business throughout the grade school. He started carrying cameras to school and photographed sceneries and mementos since the fourth grade. Gifted in drawing, Hsieh often represented the school to attend art competitions and received numerous awards. This groundwork and cultivation in composition and aesthetics gave him an edge in framing the shots. Through middle schools he apprenticed

under his father and accumulated vast experiences. He even took a side job at the hospital processing X-ray film to make money. All the training prepared him for an illustrious career of photography.

The years from 1961 to 1963 were a prolific period for Hsieh. He had worked hard for many years in the field of photography in the north and had returned to Tainan to start his own studio. To establish credibility and promote business, he traveled vigorously over the countryside and documented the simple and beautiful landscape and people. His photos won numerous first prizes in Japan Photo Art contests. In one unexpected movie still audition, his practical mind and boldness to experiment caught the attention of director Pan Lei and he was awarded with this unforgettable trip to Orchid Island in 1964.

Whenever Hsieh talks about his photographical concepts, he always enumerates the three principles taught by his father: 1) be ready and steady before shooting; 2) you control the camera and not vice versa; 3) discover the idea of the picture: what do you want to shoot and why do you shoot this way? These three principles are easy to understand, but only after continuous application and practice can they be imprinted in one's mind and become an instinctual behavior when the hand pushes the button. Hsieh's *Images of Orchid Island* represents such approach and also reveals the following characteristics:

I) He never contrived when framing the pictures, therefore his images appear natural, accessible and inspired. He humbly attributed this to a lack of organizational skills and design aptitude in both his personality and artistic inclination. However, this quality became an aid and advantage in documentary photography. His depiction of mothers and children clinging to one another, children playing, family gathering, or men fishing reflect a spontaneous and ordinary point of view. Women giggling while watching little boars passing by the house, bashful young girls, men cutting hair of one another, people huddling around the camera - all reveal the rare ease and humor of the Tao people. The pictures of the spur-of-the-moments were not carefully manicured, and therefore deliver a more objective and authentic portrayal of the life on the island.

II) Hsieh commanded the language of light and shadow in a unique and masterful manner. Mountains in the twilight, back-lighted ocean, close-ups and profiles of the Tao people were often presented by strong contrasts of light and darkness. As a result, the subjects and the landscape were given a greater definition in dimensions and vertical depths, and yielded a stronger pathos and impact.

III) He was able to make instant and perceptive decision in split seconds of stillness or movement. As the Tao people performed the exorcism ritual "anito" before launching the canoe, two teams of men contested in wild and feverish choruses. With three cameras of different focal lengths on his back, Hsieh was able to capture the most immediate and potent moments of the ceremony from all different angles and perspectives. Just as Hsieh divulged, the facial expressions in the photos were genuine and authentic,

and revealed the true character and soul of the last generation of the Tao people. The whole series is marked by a contrast between stillness and motion, a tension in the composition, an outburst of vitality, a mixture of close-ups, medium shots and long shots, and builds up a lively and complete montage of the ritual. In comparison to past visual documents of similar subject, Hsieh's works are especially luminous, and undoubtedly should be considered in the same league as Chang Tsai's photographic series of the late forties.

Every generation has its visage and posture, its unique ecology, air and soil. Passed on from generations, the spirit, might, rhythm and diligence of the Tao people were captured by the then youthful Hsieh forty years ago. Their encounter might be brief, yet we seemed to sense in their sparkling eyes a powerful honoring and celebrating of both life and earth.

Together, the photographer and the islanders of the sixties safeguarded for us the markings of time. Such testimony of light and shadow was created by weaving nature's ruggedness and beauty, and men's fortitude and glory. We are indebted to their effort in preserving this profound interpretation and rendering of humanity and authenticity through the corridor of time, and hence allowed to revisit another generation and another land in another time, and to forever commemorate their awesome spirit and heart.

Chang Chao-Tang

Chang is currently a professor of Graduate Institute of Sound and Image Studies in Documentary at Tainan National University of the Arts. He graduated from the Civil Engineering Department of National Taiwan University. He was a photojournalist with China Television Company, a multimedia planner with Government Information Office, a producer with Taiwan Public Television Service and Super Television.

美哉映像──矚目蘭嶼

浩瀚的汪洋中，最神祕耀眼的寶石來自這裡，介於現代與傳統中生存的佼佼者──達悟（雅美）。

鬼斧神工的大自然景象，就彷彿神匠為人們刻劃出一幅歷史名著。

人之島──擁有著用文字、語言都無法形容的情感，這裡孕育著豐富的生命，蝴蝶蘭、羅漢松、綠蠵龜三大國寶，展現出蘭嶼尊爵、不凡的氣勢。

在此的族人順應著上天恩賜的一切，習得尊敬自然生態，珍惜不濫用任何資源，如同珍重自己的文化傳承，即使時間流傳，現代的文明襲向這美麗之島，但他們仍擇善固執地保護著這塊土地。

映像中的族人，透露著各式各樣的生活面向，歲月的年輪呈現了島民對此生命活躍及堅忍的意志力，海浪的起伏彷彿歌頌奔放的青春，令人感受到時光迴廊的禮讚。

願你我能一同呵護這真實的樣貌。

O Beautiful Orchid Island

Recommendation by Chen Ying, Member of Legislative Yuan

Orchid Island, a mysterious and splendid sapphire in the grand ocean! Tao people, a rare winner of life through changes of time and cultural transitions!

Its fantastic natural scenery is a masterpiece created by the genius of God.

No words or languages can describe the lush and bountiful life nurtured by the island, represented by the three treasures - the butterfly orchid, Buddhist Pine, and green turtle-the pride and glory of this Shangri-la.

The natives have learned to work with the gifts bestowed by heaven, respect the ecology, cherish all resources, and value their cultural inheritance. While modern civilization keeps threatening their way of life, they are determined to protect and safeguard this land.

The images in this collection reveal a great range of dimensions of the native life, and the Tao people's resilience and vivacious youthfulness. It is an awe-inspiring celebration of the journey of life.

May we all hold dear this precious life of simplicity and authenticity.

記憶之旅

推薦序 / 夏曼·藍波安

有一天，島上的友人告訴我說：「有一本攝影集拍攝得很好，是關於《蘭嶼之歌》電影，是當時的劇照師謝震隆先生在工作餘暇所拍攝的。」因而有機會瀏覽島民當時的真情生活。

我認為，人物在時空環境條件被拍攝的自然，沒有心理的排斥與抗拒，其顯現的影像是原初的唯美、原初的樸實、原初的真情；留給後人有形、無形的想像空間。於是，我們從攝影集裡看見達悟前輩們的生活實寫與結實之人文面貌。

一九六四年，筆者恰是就讀蘭嶼國小一年級，學校裡資訊的唯一取得，就是聽取台灣來的人胡說八道：他進步、我落後，他文明、我野蠻，他穿鞋、我赤腳，他善騙、我善良等等。然而所謂的電影，或是攝影是什麼玩意，在我們兒時幾乎無從想像，如同那些被拍攝的族人一樣純樸，服務於當時的電影工作者。《蘭嶼之歌》電影被公開放映之後（達悟人沒看過），其攝影之美學、導演的專業素養、劇情之合理性，似乎不是拍攝所追求的原初目的。這一點，或許可以套用達悟人的觀點，就是可以與日本人相比較的結論：「漢族做事真的接近馬馬虎虎。」此也反映投射在二次戰後迄今，蘭嶼被台灣政府統治的事實面。

《映像蘭嶼》攝影集影本送到我手中時，恰似翻閱我這個年齡層對於自己童年成長島嶼與島民之影像記憶。我因而思考了良久，給我很深的感觸，宛如眼前的波浪在倒退似的，不時地翻攪海底沙丘，而漂浮的沙層若是記憶，它可能因為時間的拉長而模糊了影像畫質，淡忘了我父祖輩們的祖先篳路藍縷、精心經營的辛勤，才有的海洋文化；而影像深刻的記憶，如今也只能眼睜睜地看著、聽著在路邊巧遇、匯聚的耆老人群在凋零的同時，在酒攤周圍不斷地重複口述，逝去的達悟民族集體性的生活美感；有時藍色的蒼涼、青澀的神情似乎淹沒不了他們當時的豪邁與原初勞動者的傲骨，如此之氣宇，隱含深層的樸實剛毅氣質。在《映像蘭嶼》攝影集裡，我們彷彿可以嗅到那股味道，在達悟歷史文明展演的舞台上，提供了達悟族裔在文化人文學領域裡的反思腳本，好似攝影集裡諸多寧靜、輪廓深層的面容，在述說著達悟人與大海、大自然親密的雋永故事。

深夜，強勁的西南季風，吹落我家前庭芒果樹的葉片，勾起心海裡對前輩們的思念，我拾起他們那個世代慶祝新船下海儀式時的錄音帶，掏心地傾聽前人與土地、海洋、芋頭、飛魚譜曲吟唱的詩歌，歌裡有這麼一段詞；

我為我的朋友唱一首歌

是瞧不起他的一首歌（讚美他的勤勞）

我朋友的肉體從黎明到入夜

一直與土地岩石翻滾（讚美他的勤勞）

所以你的肉體與土地岩石翻滾

就是你被瞧不起所追求的目標（營造自己在島上被尊敬的基礎）

最終你的懶惰只好在風平浪靜的時候（你的勤奮被認同）

在美麗的礁岸隨著洋流飄走（因而千年流傳英明）

是的，古老的詩歌，已非我們現代達悟人追求被尊重的核心價值，「老者逝矣，少者老矣，往事只能追憶！」我以為，從健康視角來論，追憶前人的優質形貌，必須感恩於前後來訪從事攝影者的辛勞，來省思達悟人現代的臃腫身影與劣質的狐疑心態。

《映像蘭嶼》詮釋的是「肉體與土地、岩石翻滾」的歲月，我們看見的各個都是結實的肌膚、婦女的樸實、孩童的清純，見證了我們往昔勤奮的本質，見證了人與自然焠融為一體的豐腴社會。

推薦者簡介

夏曼・藍波安

達悟族作家、國家實驗研究院台灣海洋科技研究中心副研究員。曾任蘭嶼「驅除惡靈」運動總指揮、行政院「社區營造」委員會委員。著有《冷海情深》、《黑色的翅膀》、《海浪的記憶》等文學著作，曾榮獲吳濁流小說類首獎、時報文學推薦獎、二〇〇六年吳魯芹年度散文獎等。

A trip to the Memory Lane

Recommendation by Syaman Rapongan

Recently a friend on the island mentioned to me: "There is a great photography book about the movie Song of Orchid Island. It is a collection of the photos taken by movie still photographer Hsieh Chen-Lung during his off time on the film shoot." I was therefore introduced to this book and had the opportunity to appreciate the life on the island presented in it. In this anthology, characters were captured in their natural environments and showed no discomfort or awkwardness. The images reveal an original beauty, original authenticity, and original emotions and allow the readers unlimited room for imagination. What we see is a vivid and faithful portrayal of Tao people's old-timey life and culture.

I was a first grader at the Orchid Elementary School in 1964. The only way we obtained outside information was listening to the Taiwanese who came over to the island. We heard them saying: they (Taiwanese) are advanced, we (Tao people) are primitive; they are civilized, we are barbaric; they wear shoes, we are barefooted; they are crafty, we are trust-worthy. We knew nothing about movies or photography either. Just like the Tao people photographed in the book, we only tried to provide service to the movie makers. After Song of Orchid Island was shown theatrically, no Tao people ever got to see it; it appeared that the original intent of the film had nothing to do with the aesthetics of cinematography, director's professionalism, or rationality of the drama. However, the Tao people were quite aware of the truth: when comparing the ways of the Han people with those of the Japanese, the Tao people have concluded in a simple statement: "The Han people's attitude of doing things is almost sloppy." The same attitude has also characterized the way the Taiwanese government governs Orchid Island after the World War II.

To someone of my age, reading Images of Orchid Island is like taking a trip to the memory lane and revisiting the island of my childhood. I had a long reflection and was deeply moved. Memory is like the floating sand layers, and the ocean waves unearth those buried at the seafloor. With the passing of time, the imagery of past in our minds became blurry and we forgot the unique ocean culture built upon the sacrifice, hard work and dedication of our forefathers. All we can do now is trying to capture the beauty of community life of the Tao people by watching or listening to the old men musing about their past at the local bars before they slowly pass away. The dreary and rough expression on their faces cannot hide their boldness and pride as laborers. There is a simple, honest fortitude in their characters. In the book Images of Orchid Island, we can clearly sense such vigor. On the stage of Tao people's historical and cultural development, the book has provided a heart-searching script for the studies of humanities. And the serene and chiseled faces in the anthology will continue to reveal intimate and meaningful stories between the Tao people, the ocean and the nature.

Late in the night, the strong southwestern wind blew off the leaves of the mango trees in my front yard and awakened my memories of my forefathers. I found a tape recording of the songs they sang in the past when celebrating boat launching. I listened attentively to what they wrote about the land, the ocean, the taros, and flying fish. The lyrics of one song went like this:

I sing a song for my friend

A song that looks down upon him (praising his hard work)

From morning to evening, my friend's body

Keeps tumbling in the soil and the rocks (praising his hard work)

So your body tumbles in the soil and the rocks

You pursue the goals that people look down upon (laying foundation to win respect on the island)

Ultimately as the wind and the waves quiet down, your laziness (Your hard work is recognized)

Is carried away by the currents along the beautiful coral reef coast (Your wisdom will be passed on through generations)

The contemporary Tao people no longer uphold the virtue celebrated in the old song as a core value for respectability. "The elders pass away, the young age, and the past is only a memory!" I believe when we pay tribute to the old generation for their contributions, we also need to appreciate the efforts of all the photographers who have visited the island throughout the years. Because of their works we can rightly examine the greed and skepticism of the contemporary Tao people.

Images of Orchid Island is a brilliant thesis on the age of "body and soil, tumbling rocks," in which we witness hard muscles, honest women, innocent children; the diligent nature of our past; and an abundant society born out of the harmony between man and nature!

Syaman Rapongan

A Tao writer, currently an associate researcher at Taiwan Ocean Research Institute. He was the director of Orchid Island's Anti-Nuclear Waste Movement, a member of Community Empowering Committee of the ROC Executive Yuan. His works include Deep Love for Cold Sea, Black Wings, and Memory of the Ocean. He was the winner of Wu Chuo-Liu Writing Contest (Fiction category), China Times Literary Award, and the 2006 Wu Lucian Prize for the Essay.

用相機說故事的人

編者 / 許豐明

在台灣第一代攝影家之中，有許多愛好從現實生活中取材的寫實主義者。這些攝影前輩們包括林慶雲、許蒼澤、黃季瀛、徐清波、劉安明、蔡高明、陳石岸等人，都曾在台灣光復後仍積極參加日本攝影雜誌所舉辦各種形式的攝影比賽，尋求在台灣唯美沙龍攝影主流意識中無法得到的認同與肯定。這些第一代攝影家中，本書的作者謝震隆先生是其中的佼佼者。

謝震隆，民國 22 年（1933）生。小學四年級時，隨著當時少數能畢業於日本 ORIENTAL 寫真專門學校（現在東京綜合寫真專門學校前身）的父親謝錦傳先生，開始接觸攝影；民國 54 年（1965）進入香港邵氏電影公司擔任劇照師，由於過人之觀察技巧，諸多紅牌導演及影星皆指定由其拍攝劇照。本書是謝震隆於六○年代隨著邵氏電影公司潘壘導演到蘭嶼拍攝電影《蘭嶼之歌》劇照時，趁著工作空檔，以「用相機說故事」的方式所拍攝一系列黑白照片。他以投入攝影比賽的取材方式和創作精神，在明顯主題的意識觀念下，透過黑白照片讓我們看見蘭嶼當地鮮明的原鄉色彩；明明是黑白的相片，或是蘭嶼達悟族人無聲的眼神，謝震隆以精湛的曝光精確度，加上適當的光度和明暗比，讓影像說故事的詮釋更具說服力，更讓我們從相片中聽見達悟族人的歡笑聲、談話聲，甚至當時純樸善良的蘭嶼人的思想與內涵。謝震隆充滿人文色彩的觀點所發之聲，鮮活地存在海峽兩岸的影像記憶中。

民國 90 年（2001）謝震隆曾以百幅反映六○年代台灣鄉村風情的攝影作品，在北京國立中國美術館舉行《台灣鄉土風情獵影》展，這是台灣攝影家在北京舉辦的第一場攝影展。謝震隆接受北京中央電視台的訪問時，提到攝影作品「示威」的創作緣起，他說：「蘭嶼人的示威儀式是一般觀光客看不到的。拍攝當天，剛好有一艘新的船下水，當地習俗是不放鞭炮，而以人們發出的高亢聲音代替。這個儀式大概延續五、六分鐘，每一個人都使盡了全身力氣，雖然感到十分疲憊，卻能持續到儀式完成。然而現在的蘭嶼，物換星移，年輕一輩為表演而表演的儀式，根本失去了前人自然和真實的精神。」

謝震隆擅長用自然和寫實的手法，以說故事的方式，記錄六○年代台灣的各地人物風情，曾獲日本攝影藝術月刊月例攝影競賽年度首獎，作品獲《Nikkor Annual》年鑑及全省各地美術館典藏。最難能可貴的是，民國 94 年（2005）謝震隆與其作品「養鴨人家的小孩」受邀參加日本東京電視網舉辦世紀攝影大展（主題：世上的孩子們，明日的見證者），主辦單位自全球挑選出從十九世紀末至今最傑出的兩百位攝影家參展，謝震隆為兩岸三地的唯一代表。

近年來，擔任基督教台北神召會董事一職的謝震隆，除了有虔誠的信仰，亦致力於地方文化和攝影技巧的教學與傳承，現為中華民國電影攝影協會理事與攝影指導、中華攝影學會作品評審委員、耕莘文教基金會攝影研習指導老師、台灣鄉土文化攝影群攝影作家、新店崇光社大講師、台

灣獵影學會會長。已出版《巴黎，我愛！》、《台灣鄉鎮獵影》、《台灣鄉土風情獵影》（中國：台海出版社出版）等攝影集。

從本書中，您將可以在一系列大師鏡頭下的蘭嶼影像史詩中，遇見一位腳踏實地的國寶級攝影大師，近半世紀以來的獵影鱗爪，在近代台灣攝影發展史的脈絡中，讓我們看見謝震隆為後輩所踩出的前進足跡。

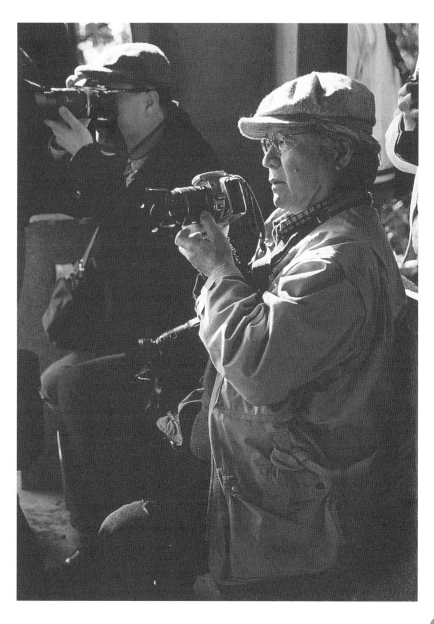

A Storyteller with Cameras

by Editor/Hsu Fong-Ming

Among the first generation Taiwanese photographers, there were quite a few photo realists who drew inspiration from everyday life. These pioneers included Lin Qing-Yun, Hsu Cang-Ze, Huang Ji-Ing, Hsu Qing-Bo, Liu An-Ming, and Cai Gao-Ming. Even after Taiwan reverted to Chinese rule, they vigorously attended many different types of photography competitions sponsored by Japanese photograph magazines to seek approval unattainable from the mainstream art photography circle in Taiwan. The author of this book, Hsieh Chen-Lung, was definitely one of the leaders among these photographers.

Hsieh Chen-Lung was born in 1933. Through his father, one of the very few that graduated from Tokyo Photography School (later became Tokyo College of Photography) during that time, he was introduced to photography in his fourth grade. In 1965, he joined Shaw Brothers Studio in Hong Kong and became a still photographer for movies. Impressed by his superb perception and skills, many top directors and stars sought after him to take stills for their films. During the sixties, he went as a still photographer to Orchid Island with the film crew of *Song of Orchid Island* directed by Pan Lei. He devoted his free time with intense creative energy and distinct ideology to a series of black and white photographs that were of competition themes and revealed the homeland vision of the island. Hsieh's masterful control of exposure and apt contrast between light and darkness invested in these silent black and white photographs a convincing power to interpret the stories of the images. Through them, we can hear the laughter, the chattering, and the innocent rhythm of the Tao people. There is an original voice of cultural essence in Hsieh's perspective that still resonates in our visual memories.

In 2001, Hsieh held solo exhibition *Rural Landscape of Taiwan* in Beijing National Art Museum of China, becoming the first Taiwanese photographer to have ever exhibited in Beijing. A total of a hundred photographs portraying the beauty of the Taiwanese countryside during the sixties were showcased in this exhibition. When interviewed by Beijing CCTV, he recounted the behind-the-scene story of Exorcism, the cover photo of this book. "Normally, the everyday tourists would never get to see the exorcism ceremony of the islanders. It happened that a new boat was being launched into the ocean that day. The local custom didn't allow them to burn firecrackers. So instead, they used the natural resounding human voices, which they believed to have the power to exorcize. That's what they did. The ceremony took about five or six minutes long. After repeating the movements many times, they were completely exhausted. Nowadays, so many years later, things have changed. The younger generation gives the performance only for show. It just doesn't have the same kind of reality and power any more."

Hsieh is famous for recording Taiwanese people, landscape and culture during the sixties through his natural, realistic, and storytelling style. His works have won several first prizes from the Japan Monthly Photo Art Annual Competition, included in *Nikkor Annual* and collected by art museums throughout Taiwan. Most significantly, in 2005, Hsieh was invited to exhibit his work "Children of the Duck Farming Family" in "Century Photography Exhibition" hosted by TV Tokyo Network. (The theme of the exhibition was "children of the world, witnesses of tomorrow.") The exhibition presented works from two hundred most excellent photographers from the end of 19th century to the present day, and Hsieh was the only photographer selected from the region of China, Hong Kong and Taiwan.

A dedicated Christian, Hsieh is currently a board director of the Taipei Assemblies of God church. In recent years, he has devoted himself to the education of local culture and photography. He is currently director and photography instructor of the Chinese Society of Cinematographers; jury member of Chinese Society of Photography; instructor of Cardinal Tien Cultural Foundation photography camp; member of Taiwanese Indigenous Cultural Photographers; Hsintien Chungkuang Community College lecturer; and chairman of Taiwanese Society of Scenic Photographers. He has published *Paris-je t'aime, Realistic Shots from Country Towns,* and *Realistic Shots from Rural Taiwan*. (published by China's Taihai Publishing House).

Through a series of brilliant epic montage of Orchid Island in this book, you will meet a down-to-earth master photographer who has captured the soul of this land through his visionary lens in the past half century. In the course of development of Taiwanese photography, we can conclude that Hsieh has braved a new path for the photographers after him opening toward a very promising future.

作者序

謝震隆

從小我就對攝影著迷，父親謝錦傳先生是早年日本 ORIENTAL 寫真專門學校畢業生，一輩子以攝影為業。家中五兄弟，我對攝影最有興趣，所以父親也教我最多。小學四年級時父親經營一家攝影社，當同年的孩子忙著遊玩，我已經是父親暗房裡的助手。一盞幽暗的紅燈下，調製藥水、沖片、計時，看著照片上的影像顯現，是我最快樂的時光。台灣光復前，當多數人還無法擁有一張自己的相片時，我已經有機會借用父親的 BALDAX 疊式德國相機，隨著父親四處拍照；唸中學的時候，我甚至已經有名牌 ROLLEICORD 相機可用。回顧這樣的成長過程，往後走上攝影的路，實在是一件再自然不過的事。

1962 年，我在台南開了一家攝影沖放店，為了打響知名度吸引顧客，我穿梭在小鎮農村，拍了一系列照片；同時參加多項國際攝影比賽，最後鎖定素有攝影文化大國的日本為參賽的主要目標，一方面砥礪自己，一方面也為證明自己的實力。從 1960 年到 1963 年期間，榮獲多次的入選獎項，並分別獲得日本五大攝影雜誌之首獎與特選，最後甚至獲得了 1963 年 PHOTO ART 月例賽 BEST10 的第一名，這項殊榮對我日後的發展產生了決定性的影響。這項比賽實際上是日本國內而非國際性的攝影比賽，在評審階段，由於我的參賽作品深深感動評審，遂破例以外國人的身分榮獲首獎，在當時的日本攝影影壇曾轟動一時並傳為佳話。直到 1964 年，在一個很偶然的機會中，我進入了香港邵氏電影公司擔任劇照攝影師，才停止這段鄉鎮獵影的生活。

踏入電影界後的第一份工作就是《蘭嶼之歌》的劇照拍攝。蘭嶼，俗稱「蘭花之島」（Orchid Island）的美麗島嶼，雅美（達悟）族人就是住在這個與世隔絕的孤島上。蘭嶼真是南太平洋的世外桃源，碧波白浪，蕉雨椰風，這裡沒有煩惱、也沒有愁苦，是二十世紀難得一見的原始世界。老一輩的達悟族人堅守著祖先傳下來的獨特文化，由於地理環境侷限於絕海之中，這個神祕又充滿少數民族特性的島嶼和外界鮮有接觸，沒電、沒自來水，故當時生活方式仍非常原始與傳統。我們外景隊一待就是五十八天，每天所拍到的底片都是利用寶貴的 20°C 天然山泉水沖洗，至今已逾五十年，狀況仍完好如初。

本書所有的作品都是利用工作的空檔、開工前的清晨，或是收工後，爭取那短短的片刻所拍攝的。我當時正好參加完日本攝影藝術雜誌所主辦的年度獎比賽，之後直接投入《蘭嶼之歌》的外景工作，因而在拍攝技巧上更顯得心應手，且都是以參加攝影比賽的心態去取材或取景。透過黑白底片，用自然寫實的方式，停格在每一幅作品上，今日再細細端詳，深深感到這些影像是那麼珍貴又令人懷念，同時也在蘭嶼達悟族的「人性」與「真實」上留下最佳的詮釋與寫照。尤其重要的是，能在屬於達悟族的歷史時空軌跡中，替他們留下寶貴的寫實記錄。

我相信攝影之美在於它常常捕捉剎那，是人為無法單獨表現的，這中間經常夾雜著大自然的力量，我們經由時間的「瞬間凝結」而窺視了萬物之美——攝影是一種見證，見證歷史、見證自然、見證自己對美的修為。

Foreword

by Hsieh Chen-Lung

I was fascinated with photography ever when I was a kid. My father Hsieh Jin-Chuan graduated from the Tokyo Photography School in Japan and had a career in photography. Among the five boys in my family, I had the strongest interest in photography and learned the most from him. He opened a photo shop when I was in the fourth grade. When most kids at my age were busy playing, I assisted my father under the dim red light in the dark room. Mixing chemicals, developing photos, monitoring time, and watching the images developing from the negatives, were the happiest time in my life. At that time Taiwan was still a Japanese colony, and most people did not even have a photo of themselves, but I already had the opportunity to borrow the German made folding camera Baldax from my dad and took pictures with him everywhere. By the time I went to the middle school, I had owned a brand name camera Rolleicord. Looking back on my developing years, I think it was only natural that I also embarked on a career of photography.

In 1962, I opened a photo shop in Tainan. To promote business and attract customers, I traveled to little villages and towns all over in Taiwan to take a series of photographs. To motivate myself and prove my capability, I also attended many international photography contests and finally zeroed in on competitions held in Japan for its influence in the field of photography. From 1960 to 1963, I had received many honors, including the first place and special jury award from the five major photography magazines in Japan. In 1963, I won the first place of the Photo Art Monthly Best 10 Contest, a decisive success in my career. Normally this competition was open exclusively to Japanese and not international photographers; however, during the jury process, deeply moved by my work, the juries decided to make an exception to award me, a foreign photographer, with the first prize. It became a legendary story in the Japanese photography circle. In 1964, I unexpectedly became the still photographer for Shaw Brothers Studio in Hong Kong, and concluded my village photography period.

Song of Orchid Island was the first film I worked on after entering the film business. The film was shot on location on Orchid Island, a remote island the Yami or Tao people call home. With the blue ocean, palm trees and banana farms, Orchid Island is a Shangri-la in the south Pacific, untouched by worldly sorrows or anxieties. Isolated geographically by the vast surrounding ocean, the mysterious islanders had limited contacts with the outside world, and the elders kept the traditional culture generations after generations. There was no electricity, no running water on the island. Lifestyle stayed primitive and traditional. Our film crew worked on the island for fifty-eight days. All the negatives were developed by precious natural mountain spring at 20 degrees Celsius; even now, the pictures are as intact as fifty years ago.

Orchid Island series were taken during the free time of filming: I fought for every single available moment either in the early morning before filming or after work. Armed with experiences from the Japanese photography magazine contests, I was on top of my game when I joined the film project, and I purposefully applied the same principles of selecting subject matters or shooting angles to this series. Through a natural and realistic approach and the power of black and white negatives, the images provided the best interpretation and history of the humanity and reality of the Tao people. When I linger on each frame of the work today, I deeply appreciate how precious and memorable these pictures are. Most importantly, I am honored to be able to present a valuable and honest record of the Tao people's life in their journey through time, space and history.

I believe the power of photography is its ability to capture the moment that often eludes any other forms of human arts and can be achieved only with the participation of nature. By solidifying the split second of time, we peep into the beauty of all creation. Photography is a witnessing act: witnessing history, nature, and our cultivation in beauty.

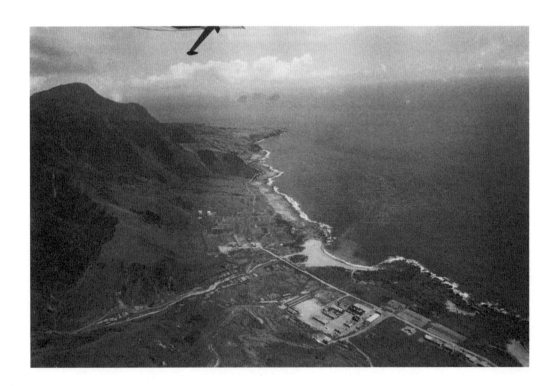

「養鴨人家的小孩」入選「世上的孩子們，明日的見證者」攝影展示集，這次大展展出超過259件作品，由200位攝影師在世界各個角落拍攝完成。我們相信，這些作品不但描繪出孩子們在歷史現實中的各種境遇，也帶給我們勇氣，看到淒涼的現實情景時，不會轉移眼光。如果這個展示被評定為「一件攝影作品可以帶動一個國家」，正確地認同攝影新聞業者的社會角色，那麼我們的努力將得到很好的回報。

本文摘錄自民國94年（2005）日本東京電視網舉辦世紀攝影大展《世上的孩子們，明日的見證者》攝影集〈序文：尋回孩子的笑容與希望〉。

"Children of the duck farming family" was selected in the *Children of the world, witnesses of tomorrow* photography exhibition, which presented more than 259 works from 200 photographers who created their images in different parts of the world. We believe these photographs not only depict children in different life circumstances of different historical backgrounds, but also bring us courage not to turn away our heedfulness in face of sorrowful realities. If this exhibition can convince us that a work of photograph can motivate a nation and affirm the social responsibility of a photo journalist, then we are well rewarded for all our endeavors.

Excerpt from the photo anthology of the 2005 *Children of the world, witnesses of tomorrow* photography exhibition sponsored by TV Tokyo Network : "Foreword - Searching for the Smiles and Hope of the Children."

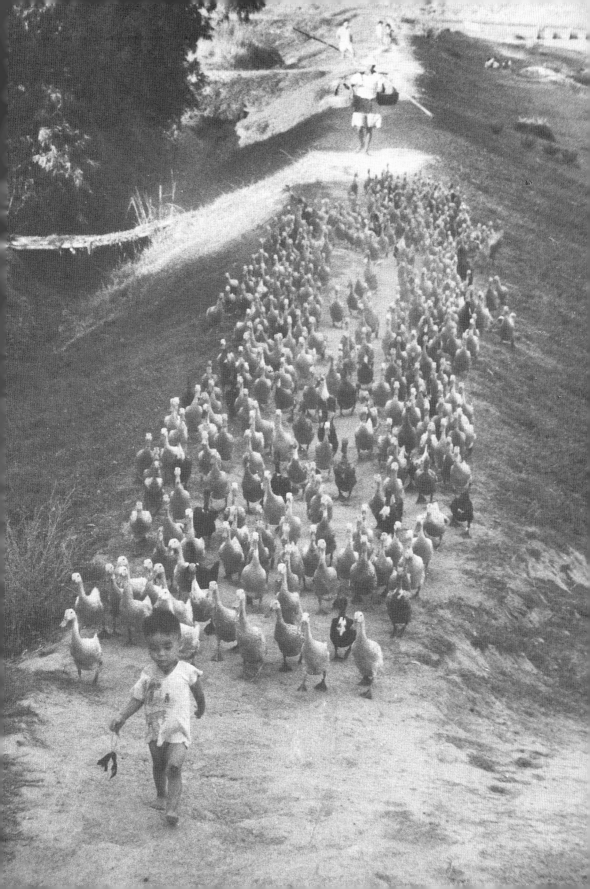

初見蘭嶼

The First Sight of Orchid Island

初見蘭嶼

夏日藍白的雲彩，在蘭嶼的天空悠閒地飄浮，我和電影公司的夥伴們，站在小船的甲板上，一手叉著腰桿子，一手放在眉心的位置，遠眺島上遠方綺麗的彩霞吻著水面上的倒影。那初見蘭嶼的心情，也隨著船影搖搖晃晃了起來，隨著岸邊的波濤盪成無數的細鱗模樣，悠悠地在每個人的心海裡悸動著。

The First Sight of Orchid Island

The summer clouds unfolded in the blue sky over Orchid Island. One hand on my waist and the other resting between my eyebrows, I stood on the deck of the small boat along with the film crew from the movie studio, looking into the distant island where the charming clouds kissed the reflection on the water. Love-struck at the first sight of the island, our hearts also quivered like the reflections of the ships by the shore vacillating with the tiny scale-shaped ocean waves.

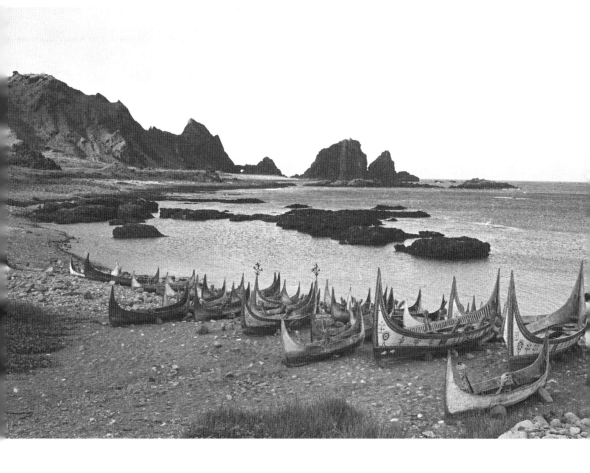

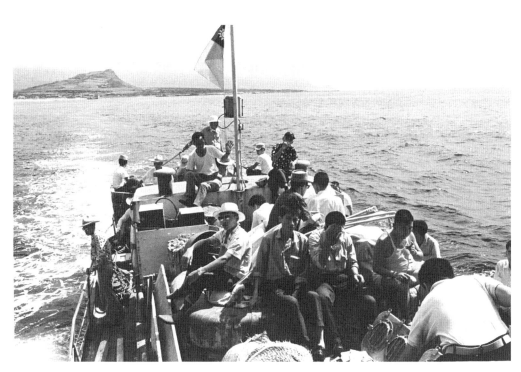

一九六四年的夏天，我和香港邵氏電影公司導演潘壘先生和工作人員，一行人浩浩蕩蕩地搭著「東光輪」，經過十八個小時的航程，再轉搭小木船，慢慢靠近充滿夏日風情的蘭嶼東清海灘。

It was the summer of 1964. I went to Orchid Island with film director Mr. Pan Lei and the film crew from Shaw Brothers Studio of Hong Kong. We started our journey with eighteen hours onboard Eastern Light cruise ship, and then transferred to several little wooden boats, and finally landed at the Tung-Ching Beach of the Island in its summer glory.

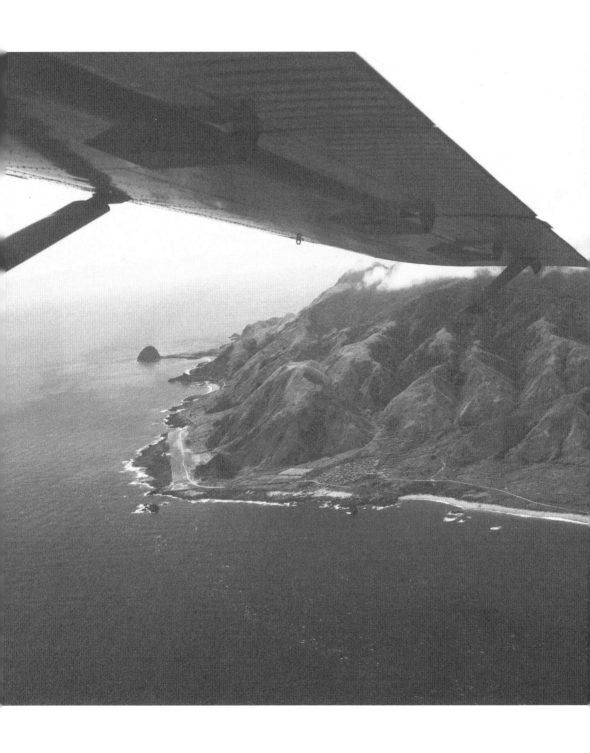

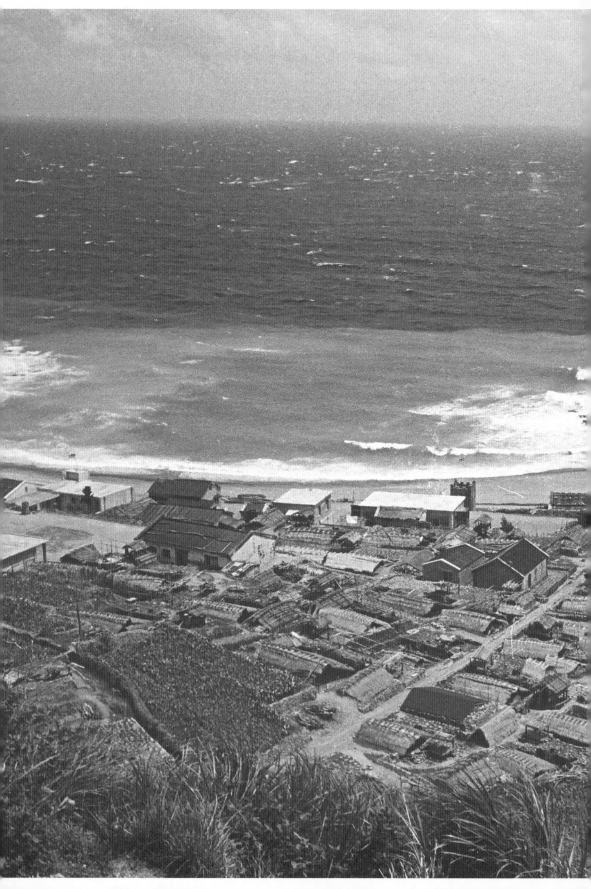

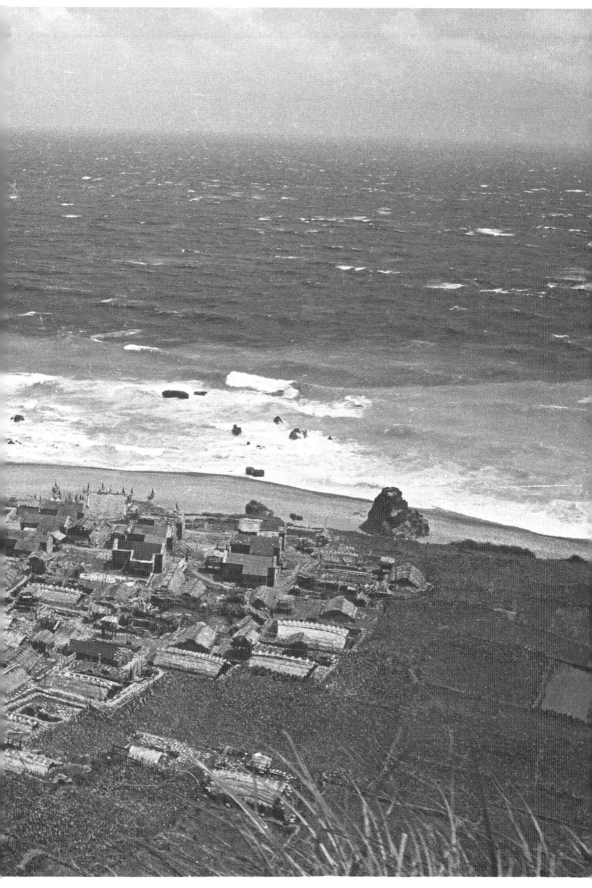

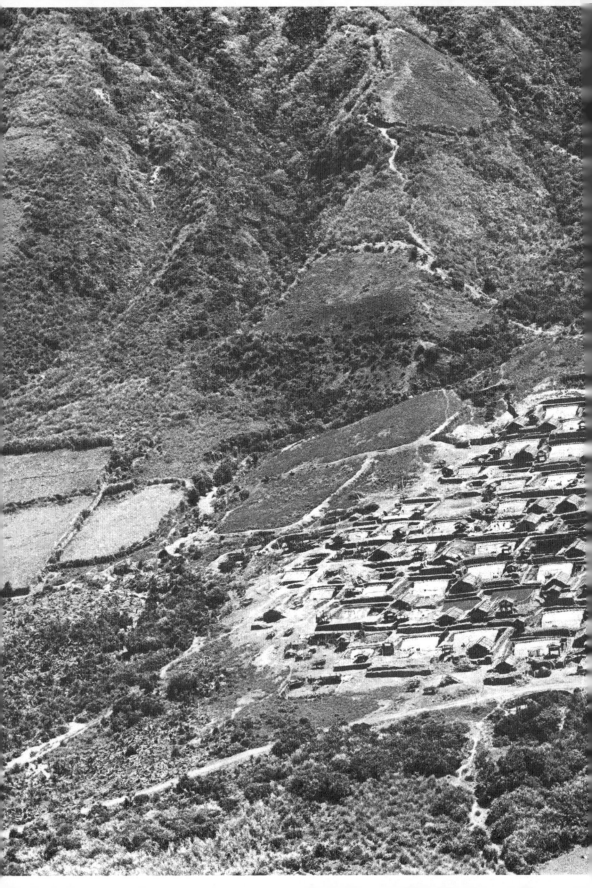

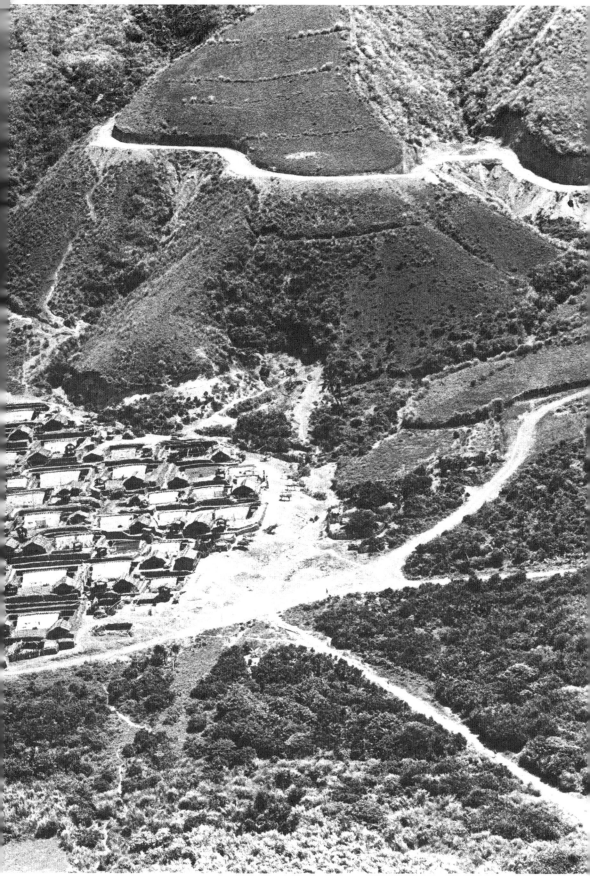

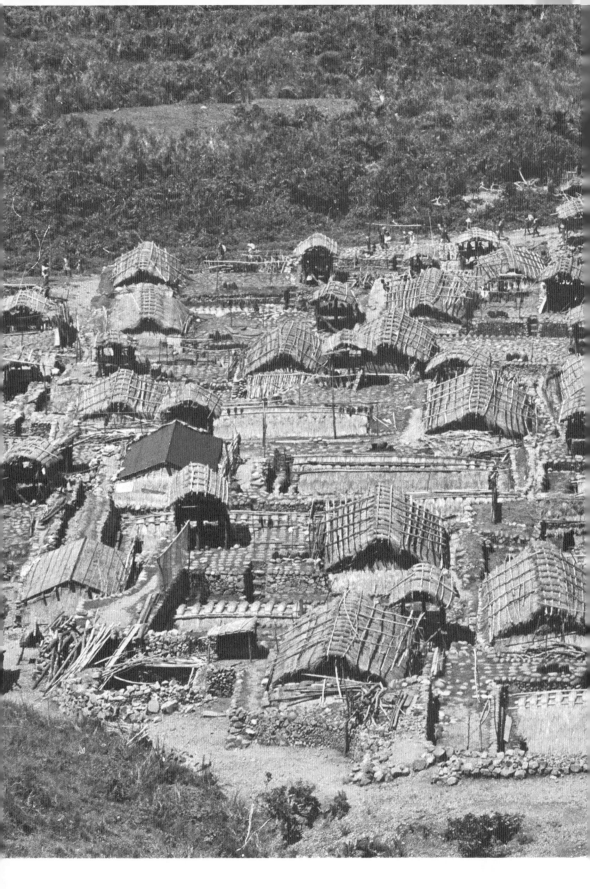

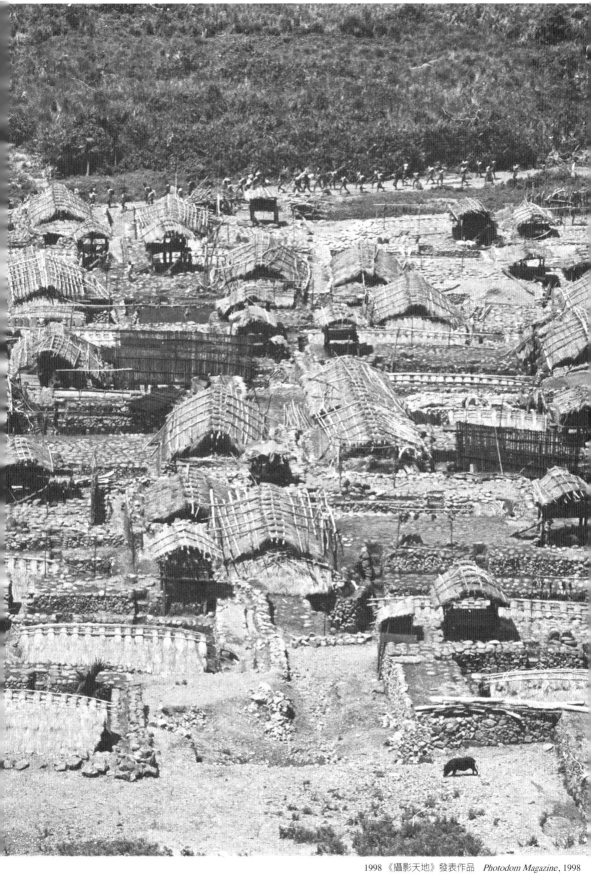

在臺灣戒嚴時期，蘭嶼是管制區，加上島上有一種稱為「紅蟲」（Tochu）的傳染病，一般人對這種容易發炎的疾病沒有抵抗力，很容易喪命，讓外地人心生畏懼。要踏上這塊人間淨土，談何容易！

It was quite difficult to travel to this island of Shangri-La in the old days. First of all, Taiwan was under the martial law and the island was an off-limit zone. Secondly, the island was infected with tsutsugamushi disease. Travelers usually had no antibodies against this contagious disease and could get killed easily. No wonder people were afraid of visiting the island.

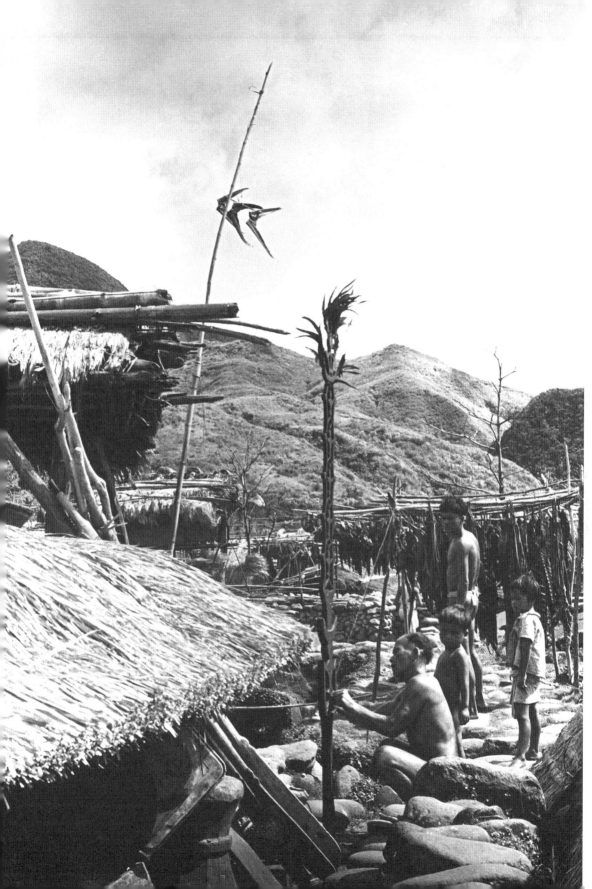

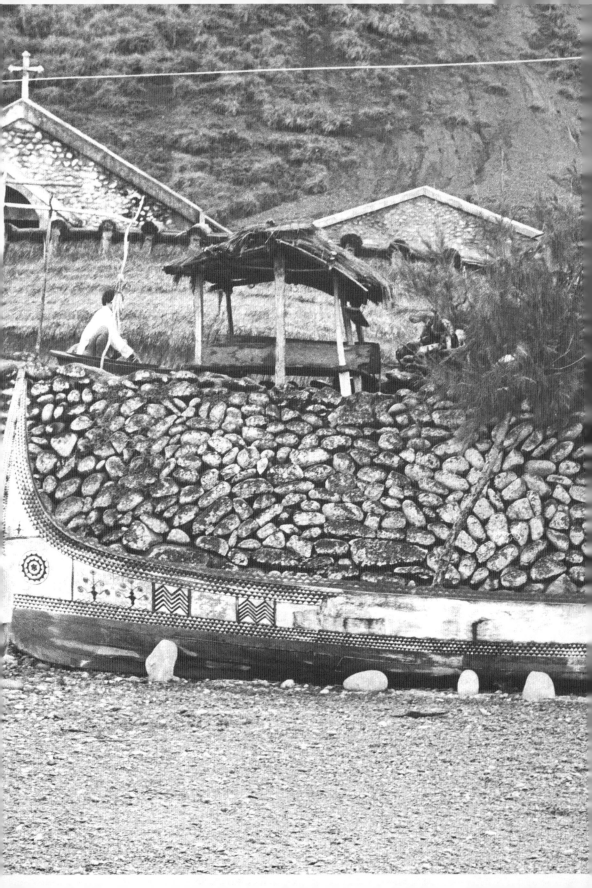

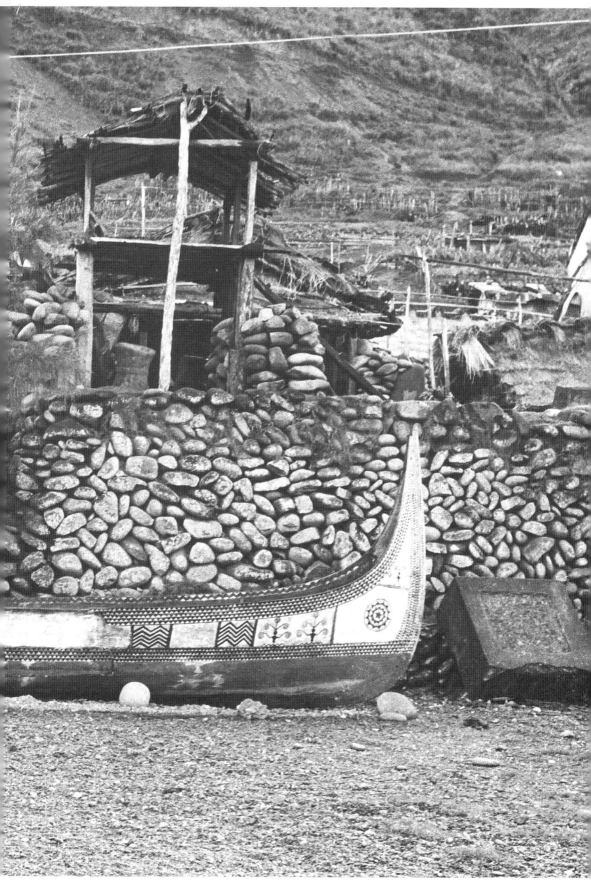

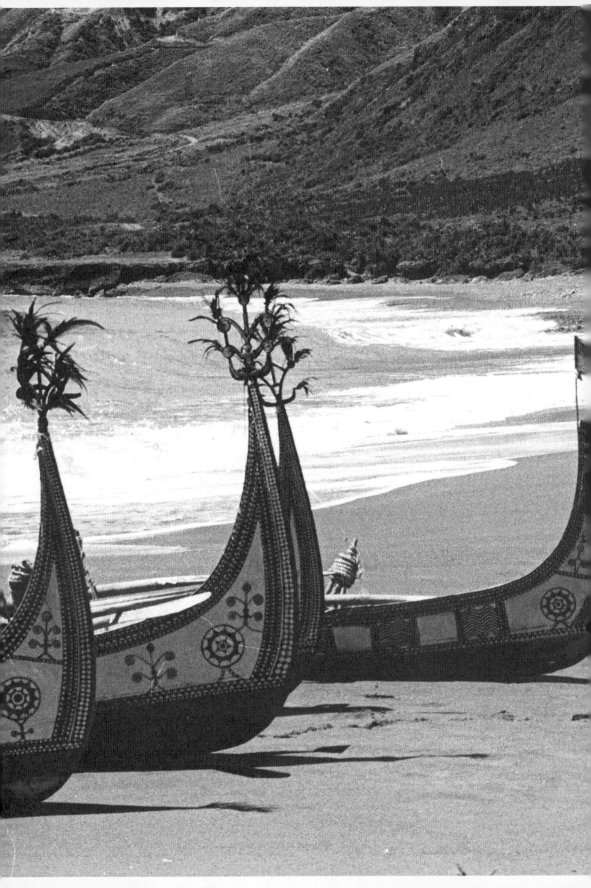

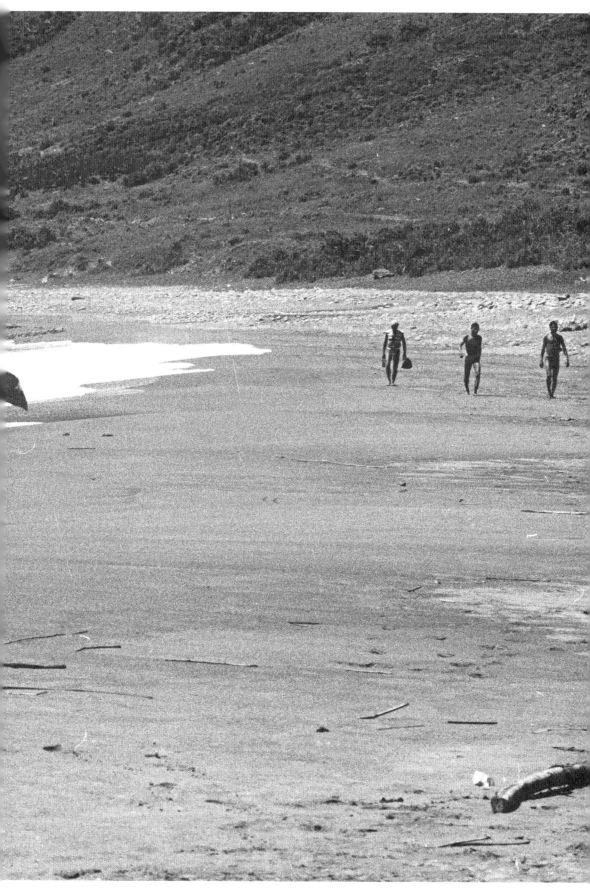

Children

鏡頭裡的小弟，是個調皮又孝順的孩子。他可能整天都靜不下來。那天早上，小弟一個人拖著一件準備洗滌的衣裳在地上蹣跚行走，吸引了我的目光。我看見蘭嶼的孩子自主性強，主動幫媽媽拿衣服。有時他們微小的身體倚著母親，窩在母親身邊，讓我想花更多的時間記錄他們活潑可愛的童顏。

The little boy in my viewfinder was both mischievous and dutiful. He probably could never quiet down for one moment. I was captivated by him that morning when he dragged the clothes on the ground to do laundry. I discovered that kids on the island had great initiative. They would help their mothers carry the clothes on their own. At the same time, they were very clinging to their mothers, with their little bodies always leaning against them. Their sweet nature and faces inspired me to spend more time recording their activities. And the series of photos called "Children" was born.

2001 年北京中國美術館展出作
Beijing National Art Museum of China, 200

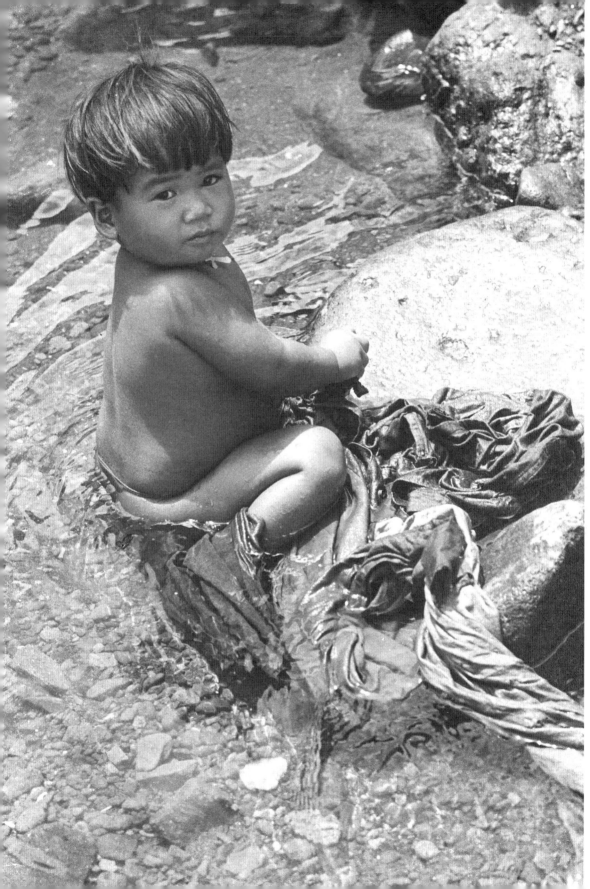

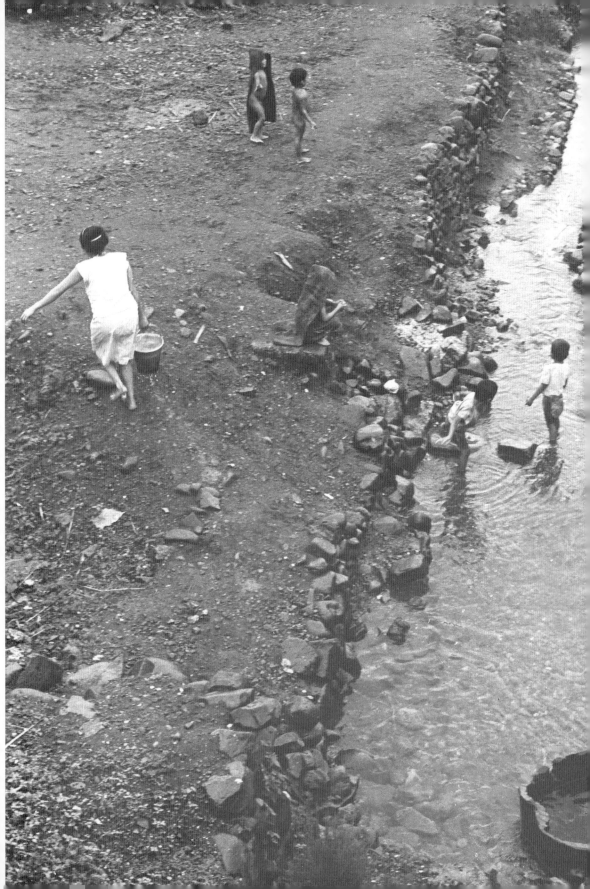

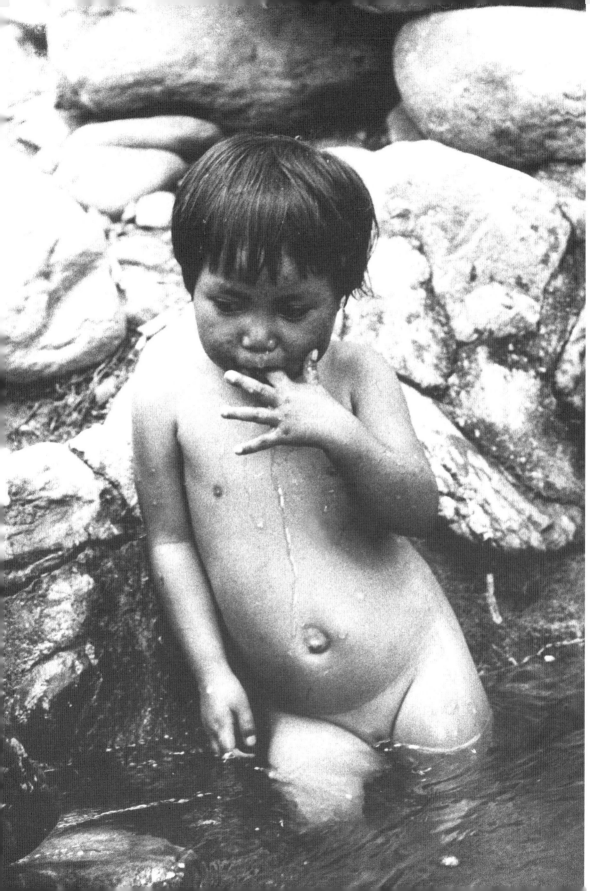

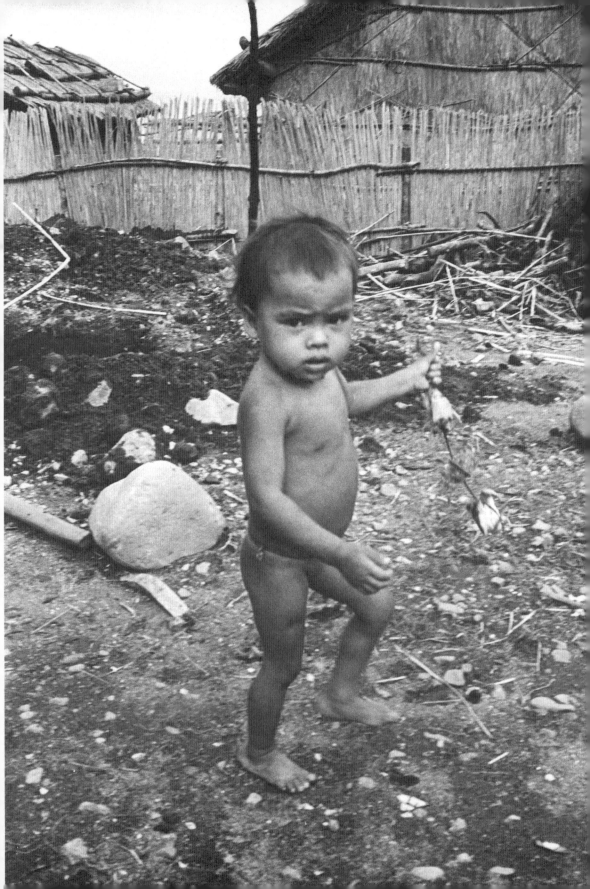

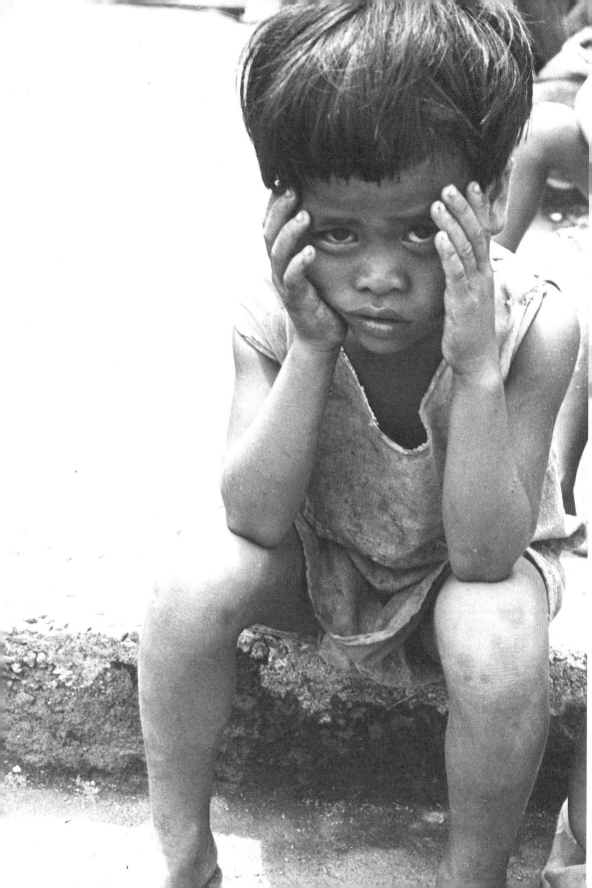

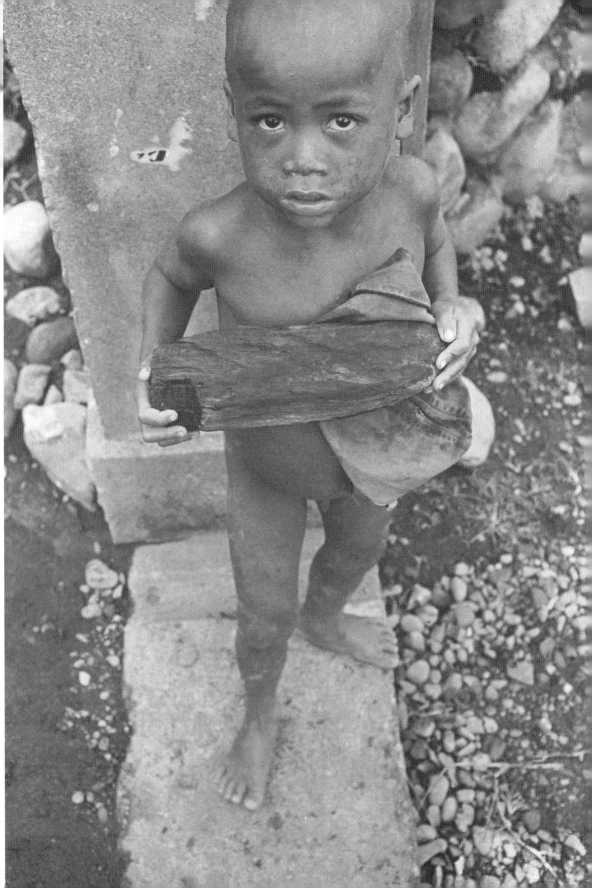

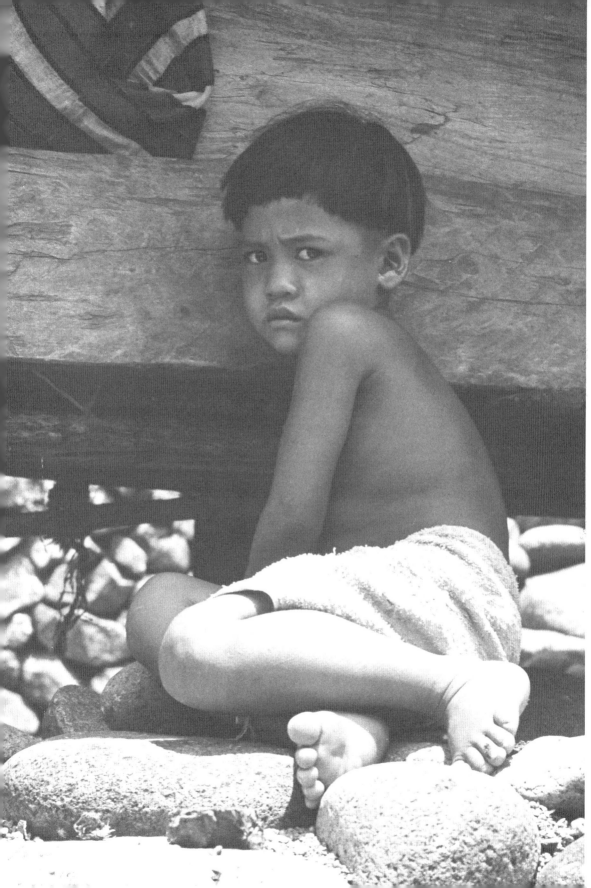

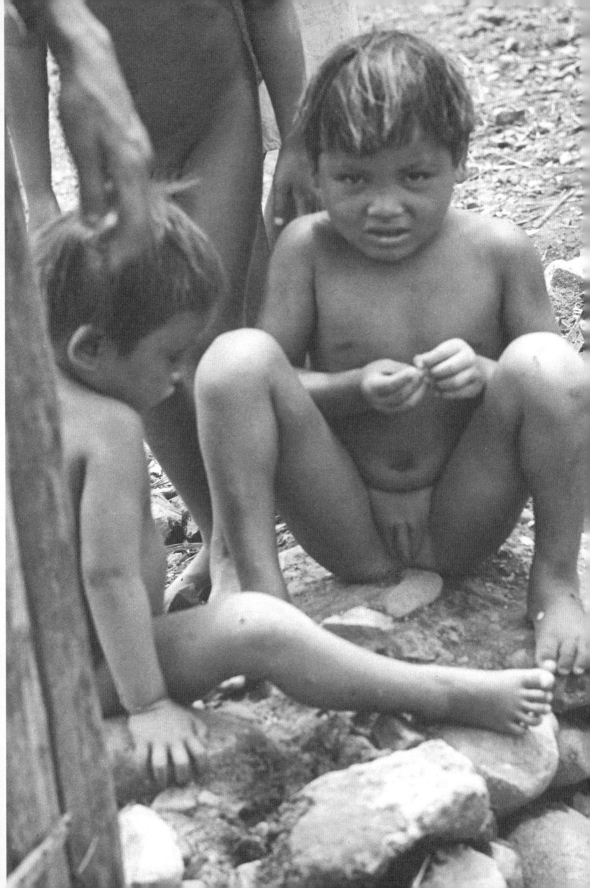

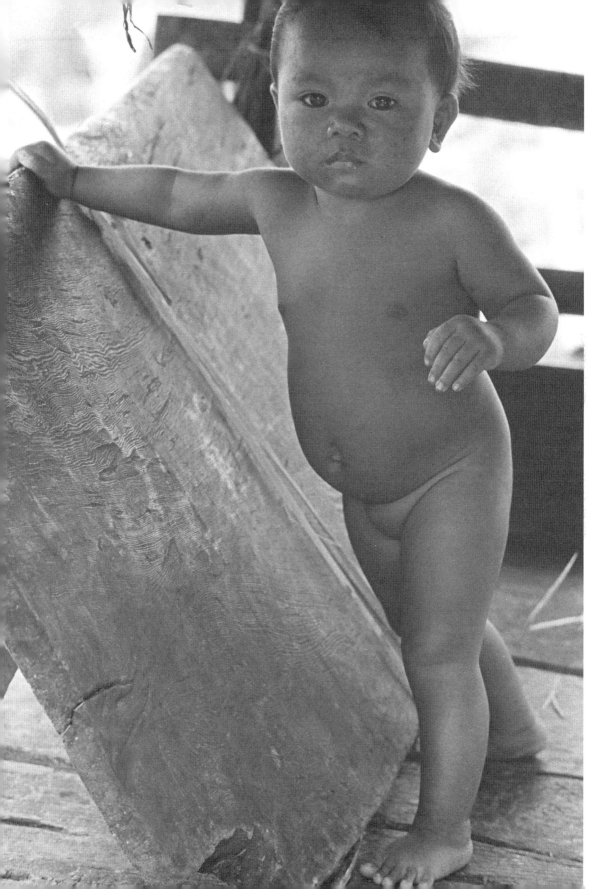

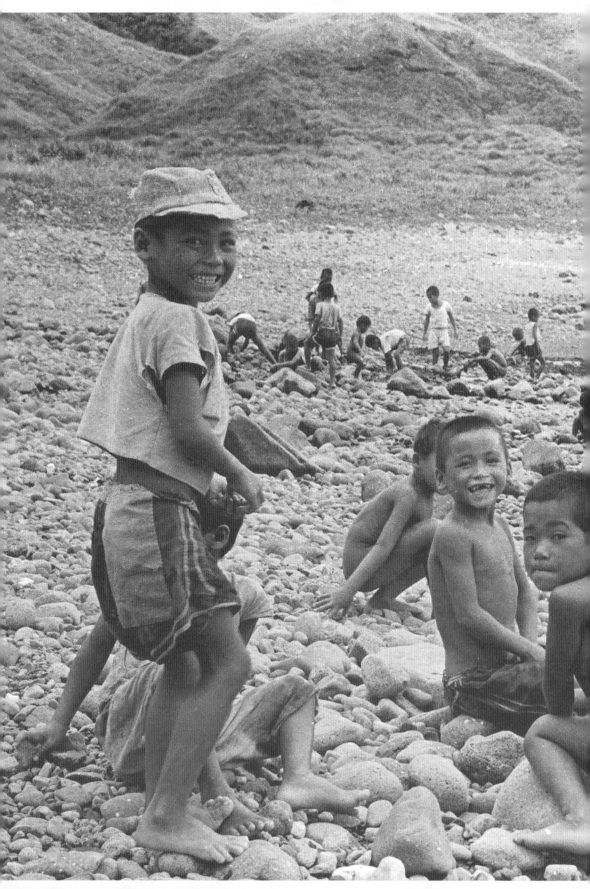

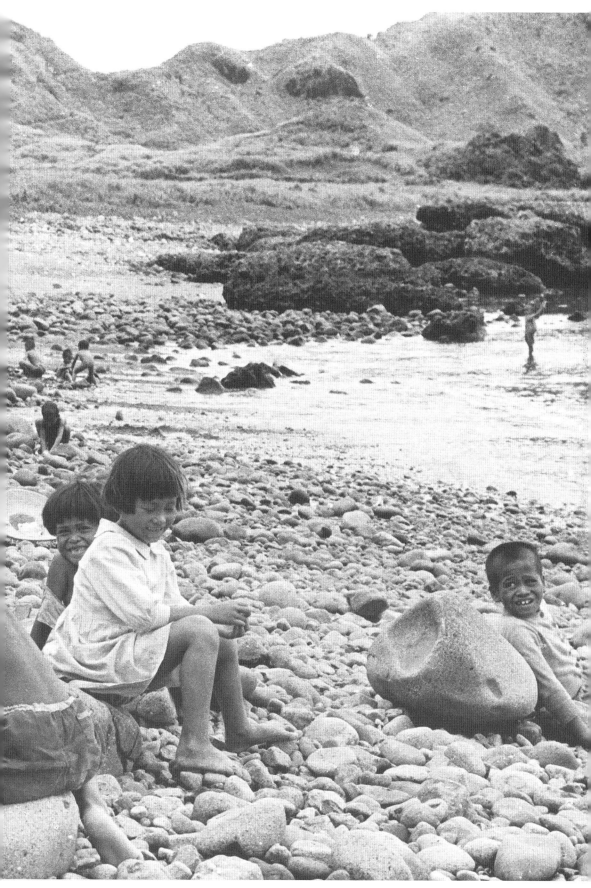

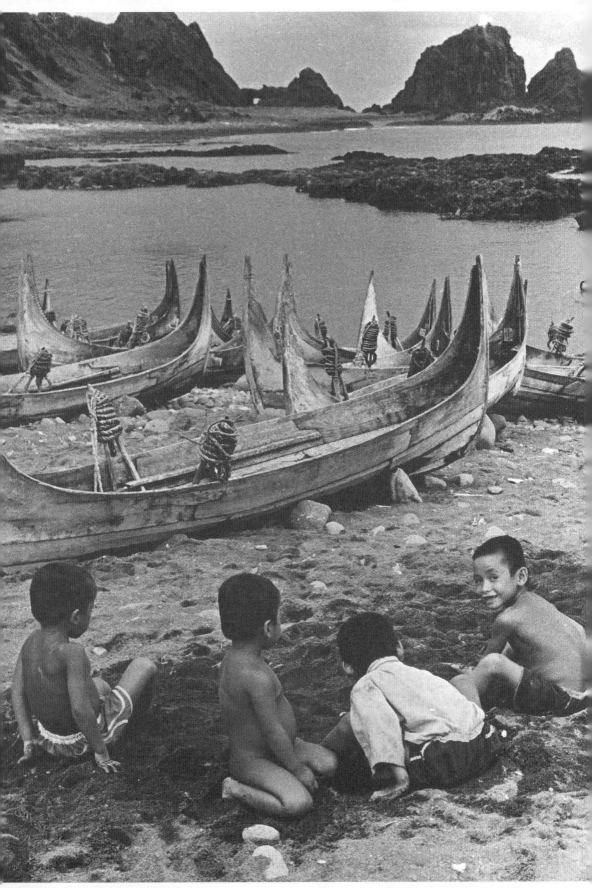

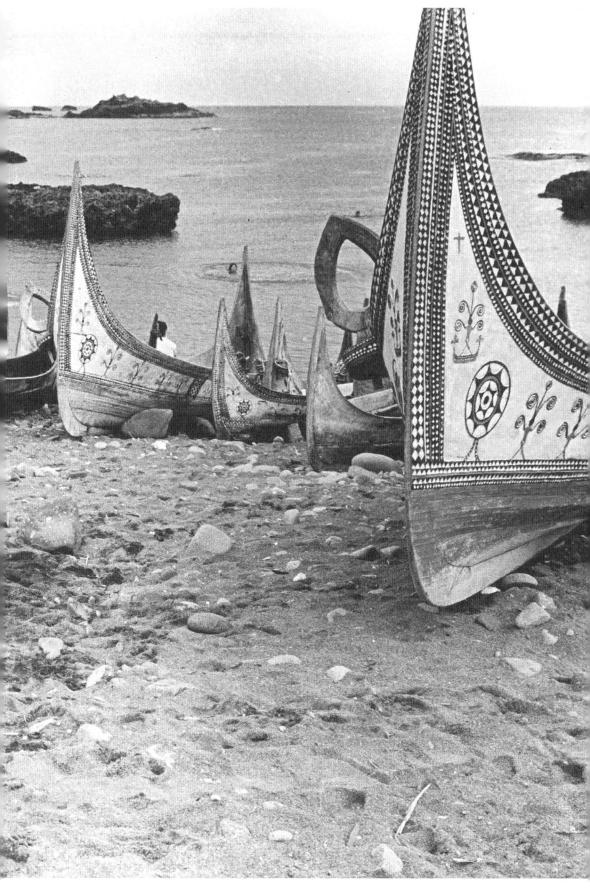

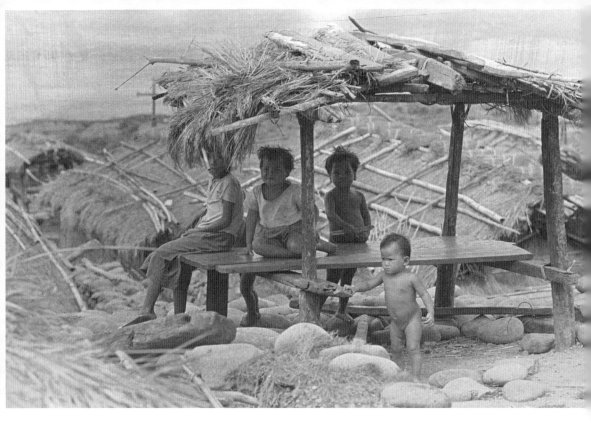

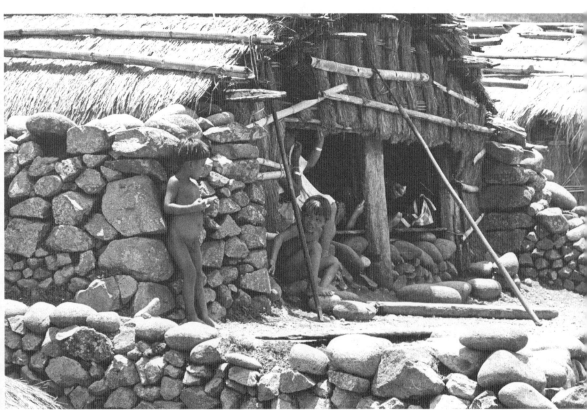

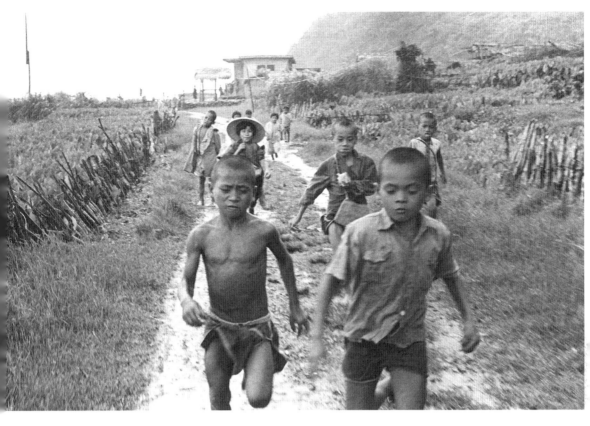

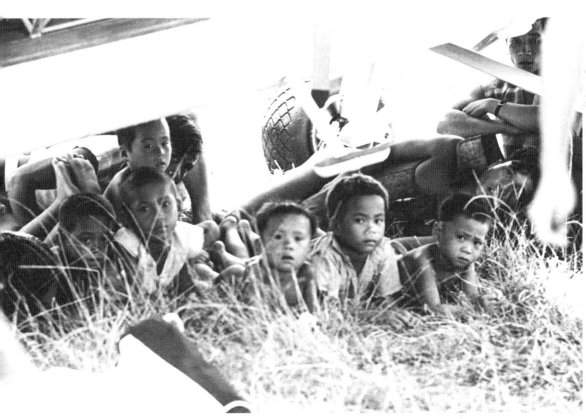

早年的蘭嶼，每個孩子都在少子化的情況下出生。據藝術家劉其偉先生的實地考察，得知當地婦女並不是在屋內生產，而是跑到戶外水井邊，把孩子生下來，放入冰涼的清水中洗滌。如果孩子在寒風中、冰冷的水裡，能夠生存下來，就表示這孩子是上天所賜的禮物了。

Orchid Island already suffered from low birth rate during that time. Artist Max Liu studied the local custom of birth-giving and discovered that the island woman didn't deliver her baby inside the house. She would go to the well outside and then gave birth. Afterwards, she would wash the baby in the cold water. If the baby survived the cold water in the harsh weather, it meant the baby was a gift given by heaven.

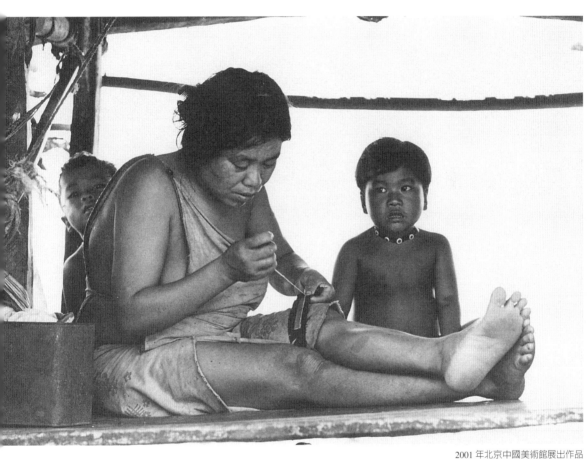

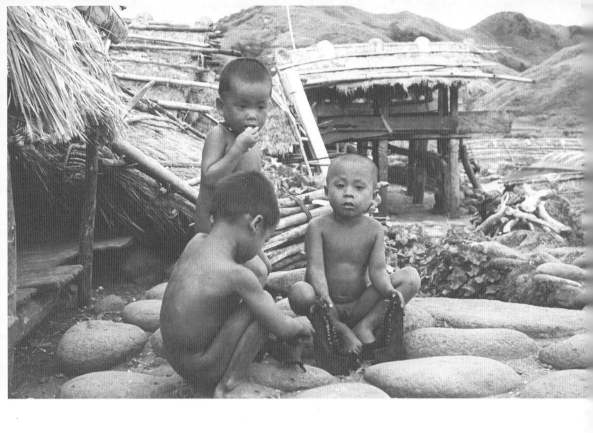

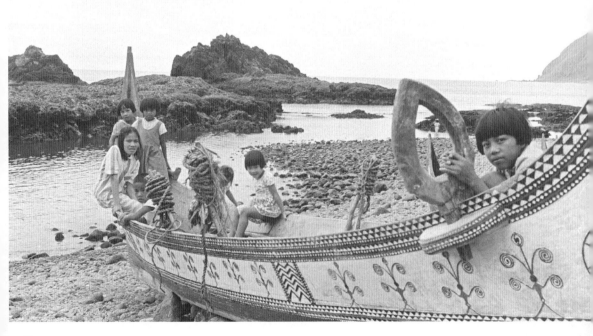

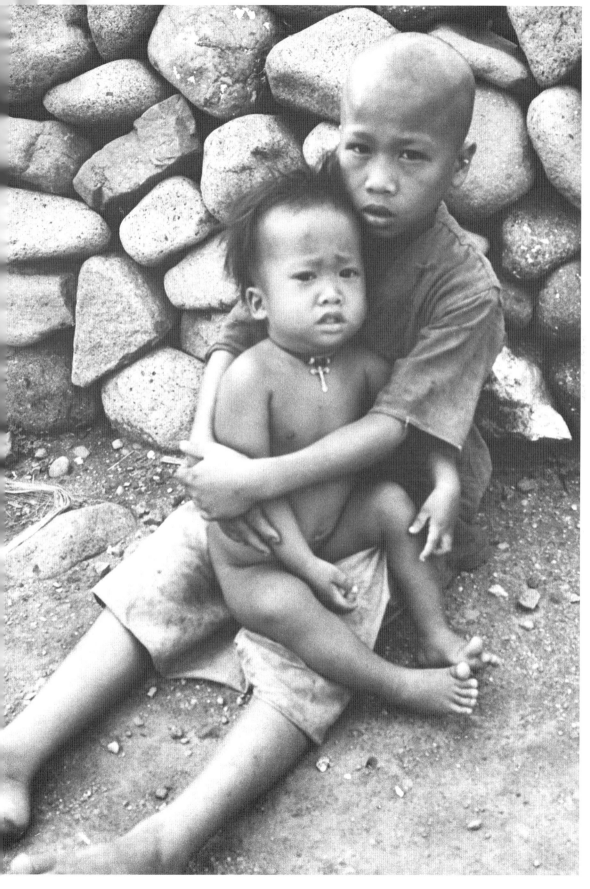

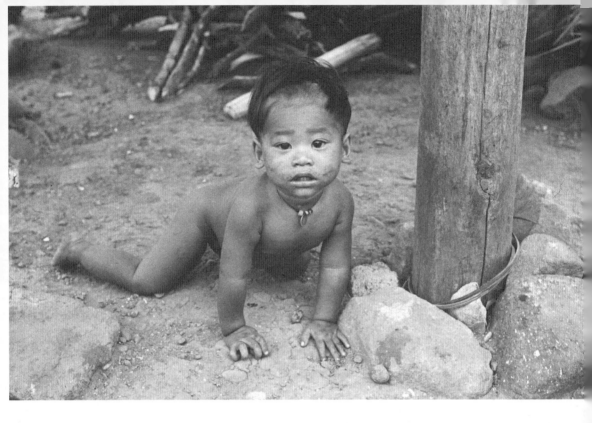

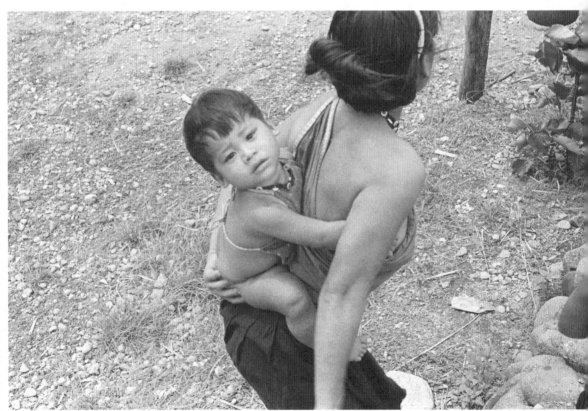

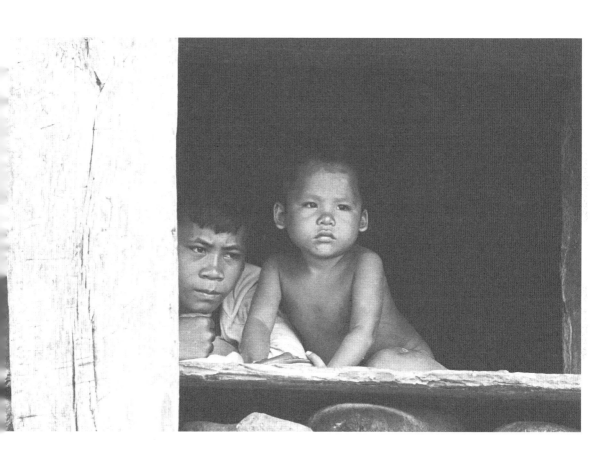

蘭嶼的孩子全是天之驕子，他們總是自由自在，全身光溜溜地在溪畔戲水、在海邊奔跑。有時，幾個小壯丁和小女娃兒，烈日下在幾艘獨木舟之間跳來跳去，很難得看到他們安靜下來。

Children on the island were truly blessed. They were always carefree, either playing in the creeks all naked, or running on the beach. Sometimes, boys and girls would jump around between the canoes under the blazing sun. They could never stay still for one second.

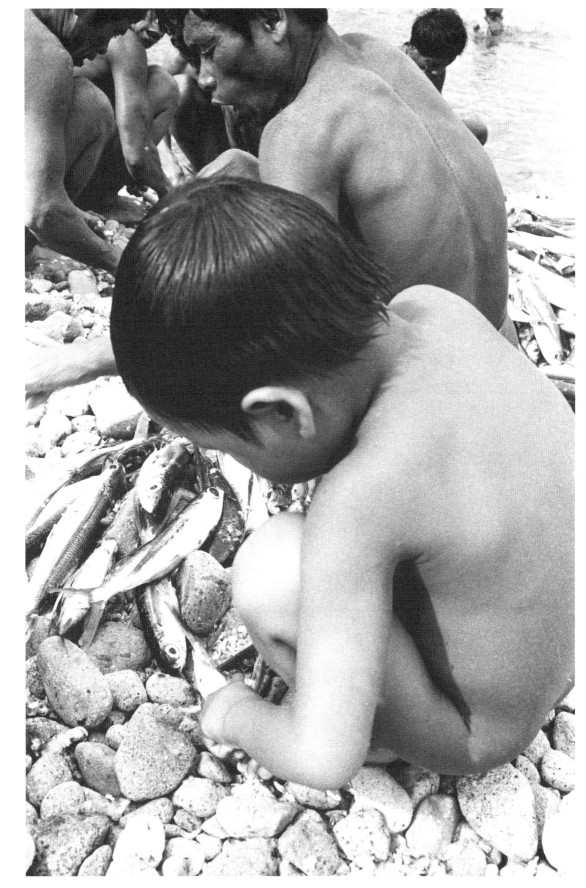

臺東縣東清國民學校

台東縣東清國民學校校況牌

中華民國53年6月5日星期5天氣雨　值週導師　劉哲夫　師師

| 學生狀況 | 公民訓練德目及細目 | 衛生訓練德目及細目 |

（愛國）週　　　快樂的生活週

年級	在籍			出席			缺席			出席百分比
	男	女	計	男	女	計	男	女	計	
一甲	20	18	38	20	18	38				100%
一乙	17	14	31	17	14	31				100%
二甲										
二乙										
三甲	20	24	44	20	24	44				100%
三乙										
四甲										
四乙										
五甲	12	11	23	12	11	23				100%
五乙										
六甲										
六乙										
合計	69	67	136	69	67	136				100%

公民訓練德目及細目（愛國）

高
我愛用國貨．
我尊敬總統．
我能愛護名勝古蹟．

中
我願盡力為國服務．
我注意保密防諜．

低
我願意參加勞軍活動．

衛生訓練德目及細目（快樂的生活）

如何使團體生活愉快．

高
我喜歡和大家同遊戲．

中
我常顧及別人的利益．

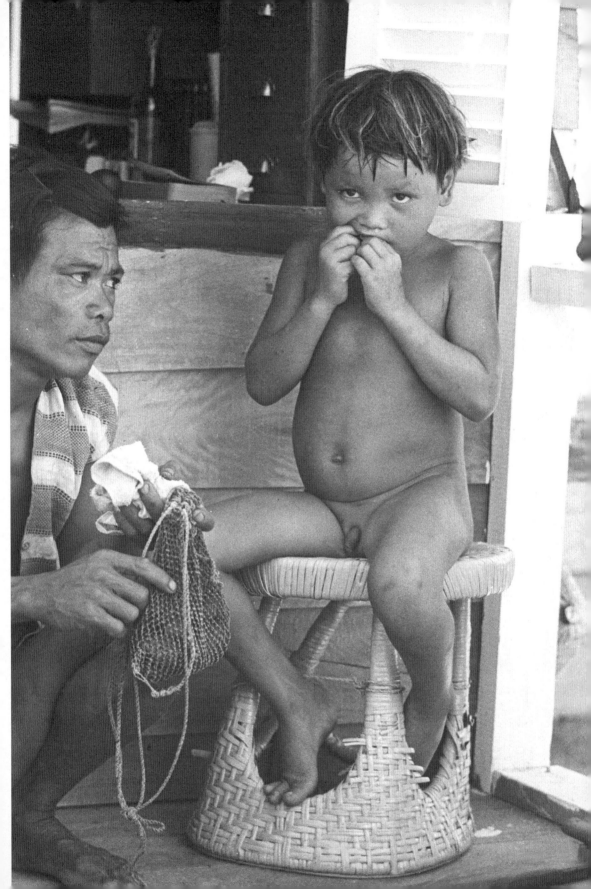

拍攝時我會特別觀察，這些孩子們是否有安靜的時候，譬如照顧弟妹時，面對陌生人，或是面對鏡頭時的羞澀表情。當年這些孩子們天真無邪的身影，在我腦海和生命中留下不可抹滅的印記。

When I photographed the kids, I liked to observe them to see if they ever had a quiet moment - moments like: when they were taking care of their younger siblings, meeting strangers, or feeling shy in front of the camera.Their innocent images left deep impression on my mind and my life.

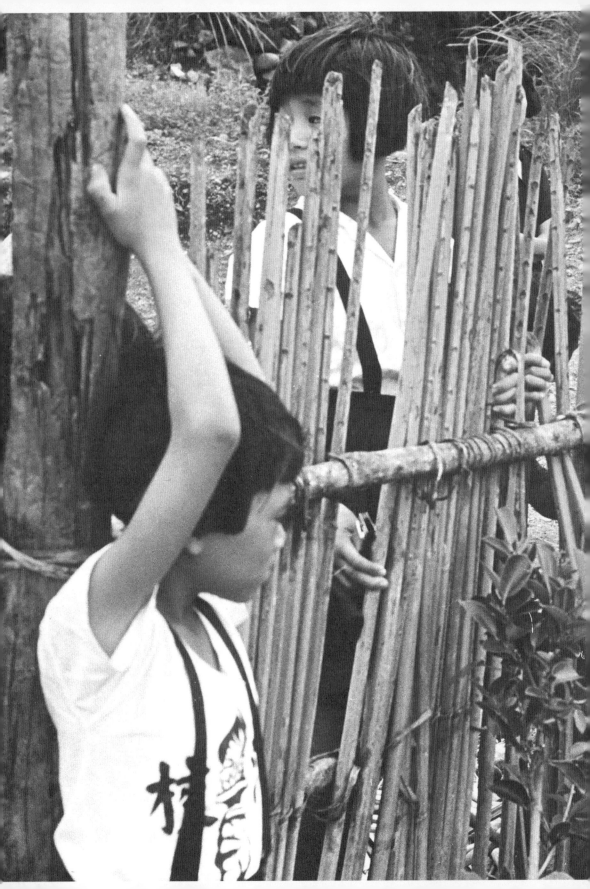

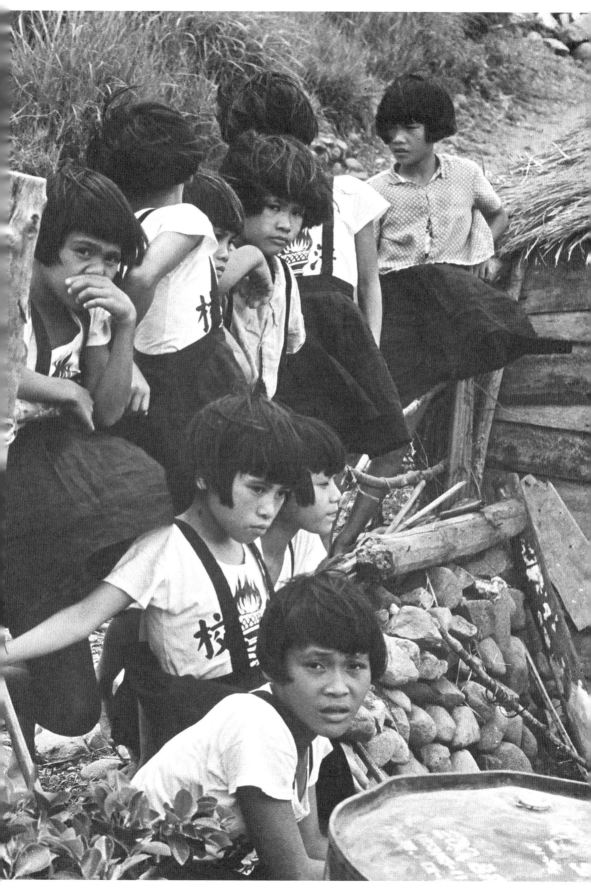

Life

生活

一葉扁舟，搖搖盪盪，滿載幸福。

獨木舟上點點漁火，只要努力划，就會有代價。

我們以海為生，我們靠海長大，

風不驚，雨不怕，就把手裡的網來撒。

好像遙遠的一首幸福的歌，不斷地流傳著。

Life

A little skiff, up and down on the sea, decked with lights, loaded with happiness

Row hard and there will be rewards.

We make our living at sea, and we grow strong in the ocean.

We fear neither wind nor rain, and we will spread the nets in our hands

Just like the song of happiness far away, it shall pass on forever.

1988 入選《影像的追尋》一

1990 年《讀者文摘》3 月號刊

1995 年台北市立美術館展出作

1997 年國立台灣美術館作

2001 年北京中國美術館展出作

高雄市立美術館典藏作

2001 年故宮博物院網頁代表作

A Search in Images (book), 19

Reader's Digest, March 19

Taipei Fine Arts Museum, 19

National Taiwan Museum of Fine Arts, 19

Beijing National Art Museum of China, 20

Kaohsiung Fine Arts Museum collecti

National Palace Museum (website showcase), 20

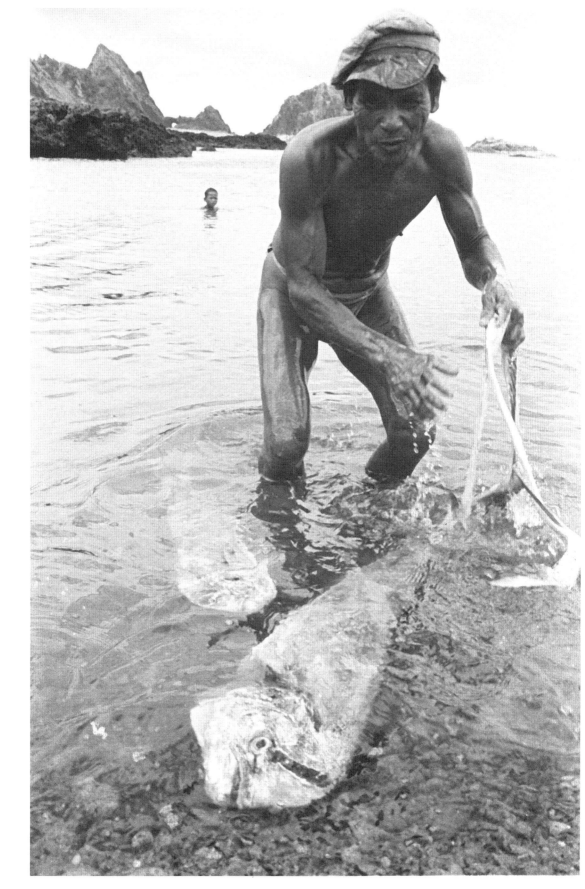

蘭嶼人以海為生，島嶼的生活形式，總離不開出海捕魚；在生活方面，更離不開孕育生命的海洋。在蘭嶼島上，總會看見成隊排列的獨木舟，以及蘭嶼人休閒時也不忘修繕船體的身影，或是待在傳統原住民的茅草屋內，躲著灼熱的陽光，三五成群閒話家常。

The islanders made their living at sea. Going out fishing was their daily routine. Their life depended on the life-giving ocean. On the island, you could always see canoes lining in rows or fishermen fixing their boats during respites. Occasionally you could see them huddle together and chitchat inside the traditional huts to get away from the baking sun.

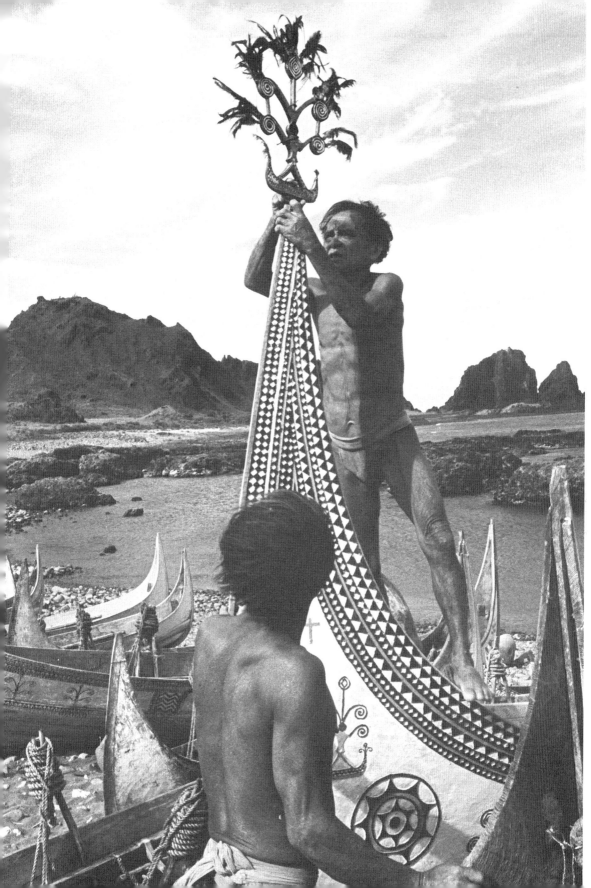

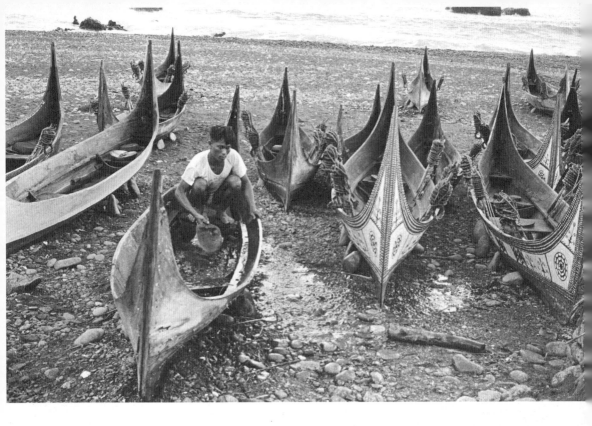

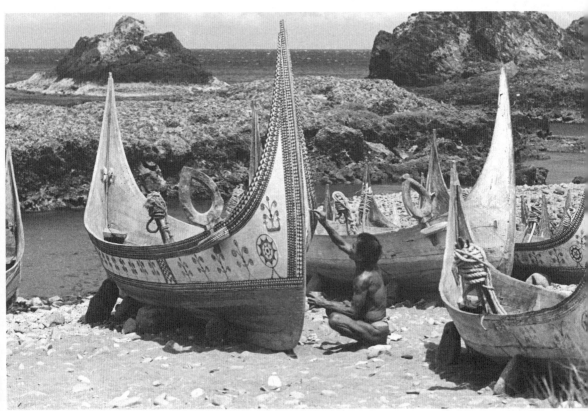

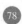

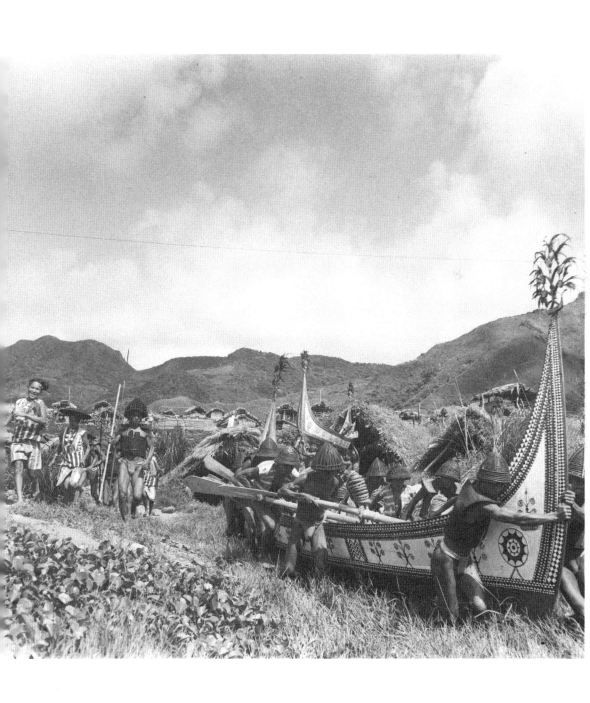

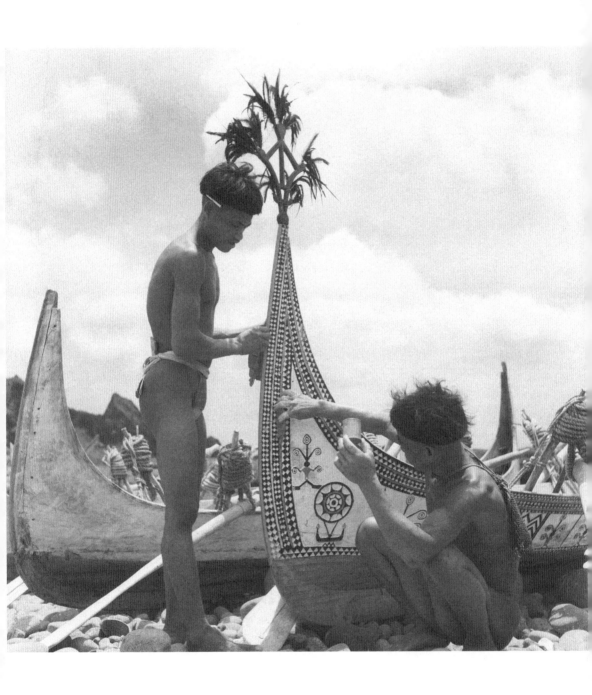

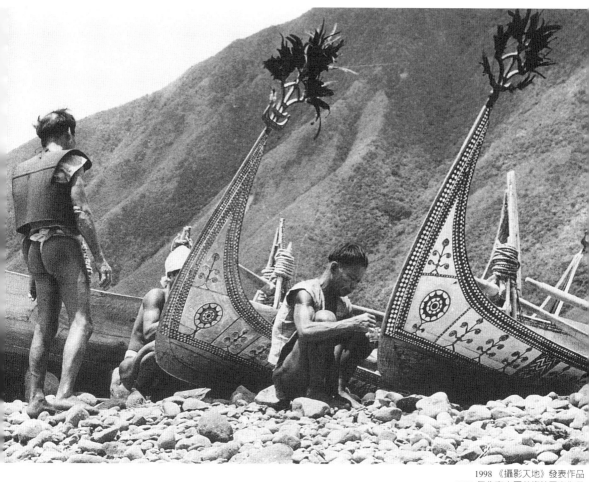

1998 《攝影天地》發表作品
2001 年北京中國美術館展出作品
Photodom Magazine, 1998
Beijing National Art Museum of China, 2001

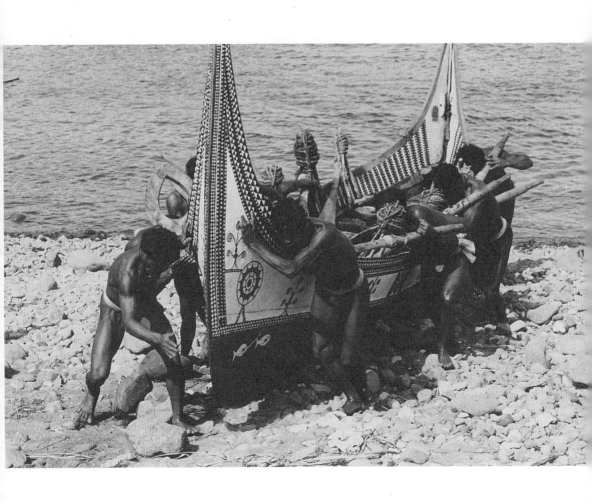

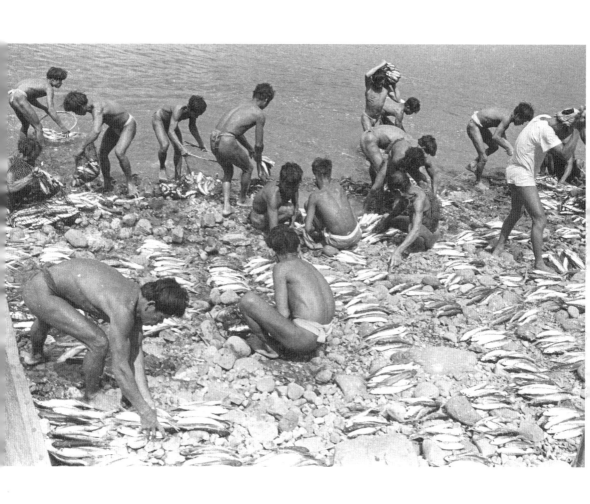

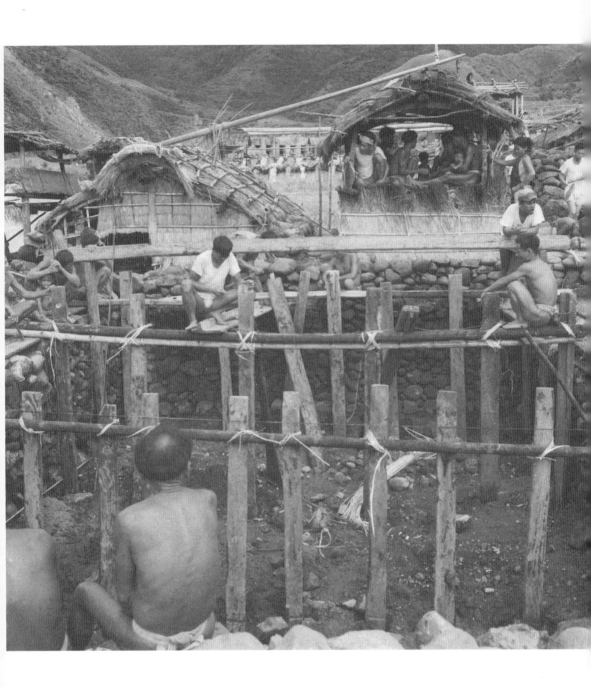

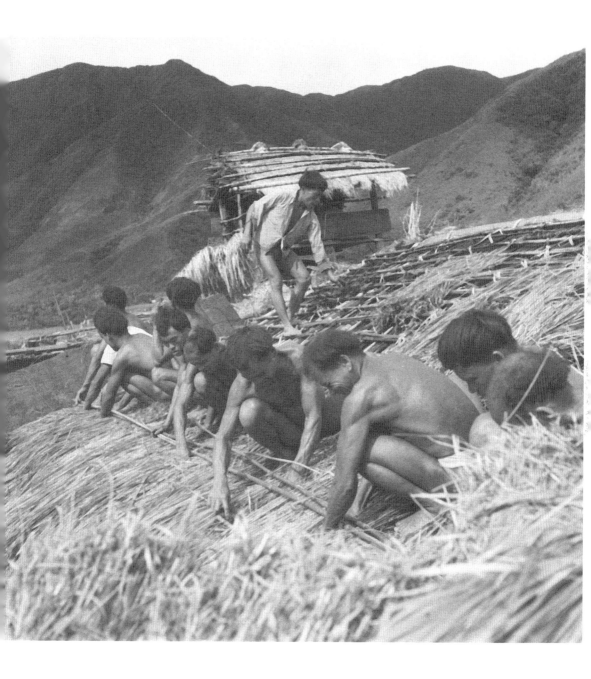

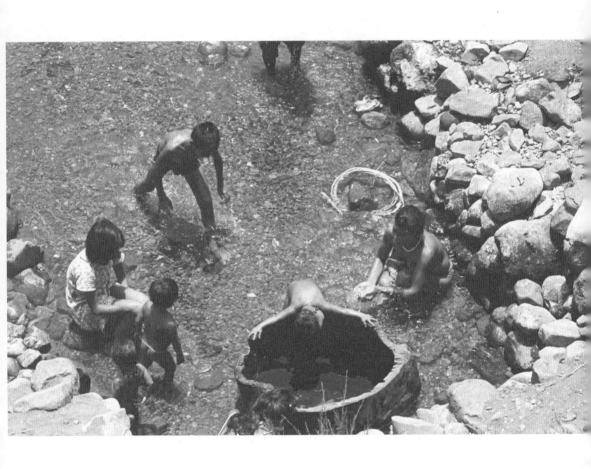

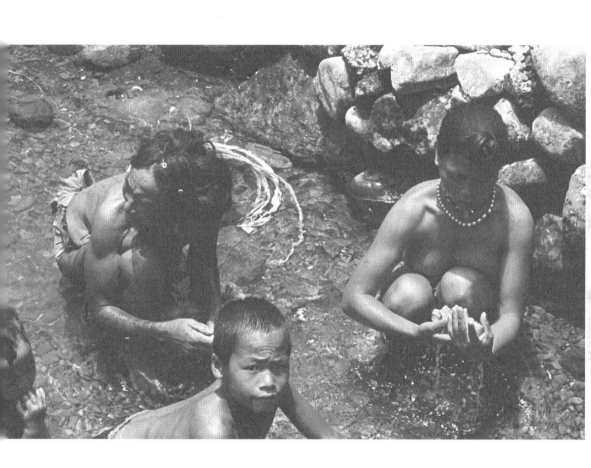

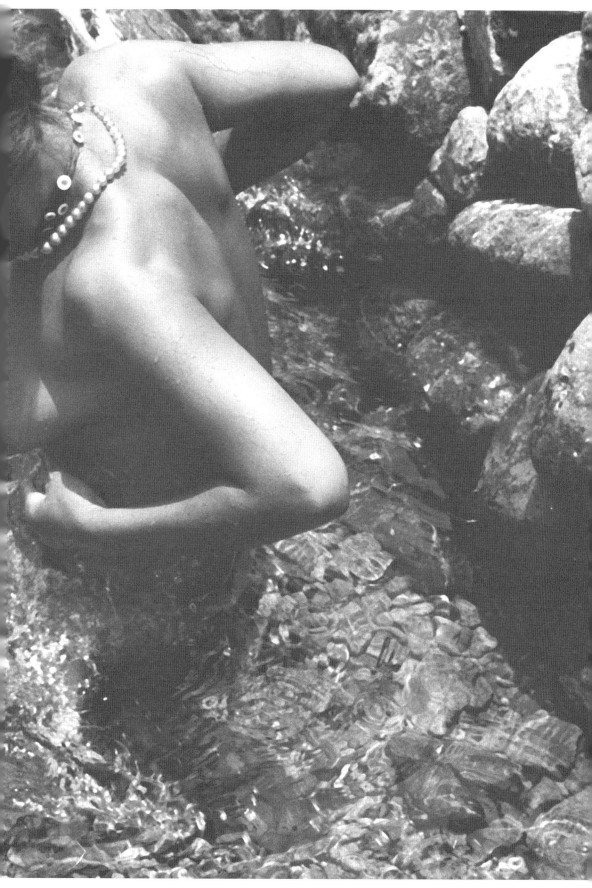

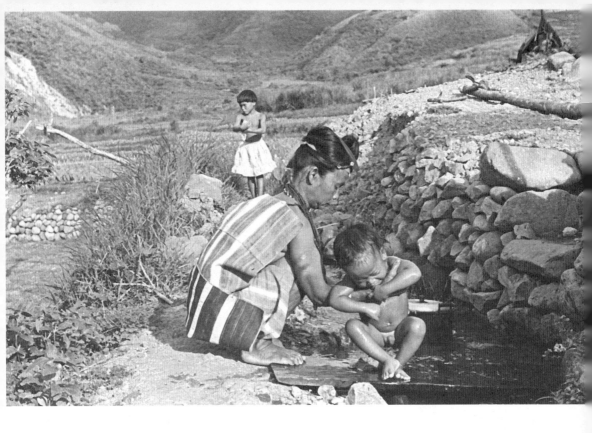

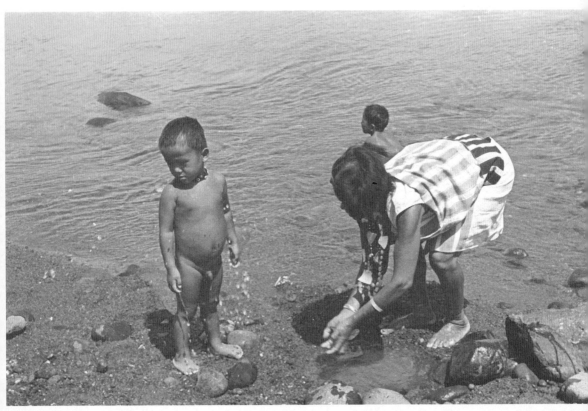

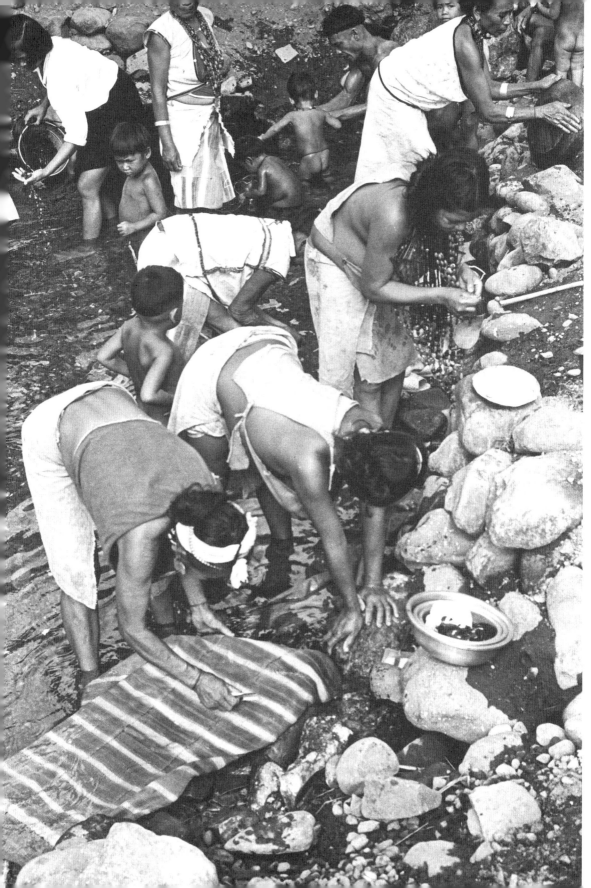

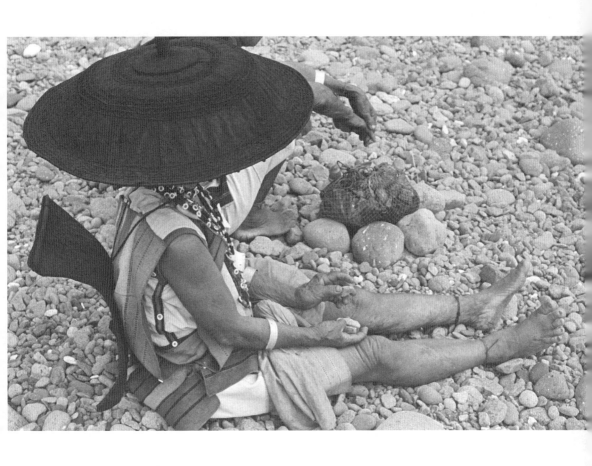

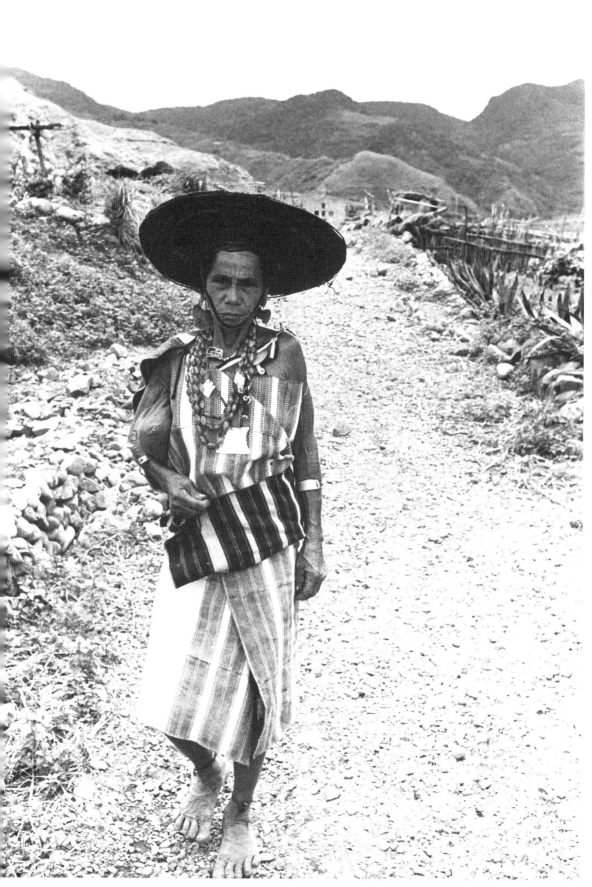

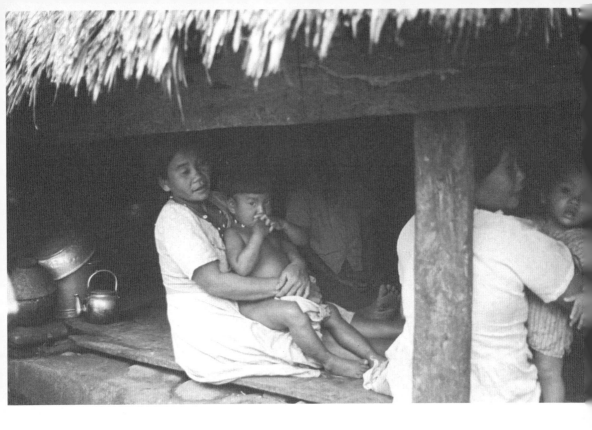

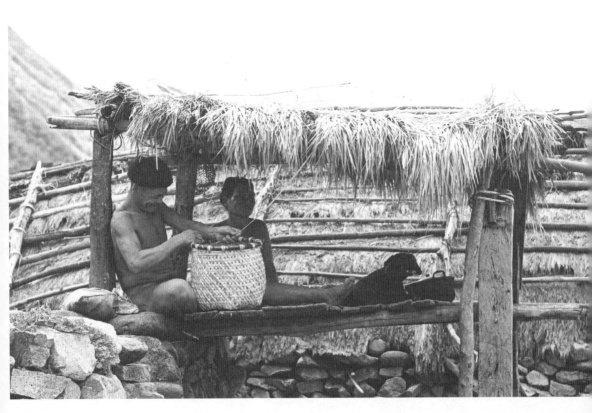

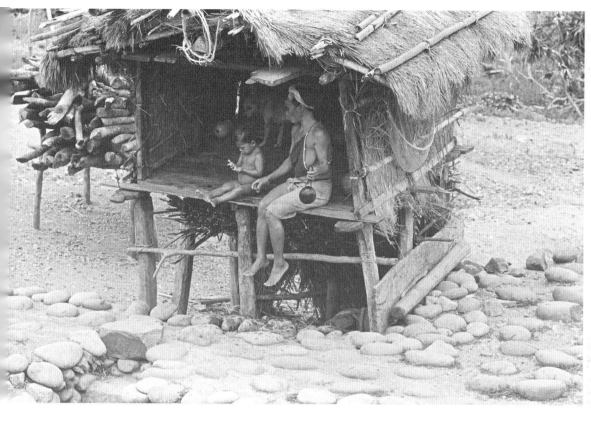

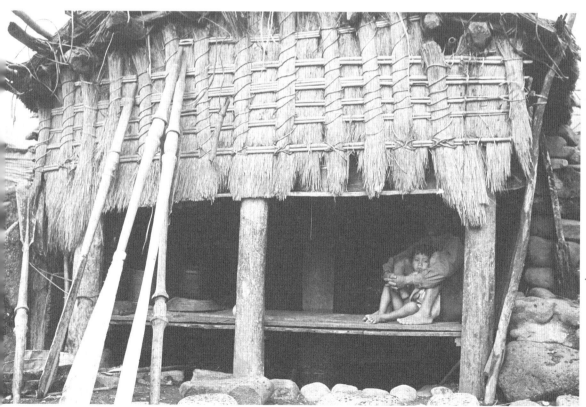

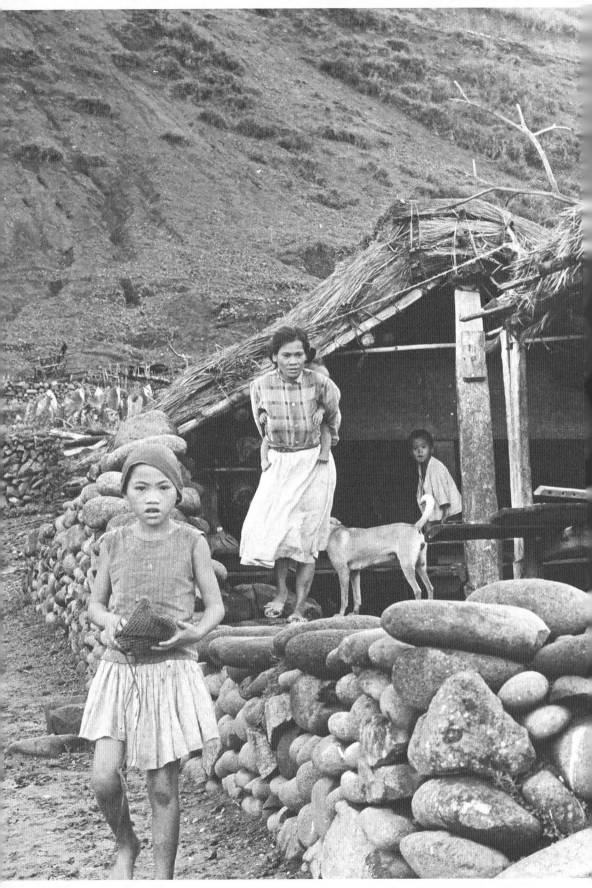

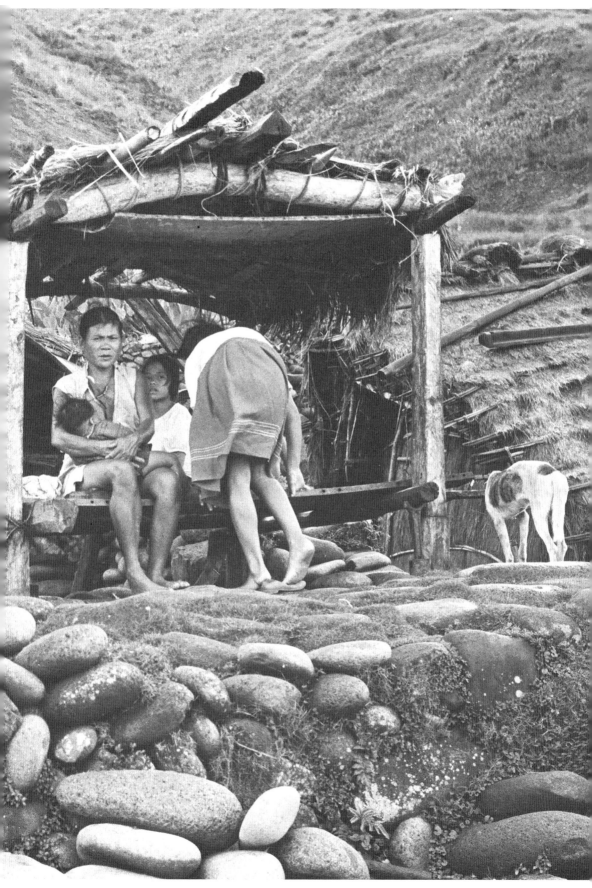

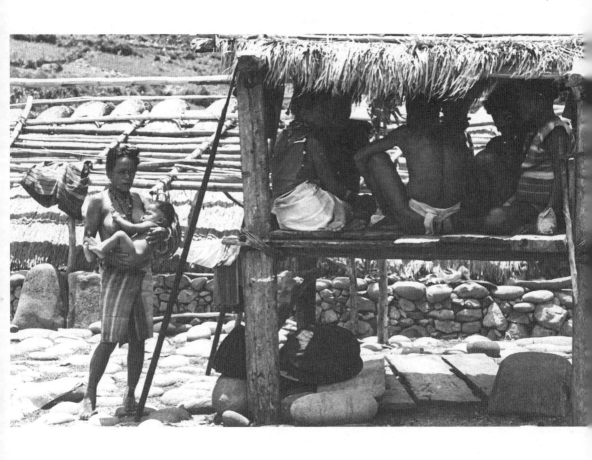

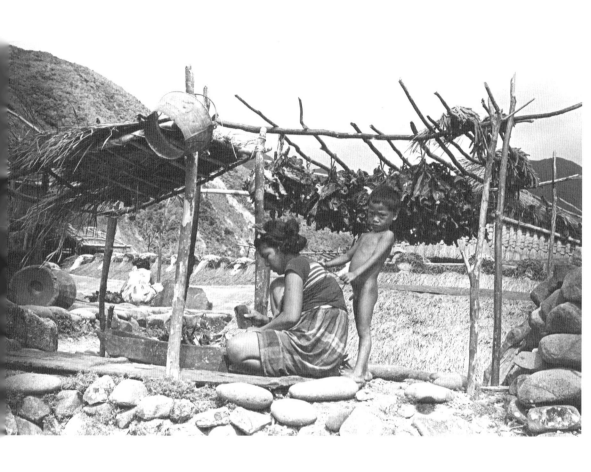

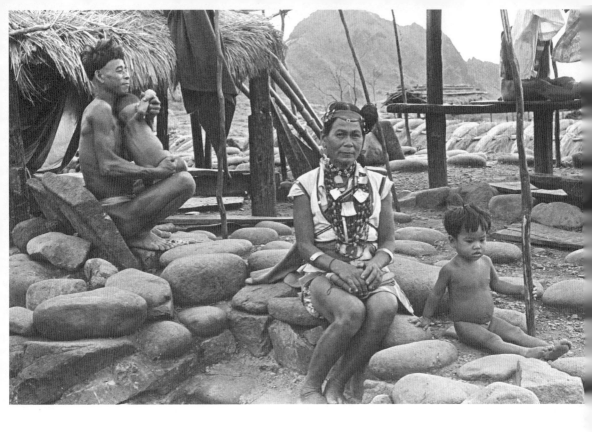

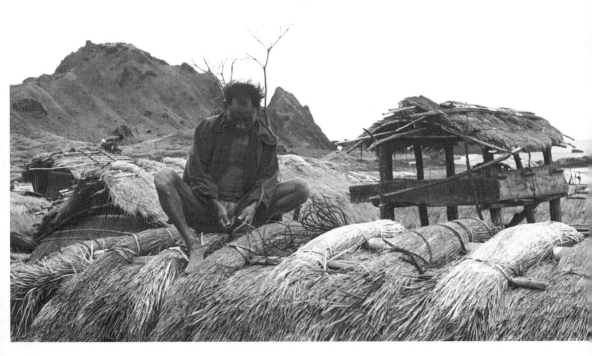

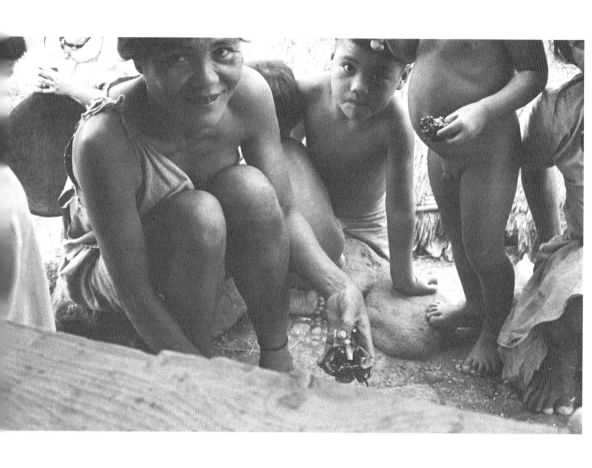

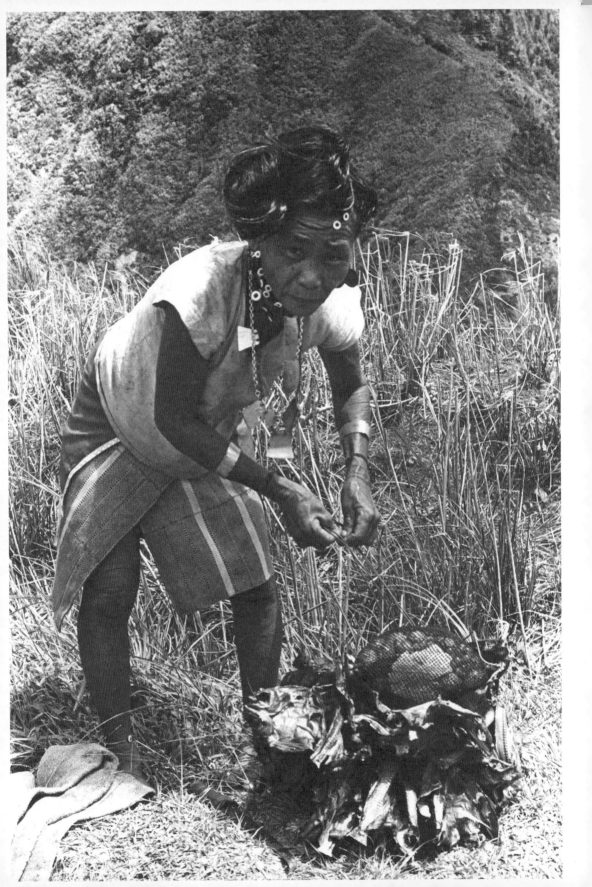

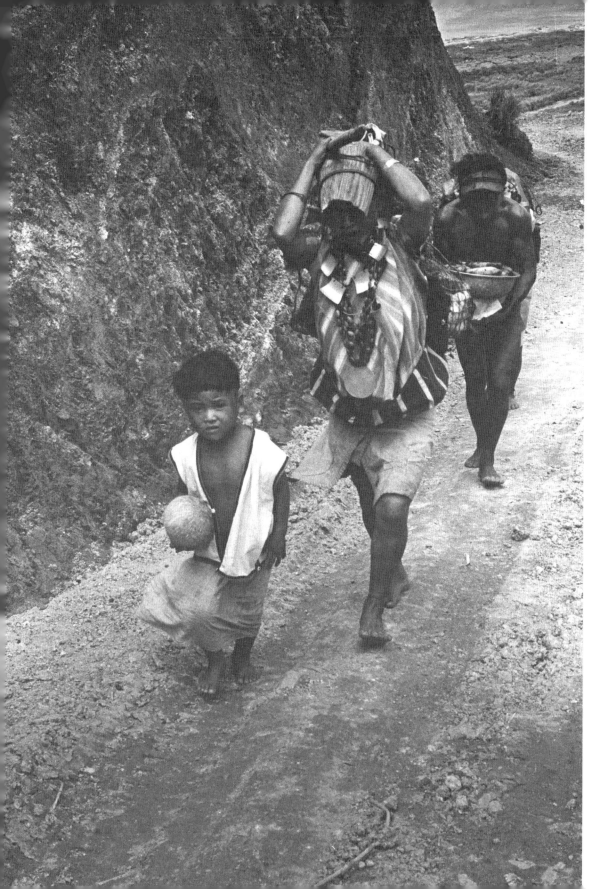

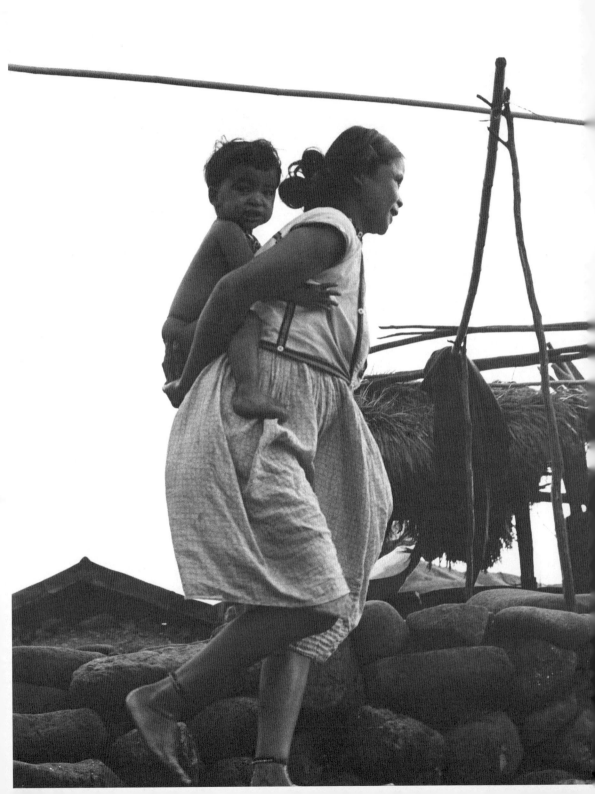

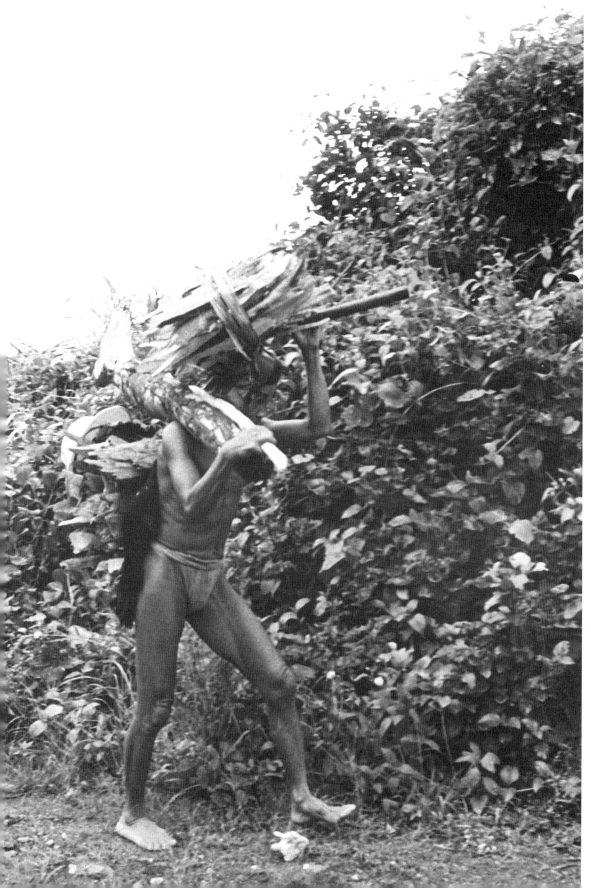

某日夕陽下，拍片收工後，我拿著相機在島上跟著一對父子行走，爸爸手裡提著剛用火燒烤過的羊，爸爸總是讓孩子走在前面，就怕黃昏來臨時，孩子會跟丟了似的。兩人保持了一小段距離，同步地踩在夕陽下，父子情深的一幕，令人印象深刻，也讓我想起多日不見，在臺灣的寶貝孩子們。

One day after filming, I carried my cameras and followed a pair of father and son walking along the road. It was sunset. The father had in his hand a lamb that was just roasted. He had his son walk in front of him, fearing otherwise his boy might lag behind when the darkness fell. In the twilight, they kept the same distance while walking in synchronized rhythm. I was deeply moved by this affectionate sight and reminded of my own little ones in Taiwan whom I had not seen for quite a long time.

1995 年台北市立美術館展出作品
1997 年國立台灣美術館作品
2001 年北京中國美術館展出作品
國立歷史博物館典藏作品
Taipei Fine Arts Museum, 199
National Taiwan Museum of Fine Arts, 199
Beijing National Art Museum of China, 200
National Museum of History of Taiwan collectio

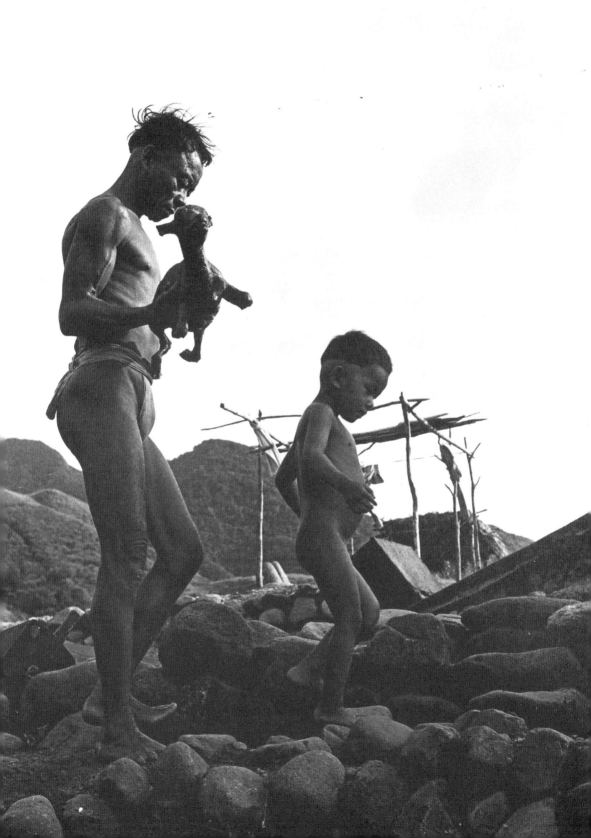

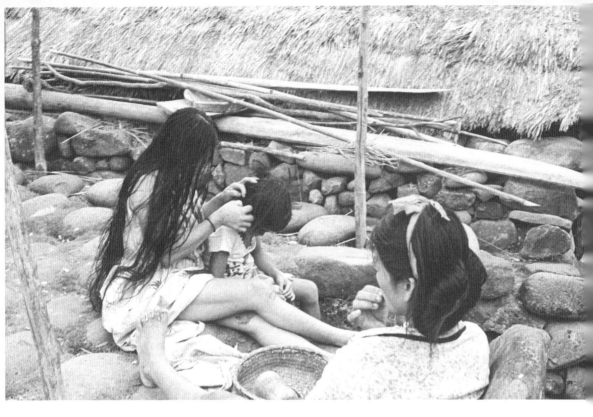

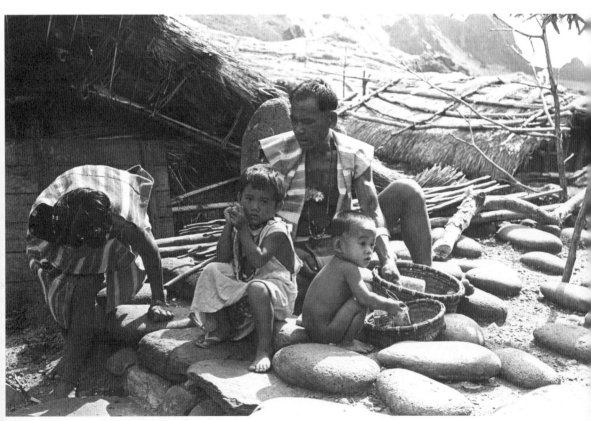

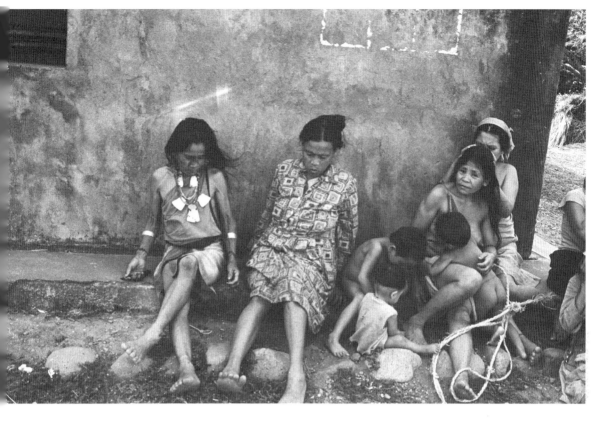

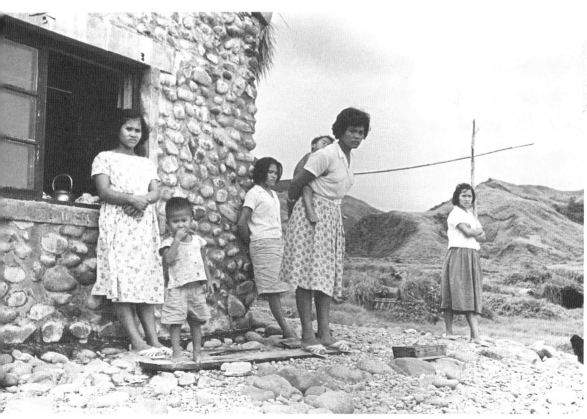

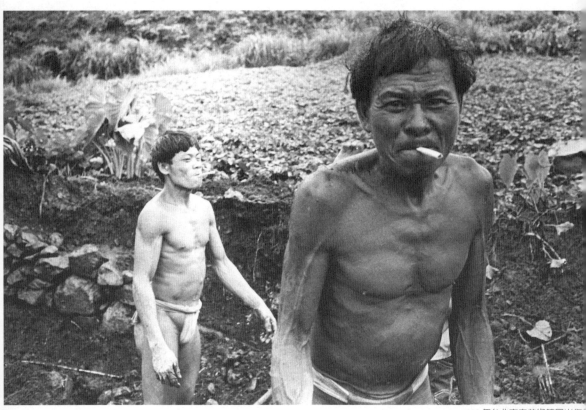

1995 年台北市立美術館展出作[
1997 年國立台灣美術館作[
2000 高雄市立美術館典藏作[
2001 年北京中國美術館展出作[
Taipei Fine Arts Museum, 199
National Taiwan Museum of Fine Arts, 199
Kaohsiung Fine Arts Museum collection, 200
Beijing National Art Museum of China, 200

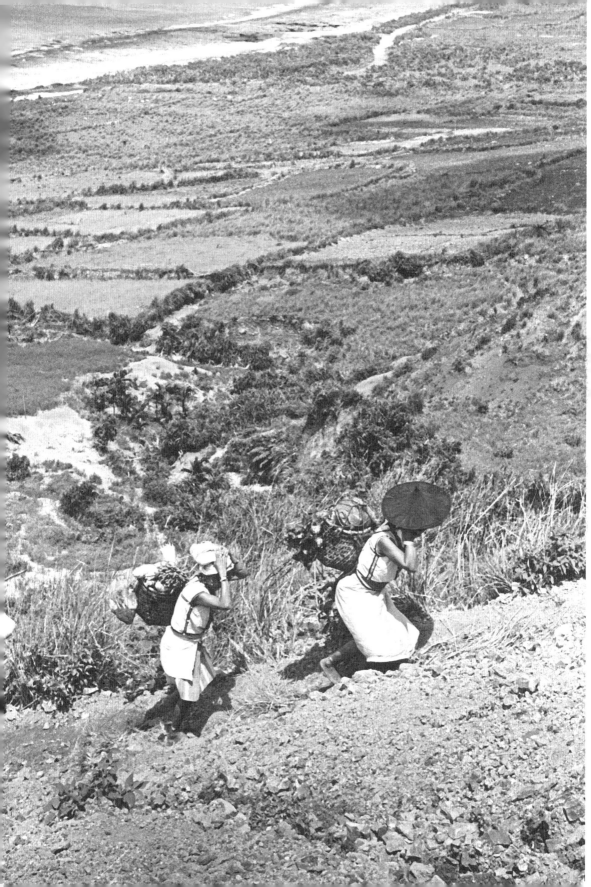

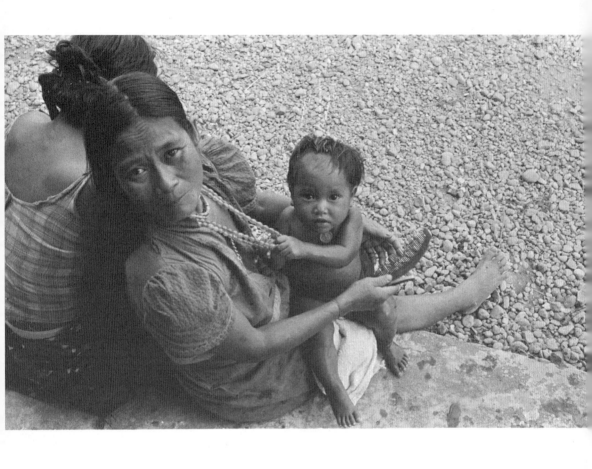

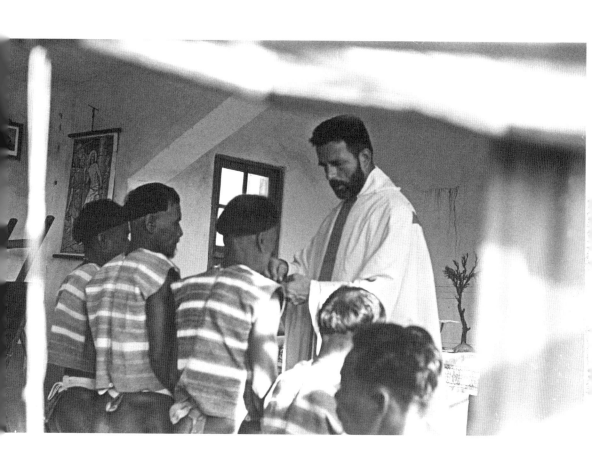

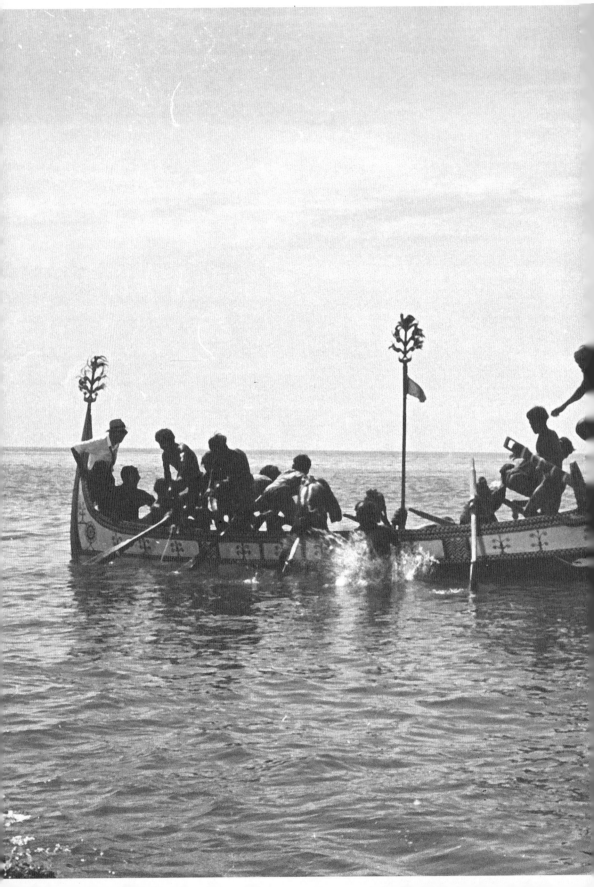

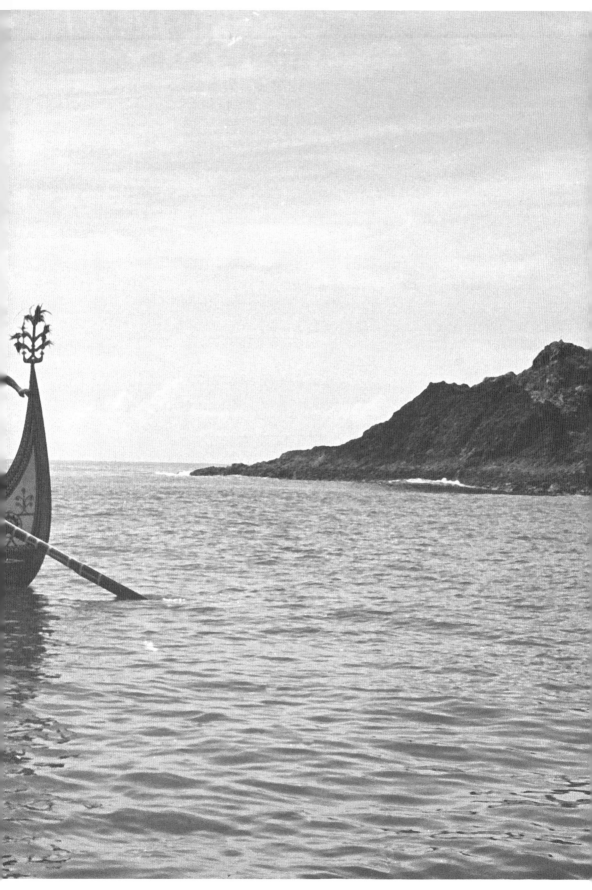

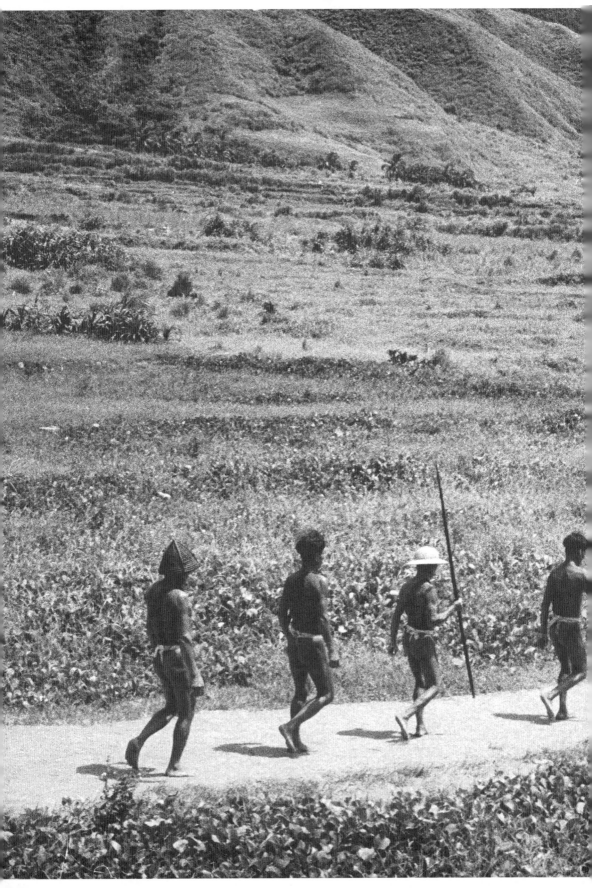

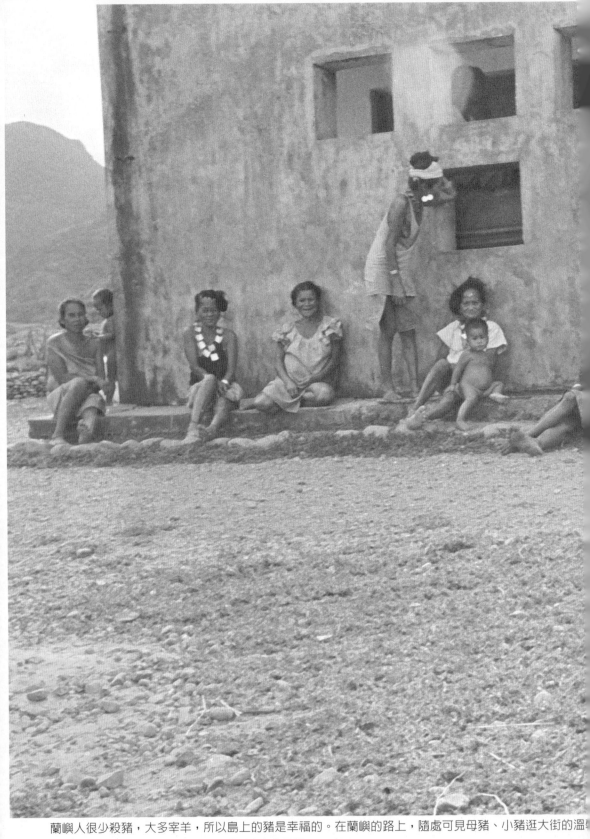

蘭嶼人很少殺豬,大多宰羊,所以島上的豬是幸福的。在蘭嶼的路上,隨處可見母豬、小豬逛大街的溫馨畫面。那可憐的小羊就遭殃了,隨時可能小命不保。

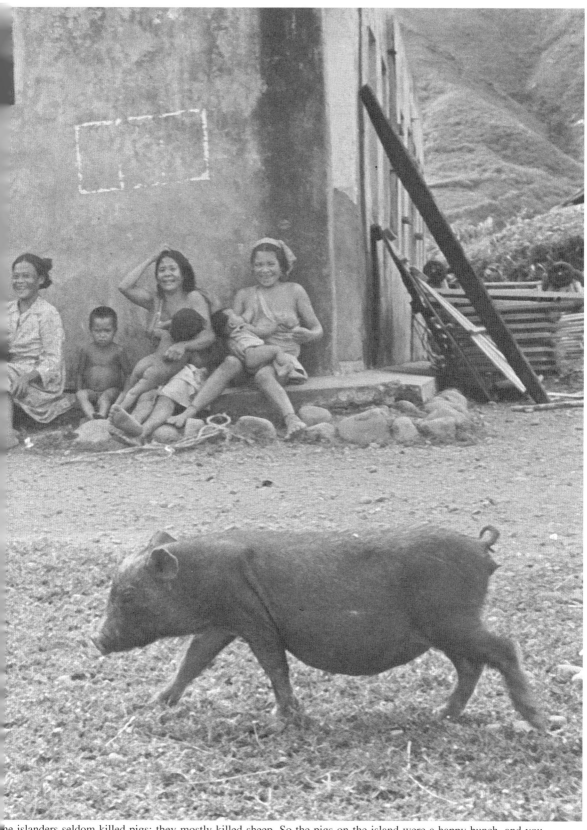

The islanders seldom killed pigs; they mostly killed sheep. So the pigs on the island were a happy bunch, and you could often see endearing sights of sows and little pigs traveling together on the streets. But it was not so for the beautiful sheep. They could be butchered at any time.

示誡

Demonstration

示威

示威和一般學者誤解是驅魔或趕鬼的意義不同，示威是獨木舟要下海前，為了展現家族凝聚力和氣勢的傳統儀式。這是我在拍攝電影劇照那年夏天，工作之餘的重要發現。如果問我在蘭嶼拍攝電影劇照的那段日子，什麼事最令我印象深刻，示威這件事無可取代。

Demonstration

Demonstration is different from what most scholars misinterpret as exorcism. Demonstration is a traditional ritual taking place before boat launching to show the cohesion and might of the family clan. This is a significant discovery I made during my off time taking movie stills that summer. If asked what the most memorable event to me was during those filming days, demonstration is definitely my answer.

那天，在拍攝工作結束後，我背著相機在海邊遇到一群蘭嶼壯丁，他們全身上下只穿著丁字褲，一群人用盡力氣地發出「嗯」、「嗯」、「嗯」的高頻聲音，或是低頻聲音，十分有默契地前進或後退，進行某種祭典或儀式。

It was a chance meeting. I carried my cameras with me after filming and met the strong men of the island on the beach. They were wearing only G-strings. With all their might, they gave out some high-pitched hums like "hmm, hmm, hmm," or some low-pitched sounds. At the same time, they moved forward or backward in one accord – obviously, they were performing some kind of ceremony or ritual.

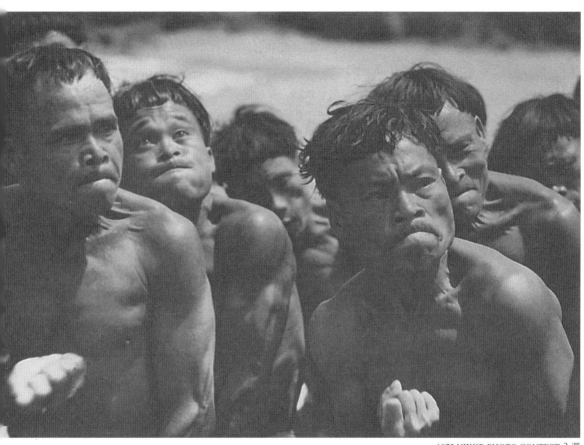

1972 NIKKR PHOTO CONTEST 入選
1988 入選《影像的追尋》一書
1990 年《讀者文摘》3 月號刊載
1995 年台北市立美術館展出作品
1997 年國立台灣美術館作品
1999 南北六人展出作品
2001 年北京中國美術館展出作品
高雄市立美術館典藏作品
2001 年故宮博物院網頁代表作品
1972 NIKKR PHOTO CONTEST finalist
A Search in Images (book), 1988
Reader's Digest, March 1990
Taipei Fine Arts Museum, 1995
National Taiwan Museum of Fine Arts, 1997
South-North Six-Person Show, 1999
Beijing National Art Museum of China, 2001
Kaohsiung Fine Arts Museum collection
National Palace Museum (website showcase), 2001

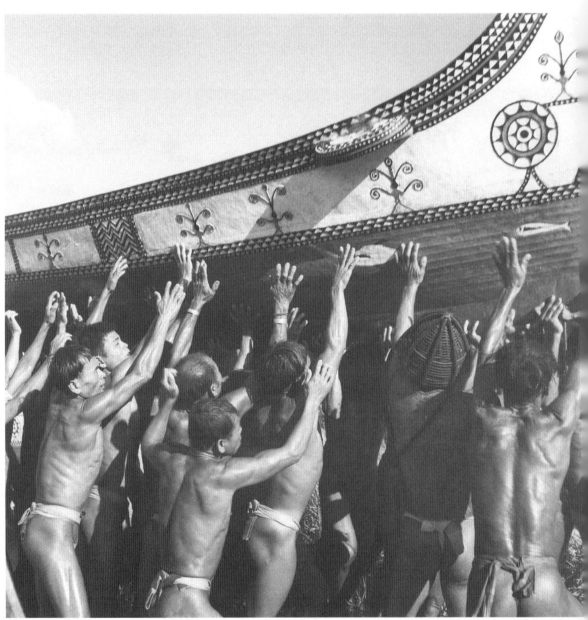

1999 南北六人展展出作
South-North Six-Person Show, 19

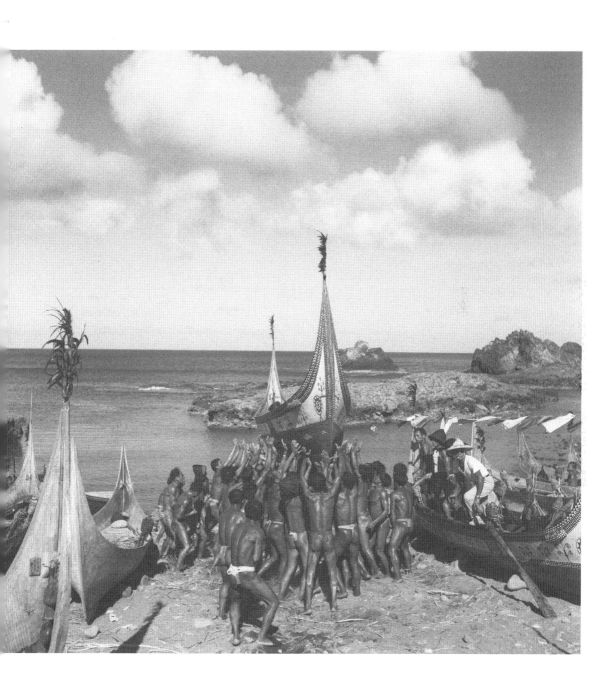

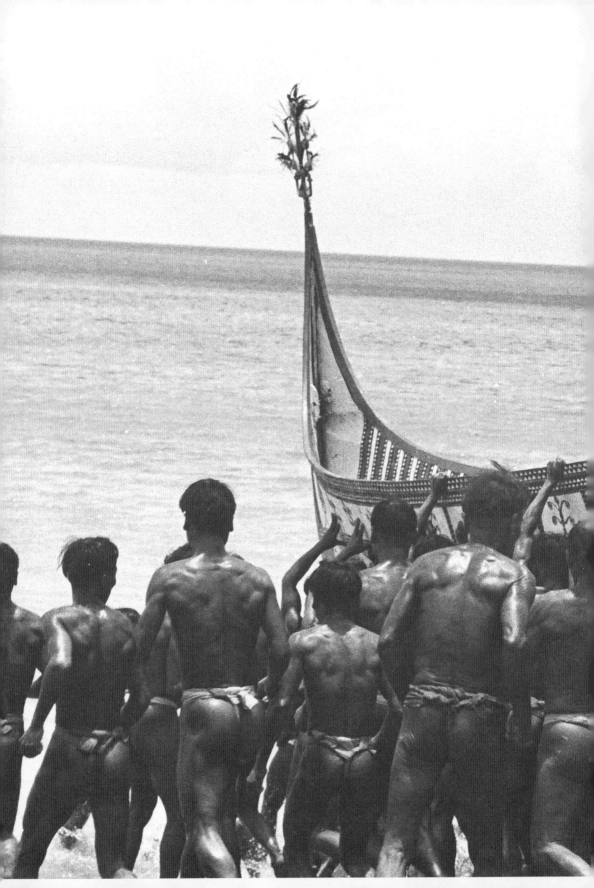

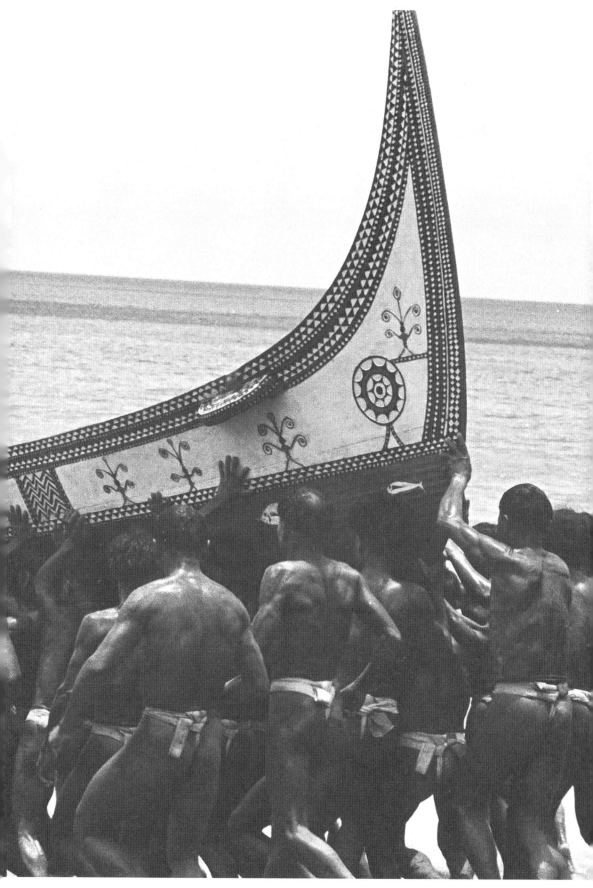

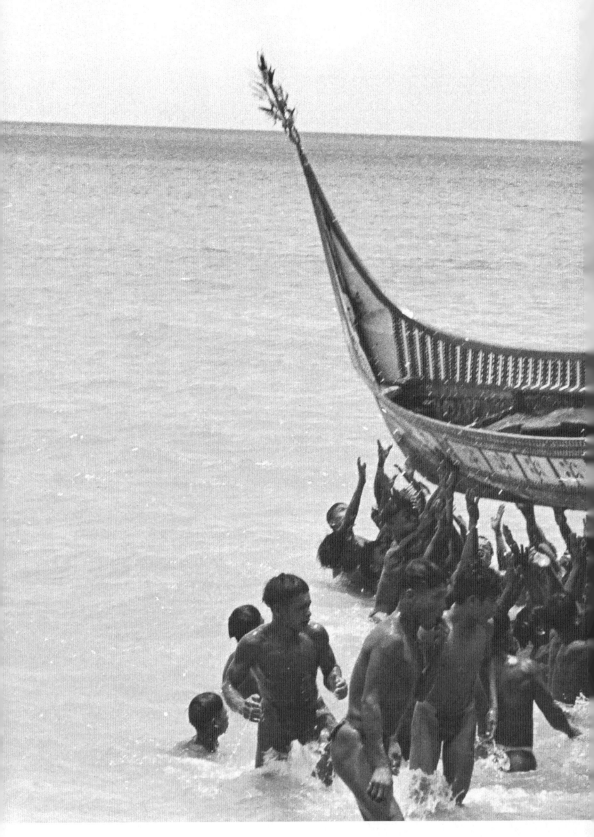

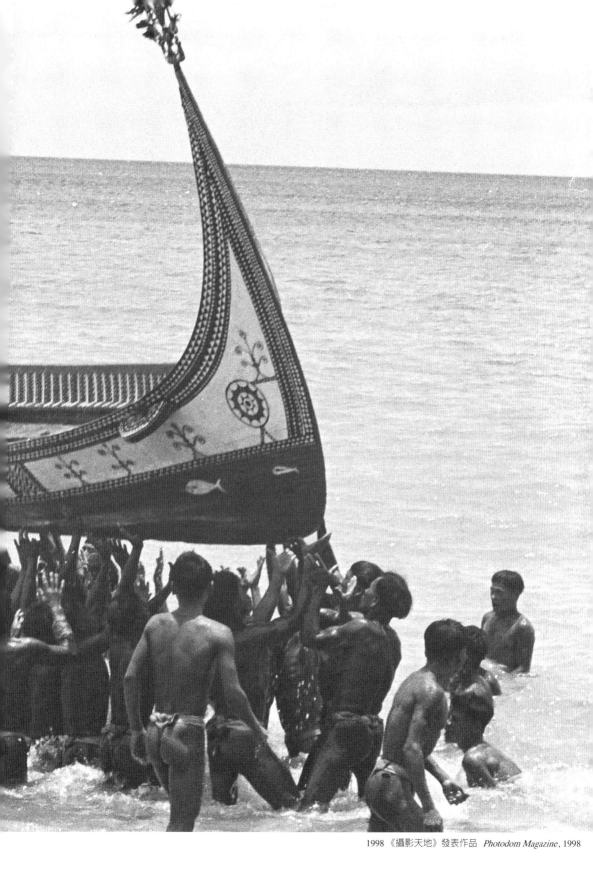

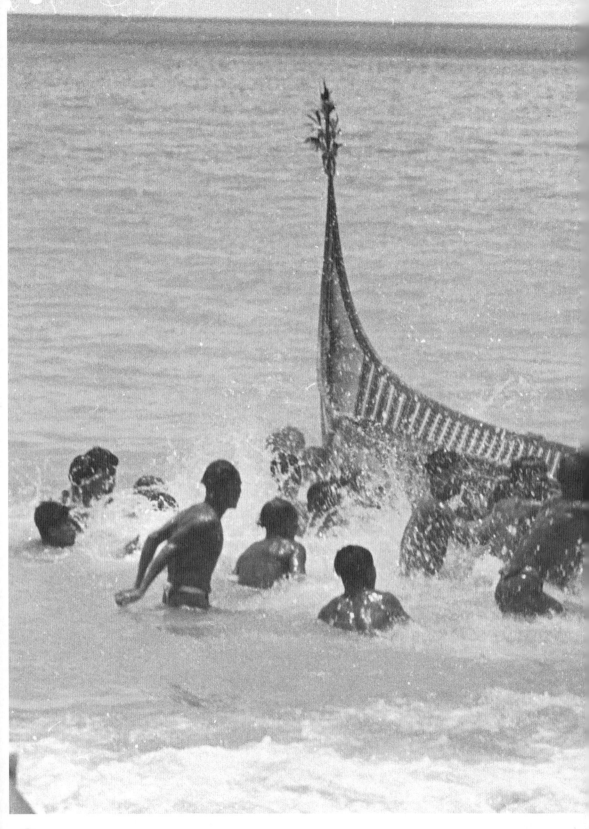

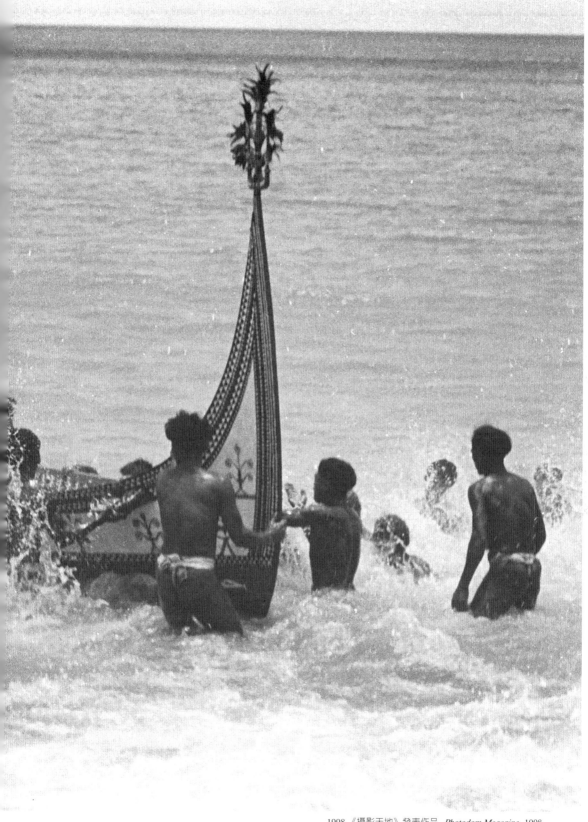

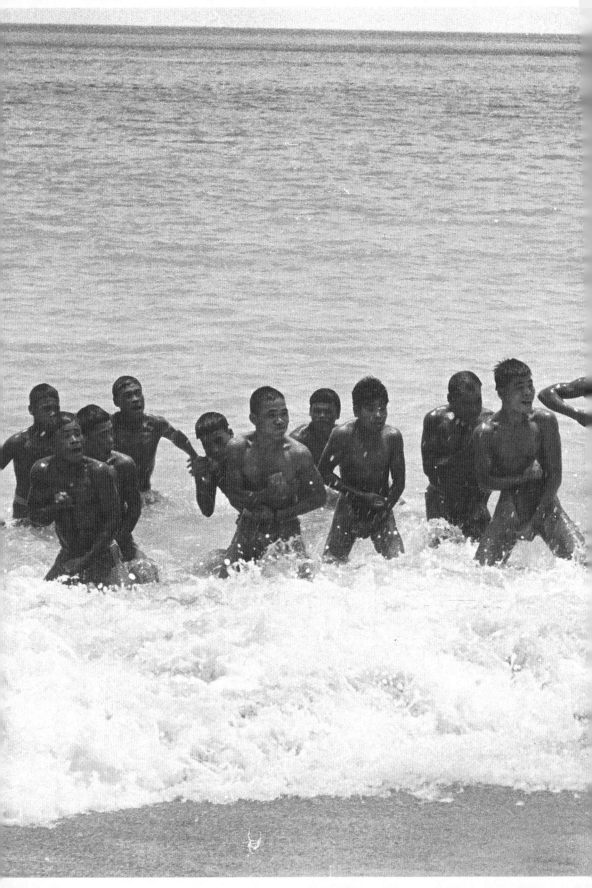

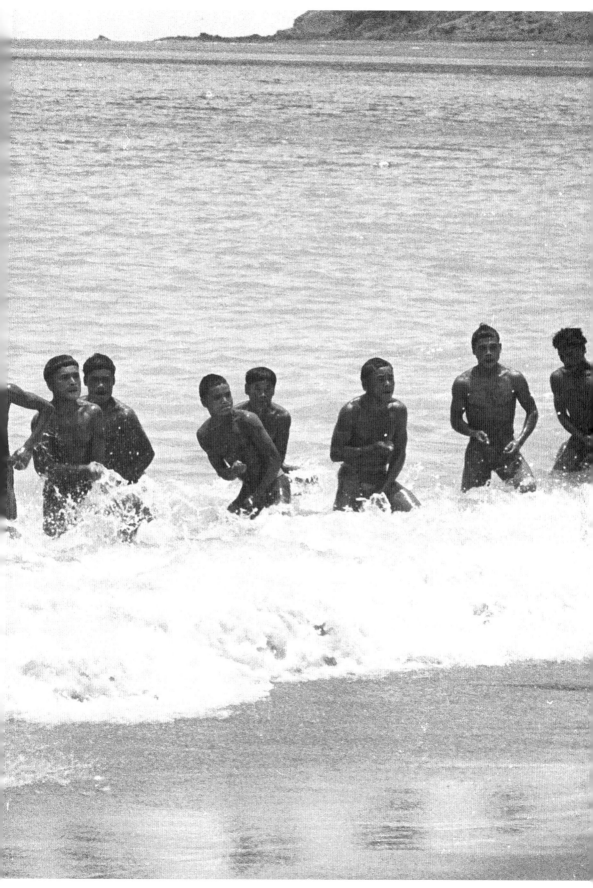

船旁邊站滿了壯丁們，一開始渾身發抖，眼珠往上吊，身體前後搖擺著，將獨木舟慢慢地移動到海邊。獨木舟下海後，儀式仍未間斷，嘶吼聲也未曾停止。一般遊客很難看見這樣壯觀的場景。

The mighty men huddled around the canoe, moving forward or backward, their bodies trembling, their eyeballs rolled up. Slowly, they carried the canoe to the shore. They continued the ritual and kept yelling even after the boat was launched to sea. Average travelers would never have the chance to witness such an awesome sight.

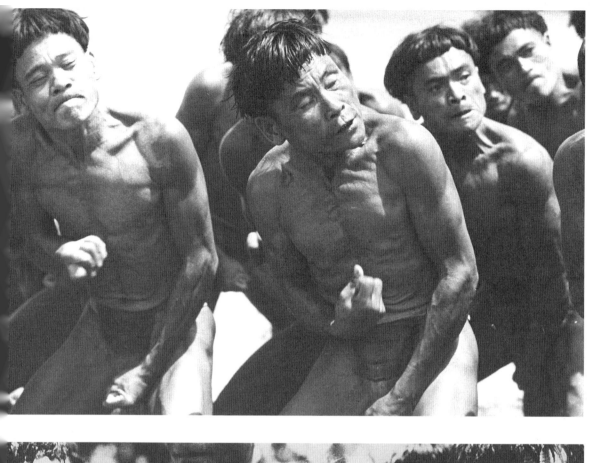

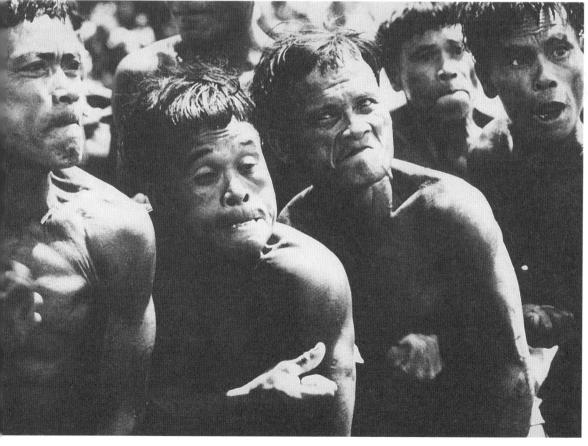

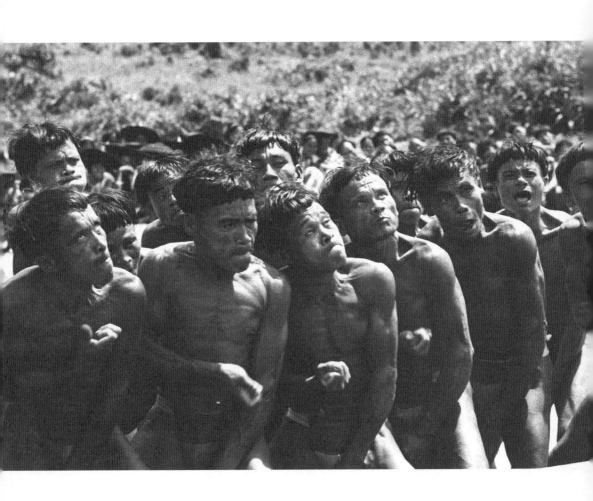

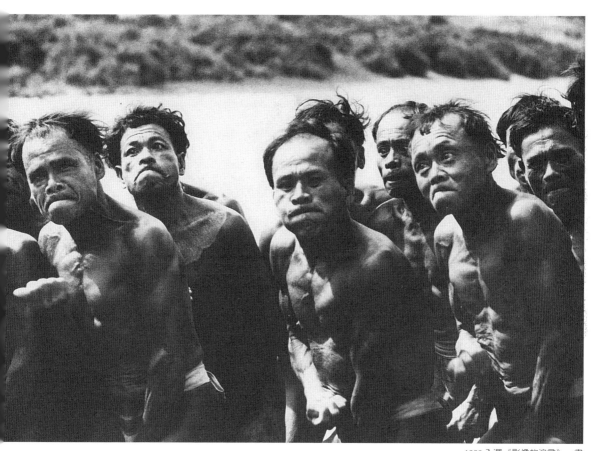

1988 入選《影像的追尋》一書
1995 年台北市立美術館展出作品
1997 年國立台灣美術館作品
2001 年北京中國美術館展出作品，台北市立美術館展出作品
A Search in Images (book), 1988
Taipei Fine Arts Museum, 1995
National Taiwan Museum of Fine Arts, 1997
Beijing National Art Museum of China, 2001

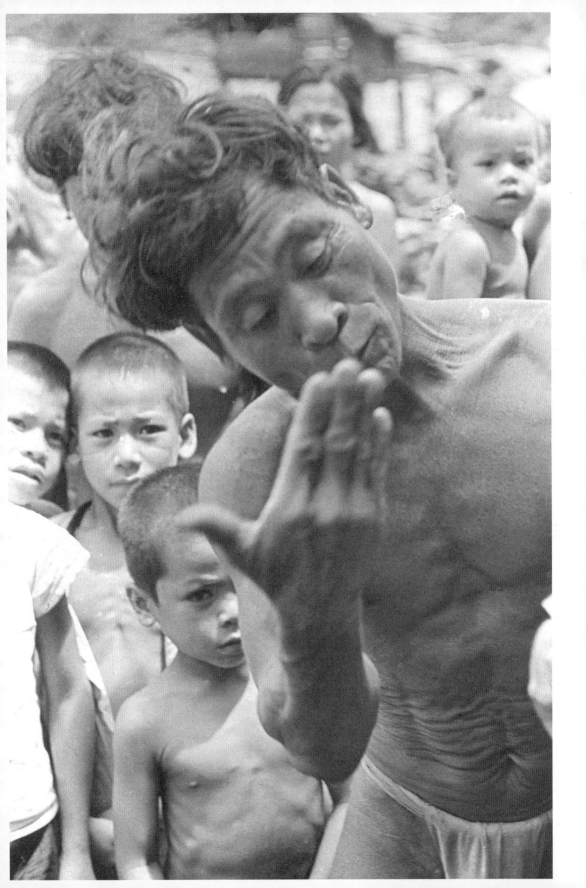

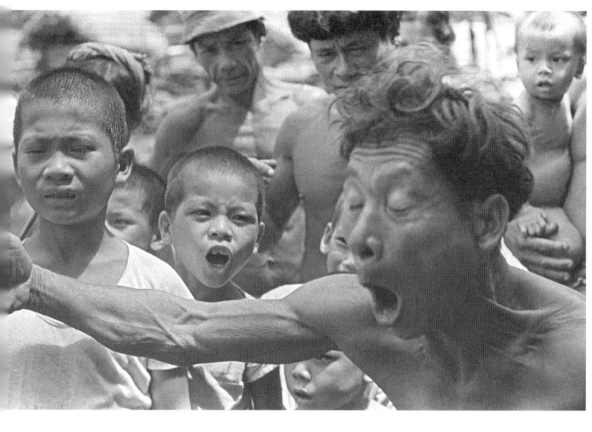

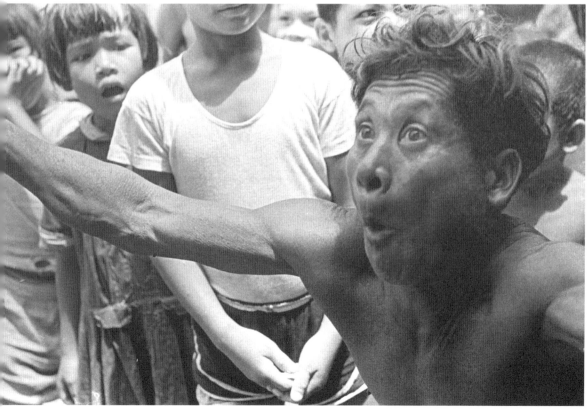

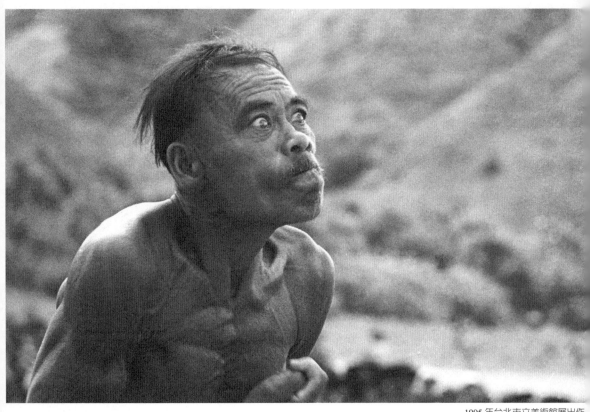

1995 年台北市立美術館展出作
1997 年國立台灣美術館作
2001 年北京中國美術館展出作
Taipei Fine Arts Museum, 19
National Taiwan Museum of Fine Arts, 199
Beijing National Art Museum of China, 200

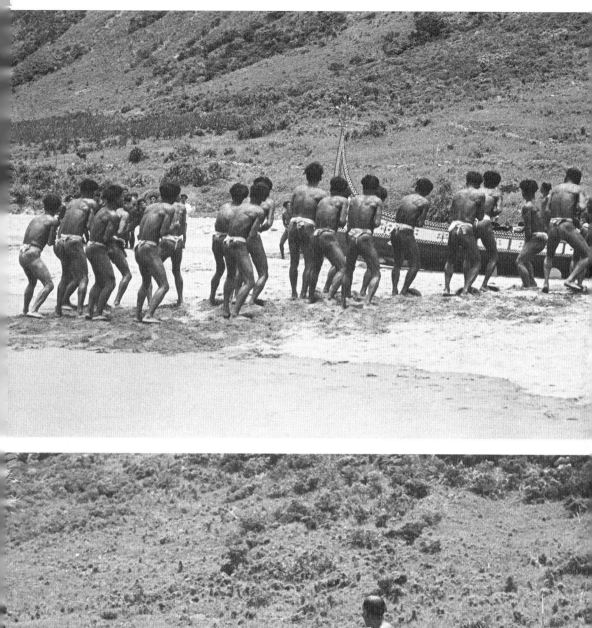
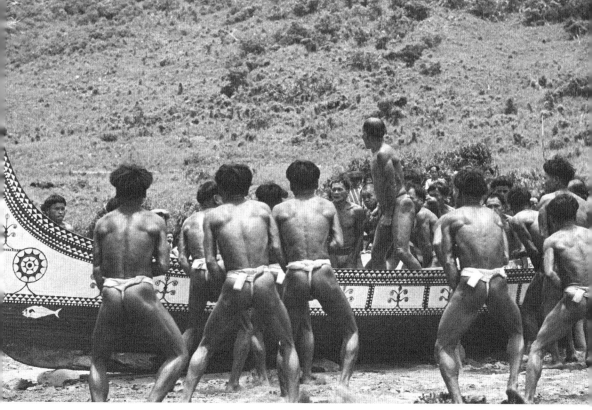

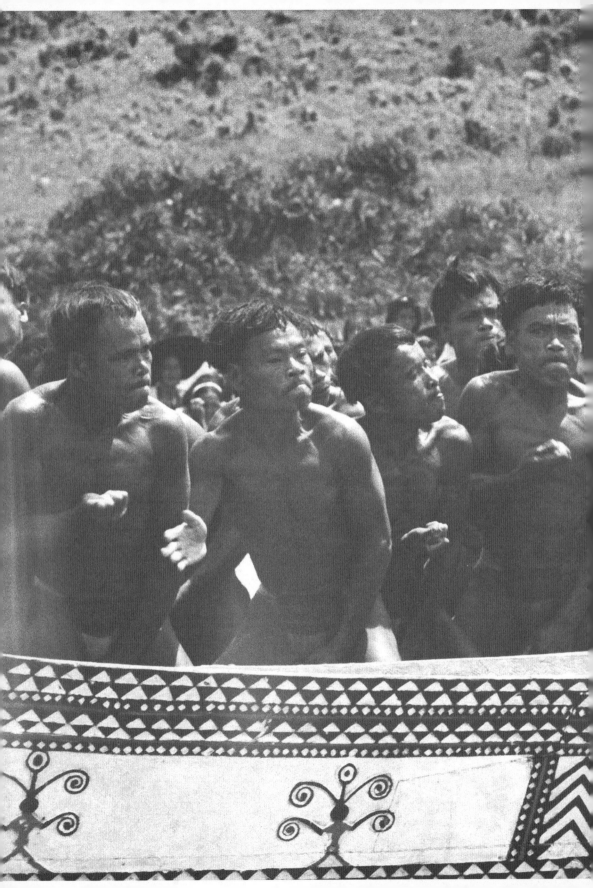

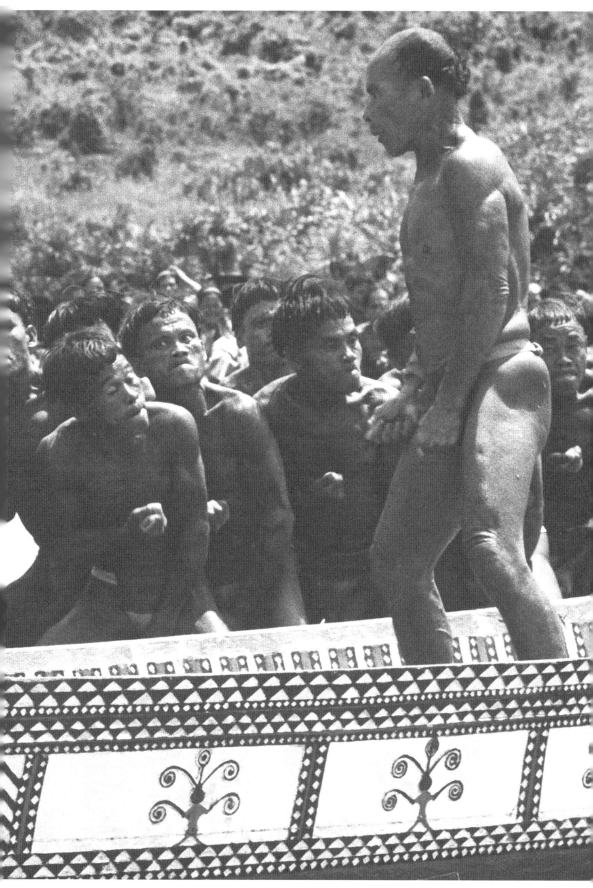

青春

Youth

青春

蔚藍的天空，伴著少數的浮雲朵朵；灼熱的陽光，讓蘭嶼島上青春年少的男女擁有古銅膚色。蘭嶼島上，有時一點風都沒有，雖然氣壓有點低沉，卻壓不住少見卻奔放的青春。

Youth

Few clouds floated in the blue sky. The scorching sun bronzed the skin of every young man and woman on the island. Sometimes there was no wind at all. The atmospheric pressure was low, but could not suppress the exuberant energy of the youth, though seldom present they were.

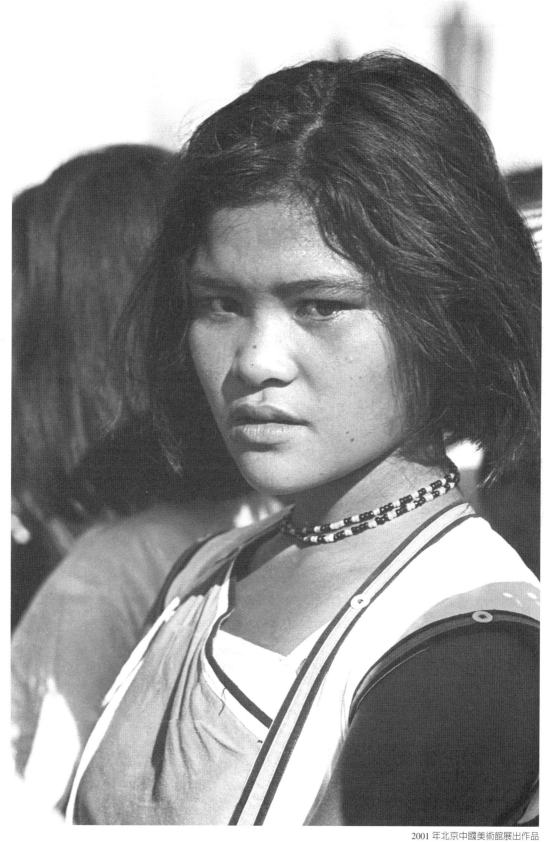

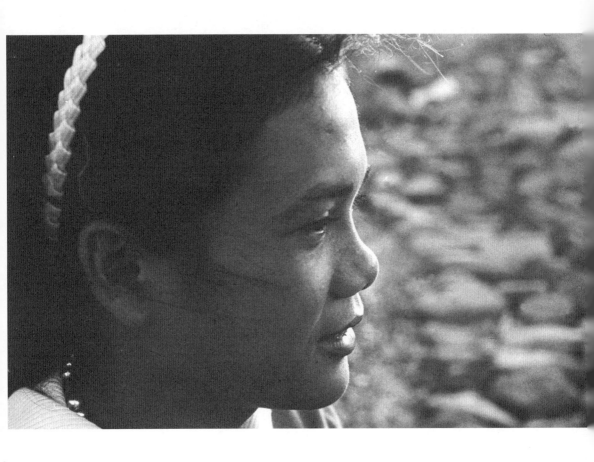

在蘭嶼停留的日子，不大容易碰見年輕人。當地的年輕男女，大多數都到臺灣找工作；留在島上的人們，多是老人和小孩。大部分的女人都上了年紀，漂亮的並不多，然而，我還是以攝影者的眼光，透過鏡頭搜尋，為這些在蘭嶼島上少見的美麗女子，或是因故返鄉的年輕孩子們，留下 青春的記憶。

During my stay on the island, I seldom saw young people, because most of the local youngsters had gone to Taiwan to look for jobs. Those who stayed were mostly old people and children. Most women were older so it was hard to see pretty ones. Still, I tried to search with my lens for some rare-seen belles or homecoming kids. I wanted, as a photographer, to preserve for them the memory of youth.

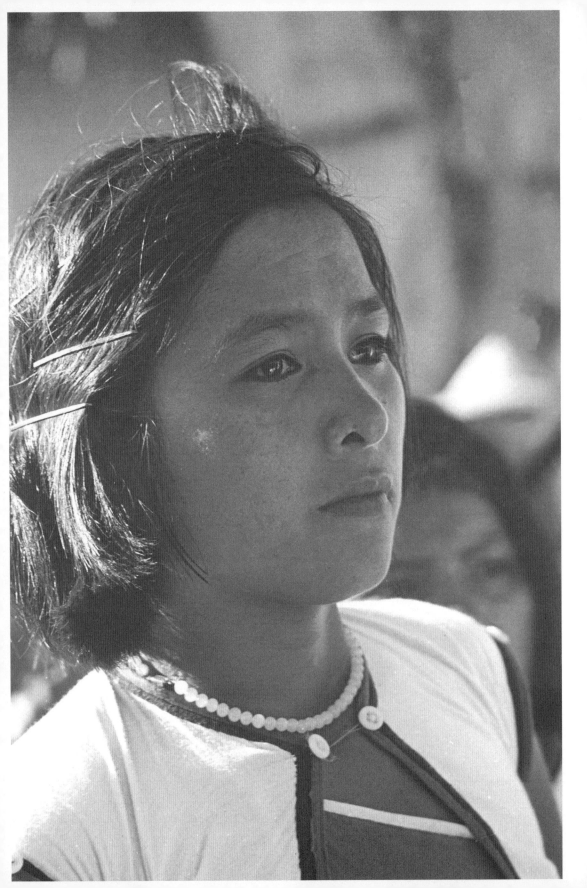

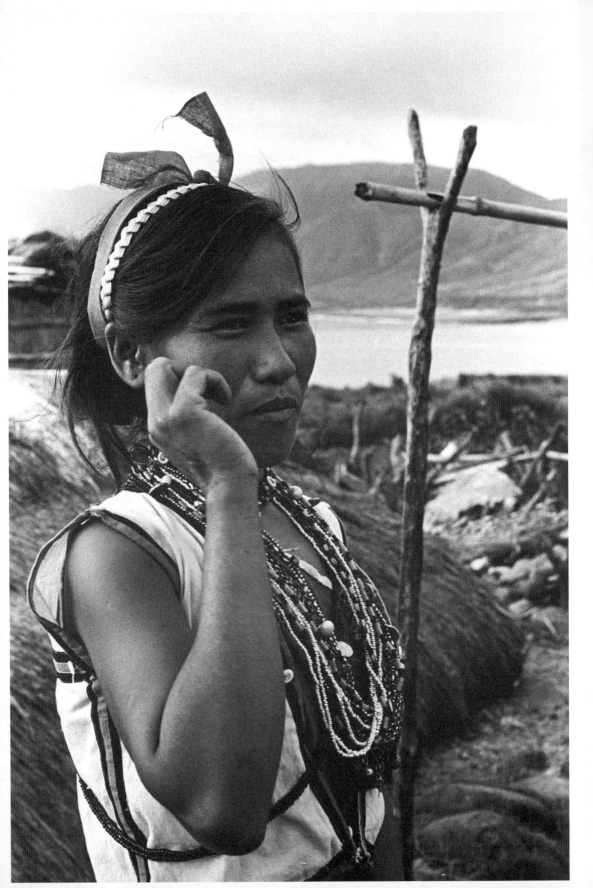

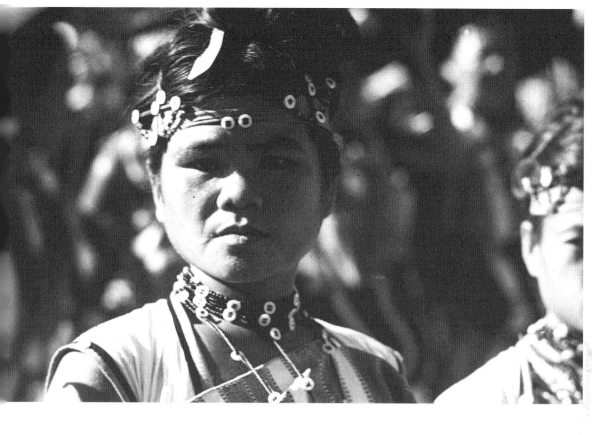

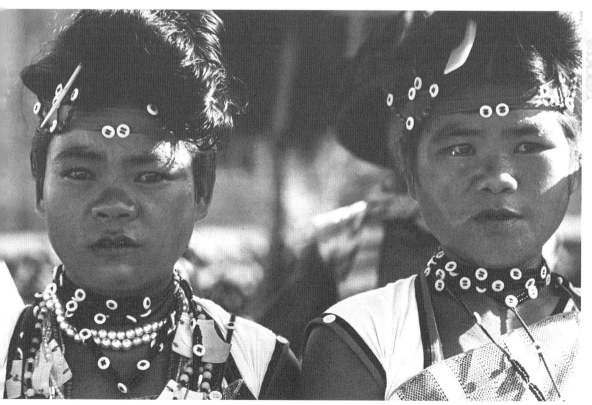

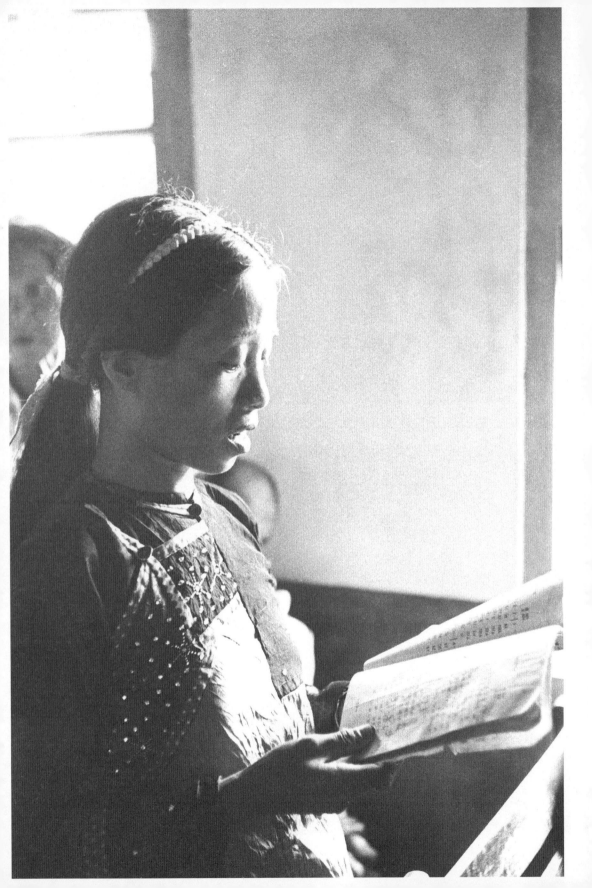

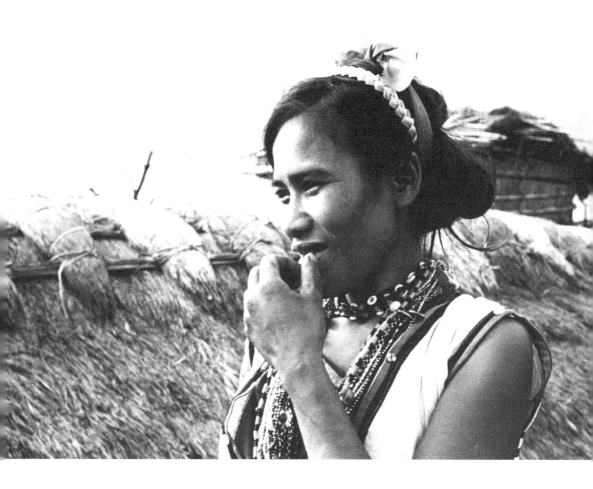

88 入選《影像的追尋》一書
01 年北京中國美術館展出作品
立歷史博物館展出作品
Search in Images (book), 1988
ijing National Art Museum of China, 2001
itional Museum of History of Taiwan

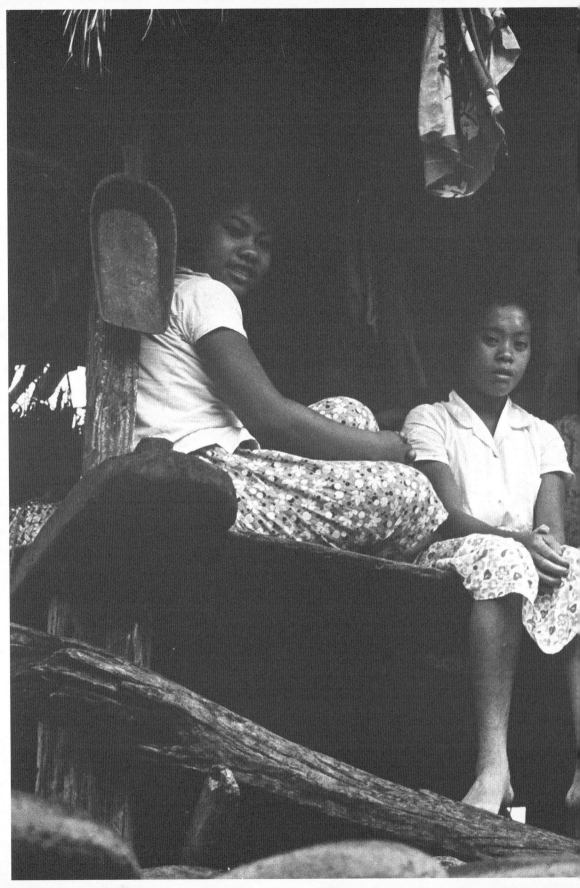

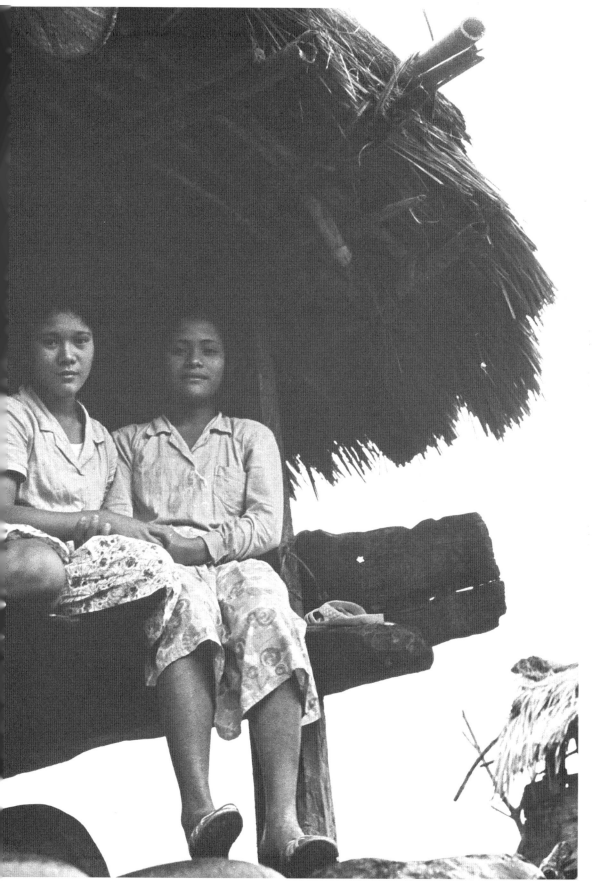

Adults

成年

第一次和蘭嶼原住民接觸，就能感受蘭嶼人無比熱情與生命力，尤其，當他們用原住民語對我們喊著：「鍋蓋！鍋蓋！（KUO! KAI!）」。他們熱情的口頭語，讓人對他們的友善印象深刻。

Adults

These natives on the island overwhelmed me with their enthusiasm and vitality when we first met. They welcomed us with eager shouting in their mother tongue:"Kuo-Kai! Kuo-Kai!" We were all touched by their heartfelt hospitality.

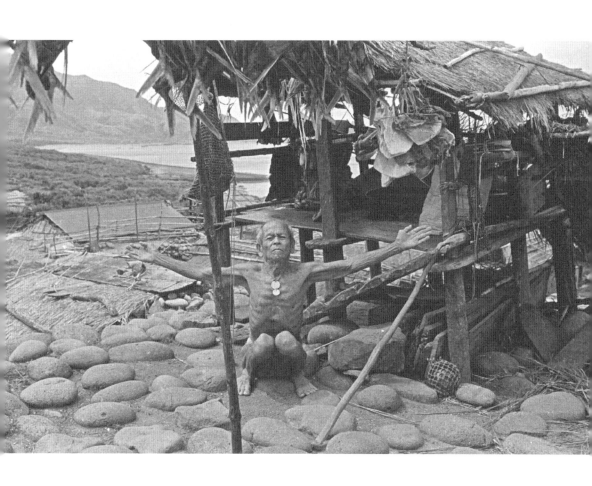

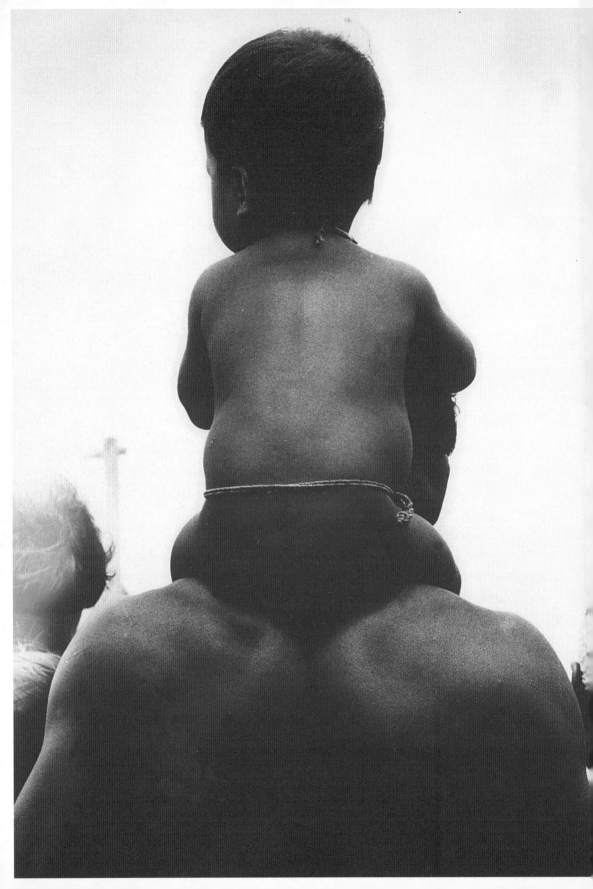

據說，蘭嶼每個小女孩的腰際上會綁一條帶子，就像這張照片中，騎在強壯父親肩膀上的孩子，細細的帶子圍在腰上，就算所有的孩子背對著父母，全身光溜溜地，身後的母親可以一眼認出自己的孩子。那腰上的小帶子，就是最好的「家族識別證」。這一系列照片中，我用相機記錄當年蘭嶼成年男女的日常作息。

According to the tradition, every little girl on the island had a string tied around her waist, just like the kid in this photograph. When the kid sat on the strong shoulders of their dads, the strings around their waists became the best "family identity cards." Even if all the children were sitting naked and having their backs facing toward their mothers, the latter would be able to recognize their own by the strings. In this series of photographs, I recorded with my cameras the daily routines and activities of the adult men and women on Orchid Island during that era.

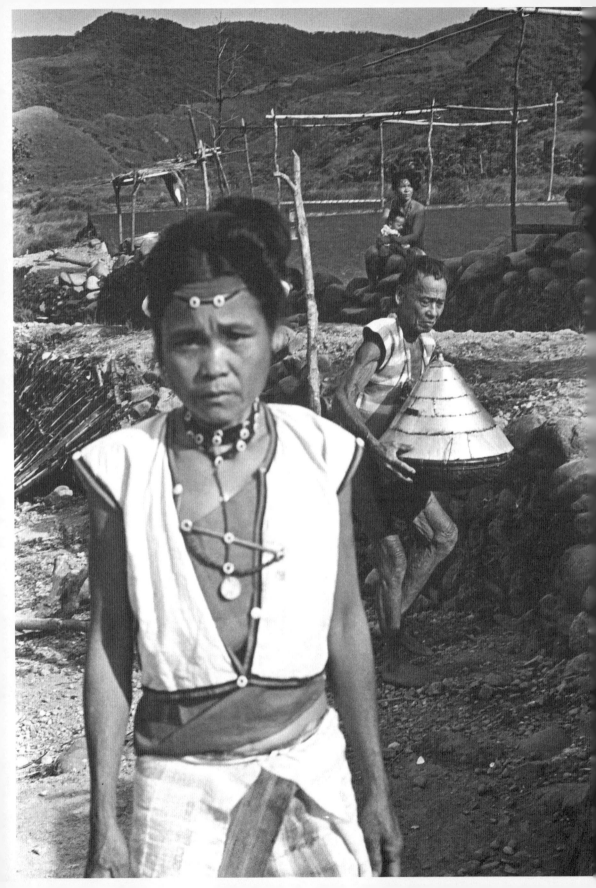

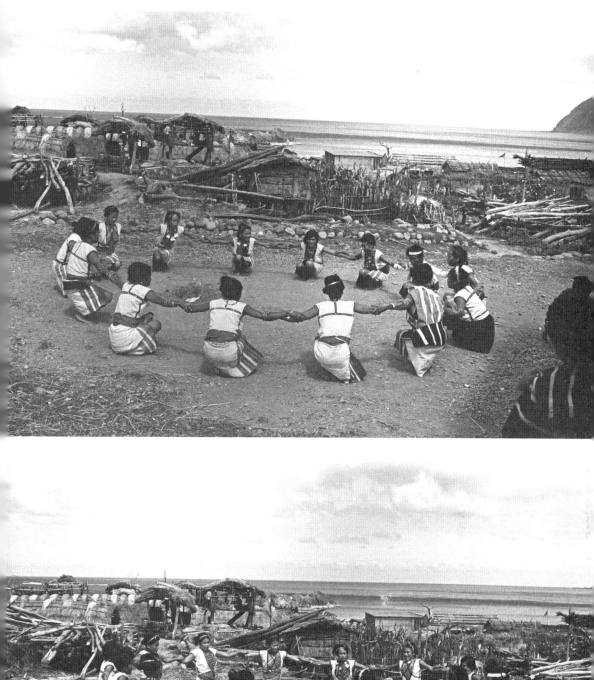
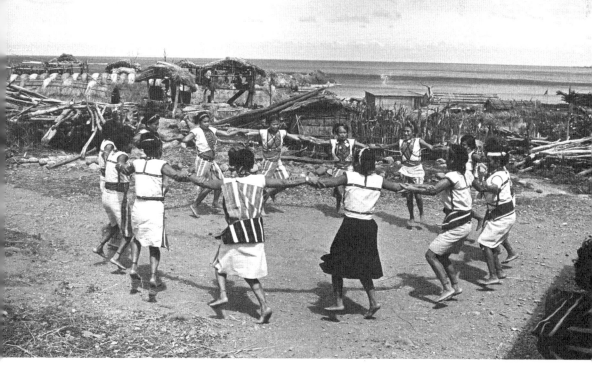

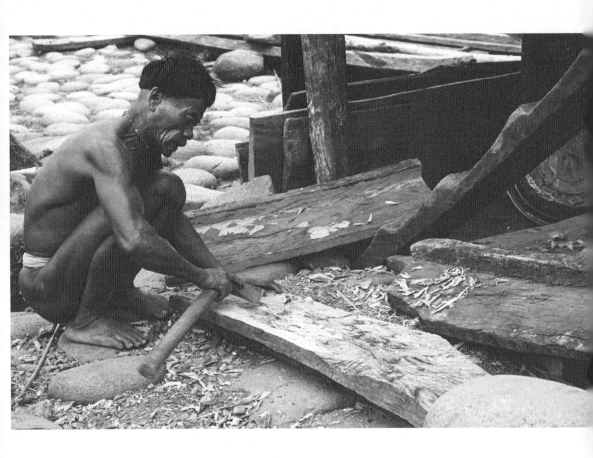

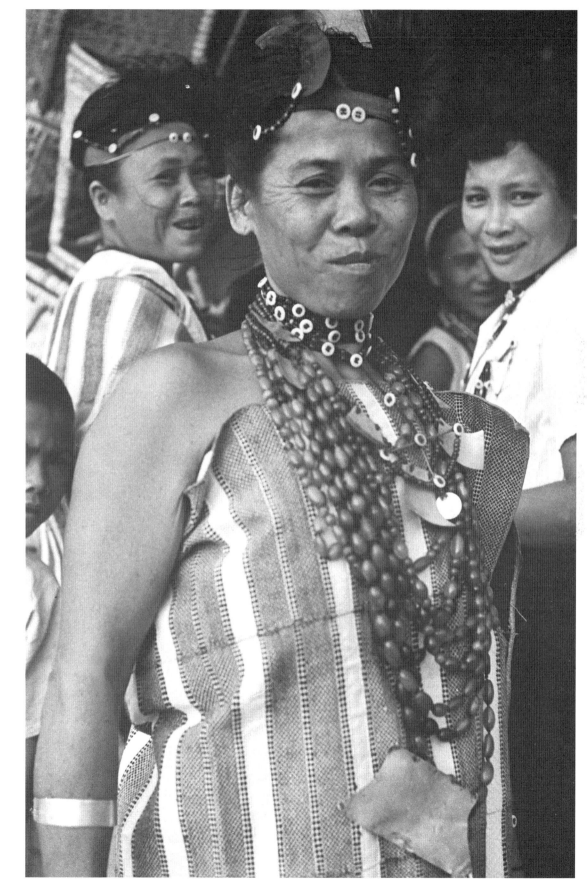

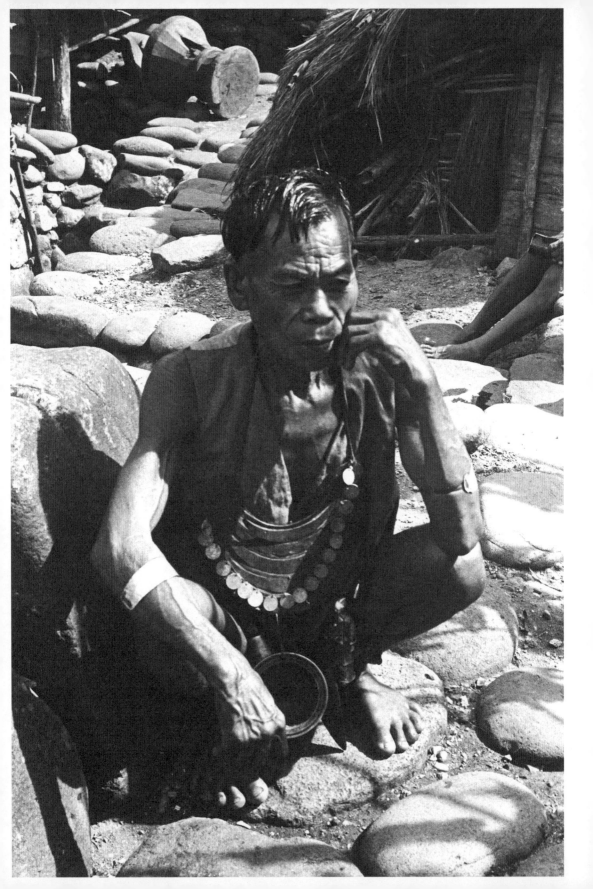

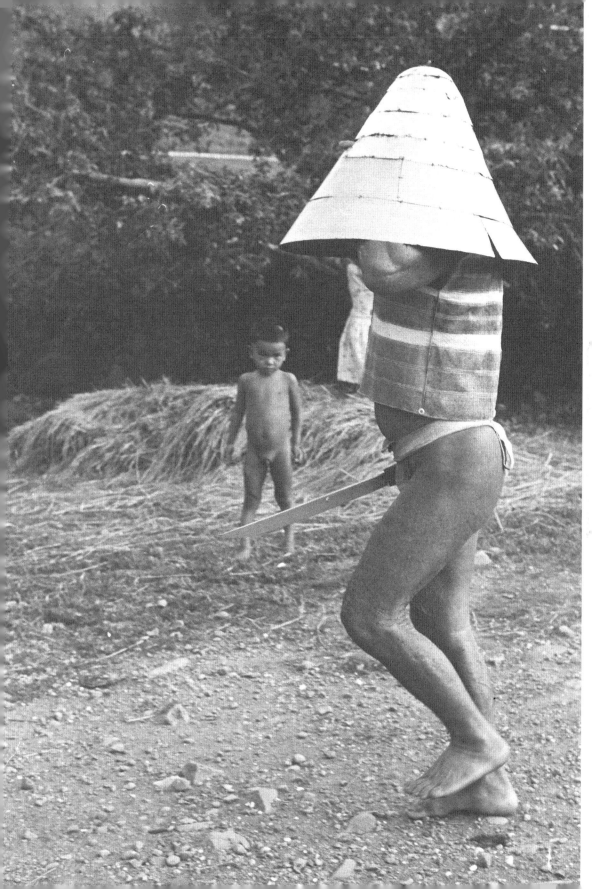

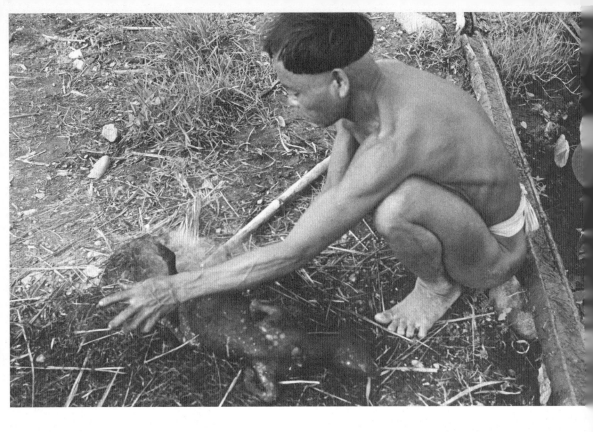

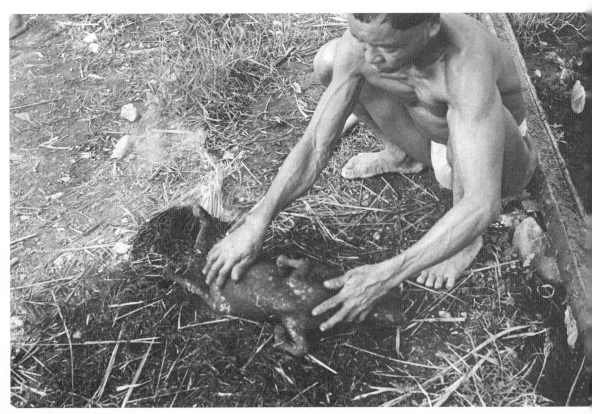

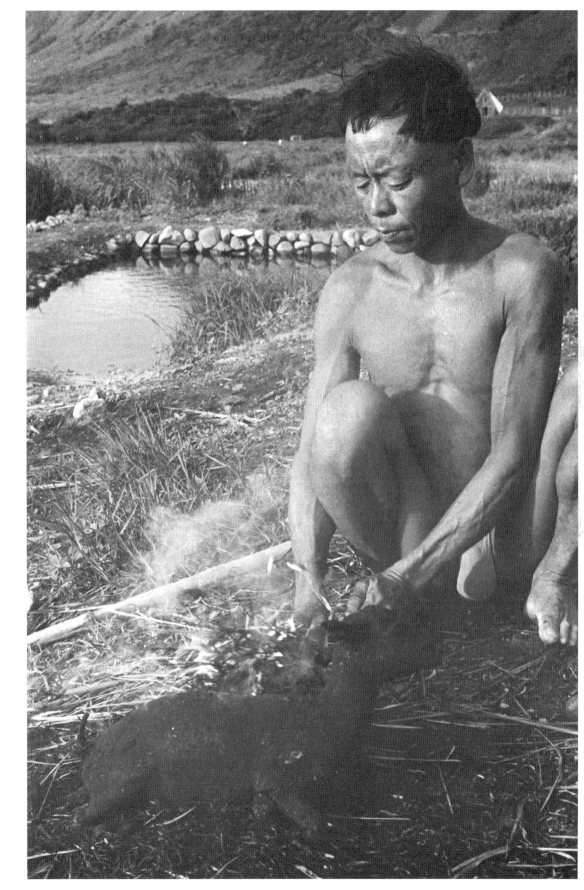

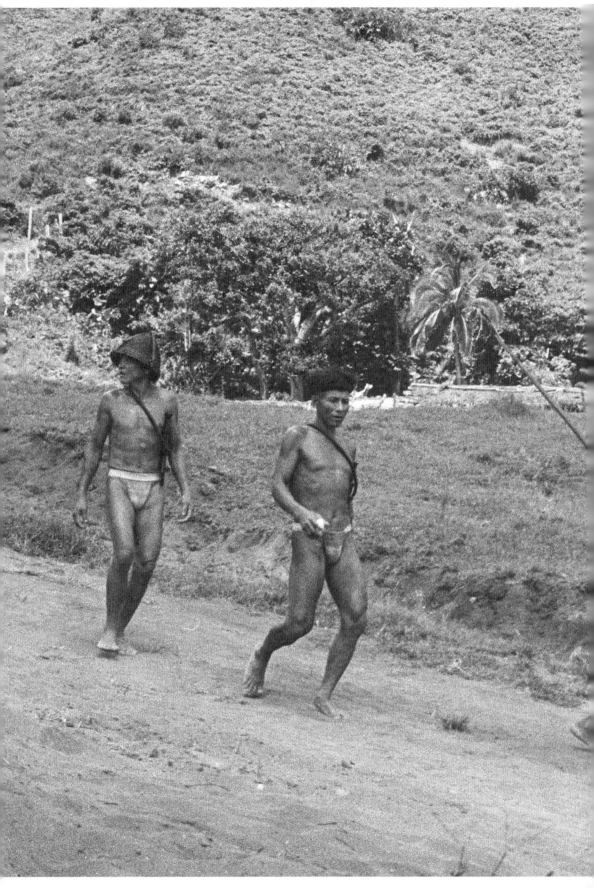

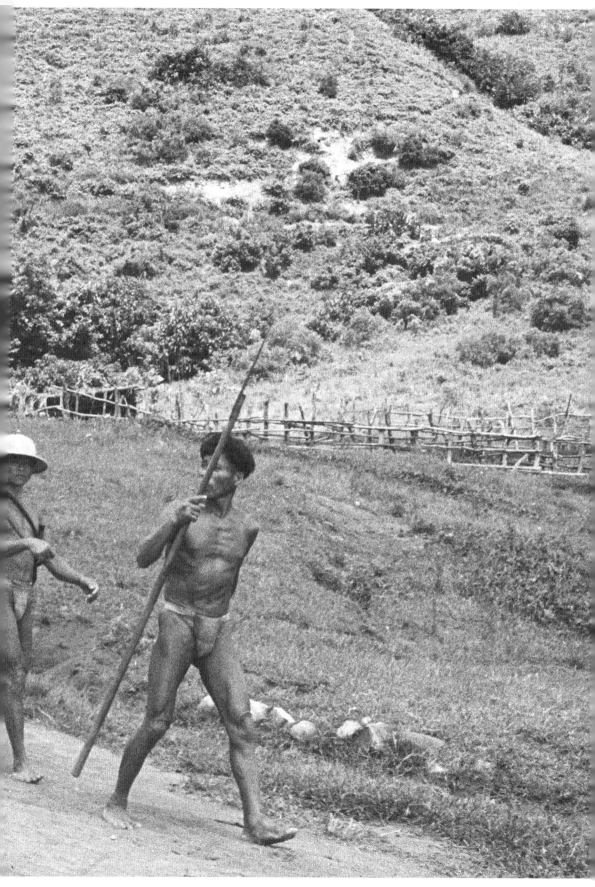

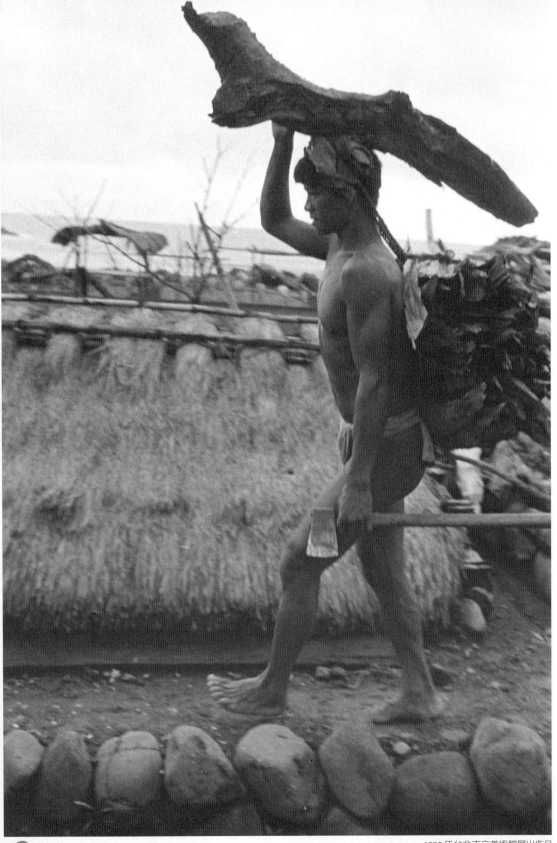

1995 年台北市立美術館展出作品
Taipei Fine Arts Museum, 1995

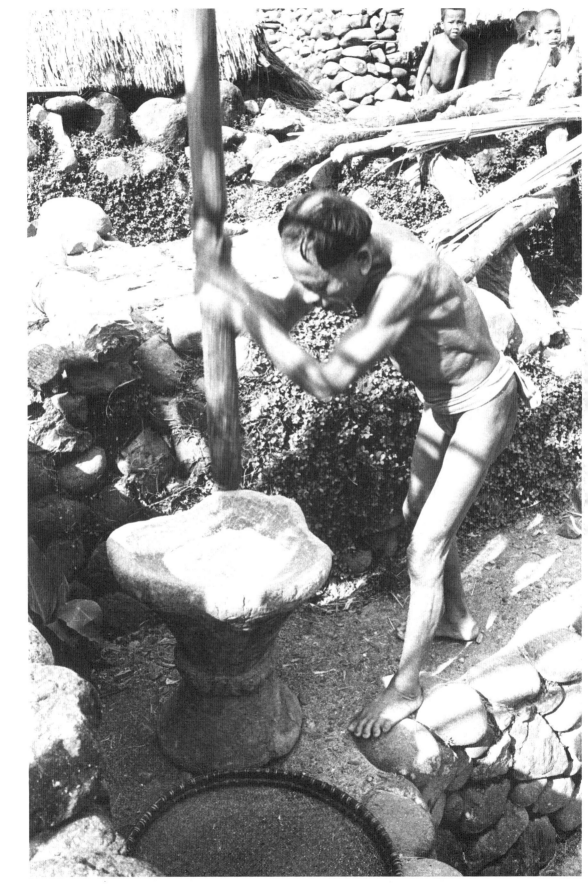

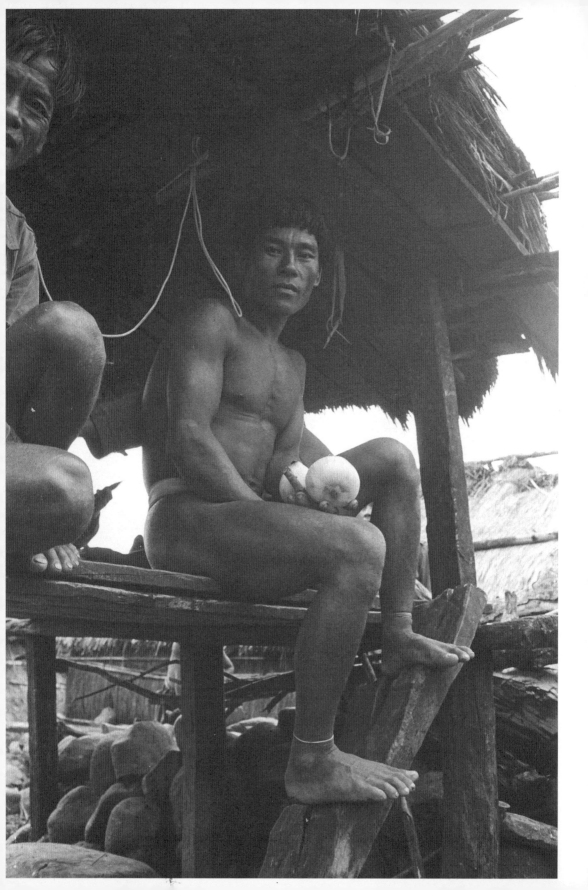

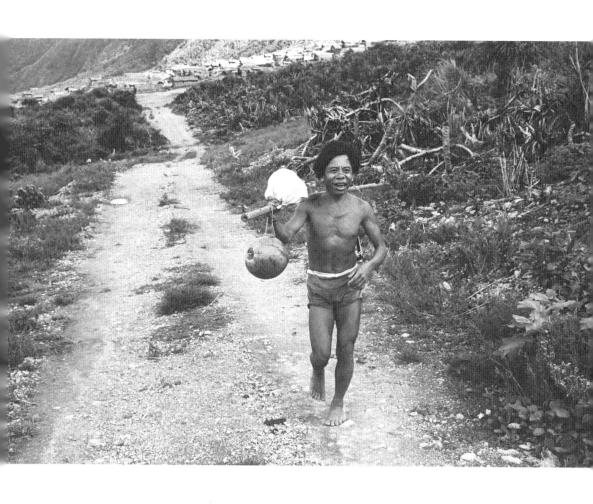

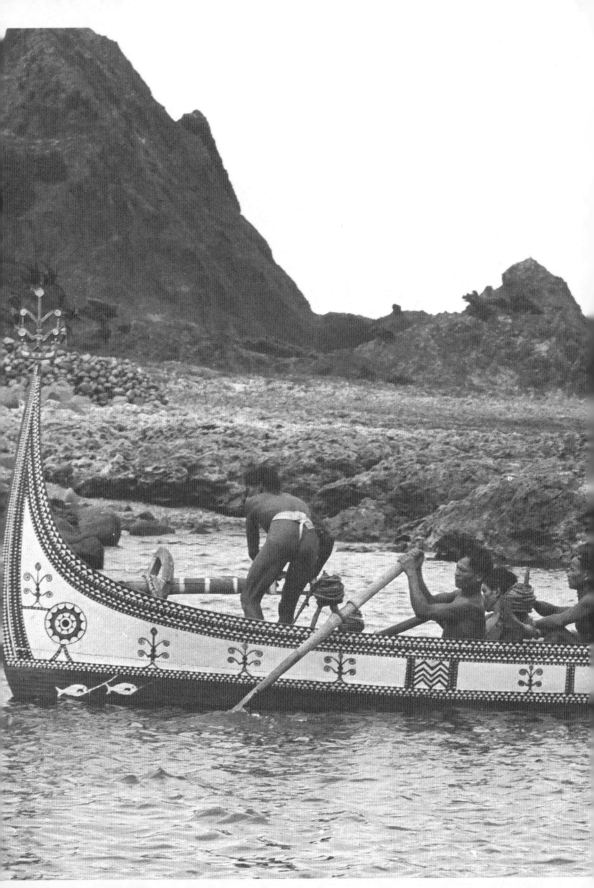

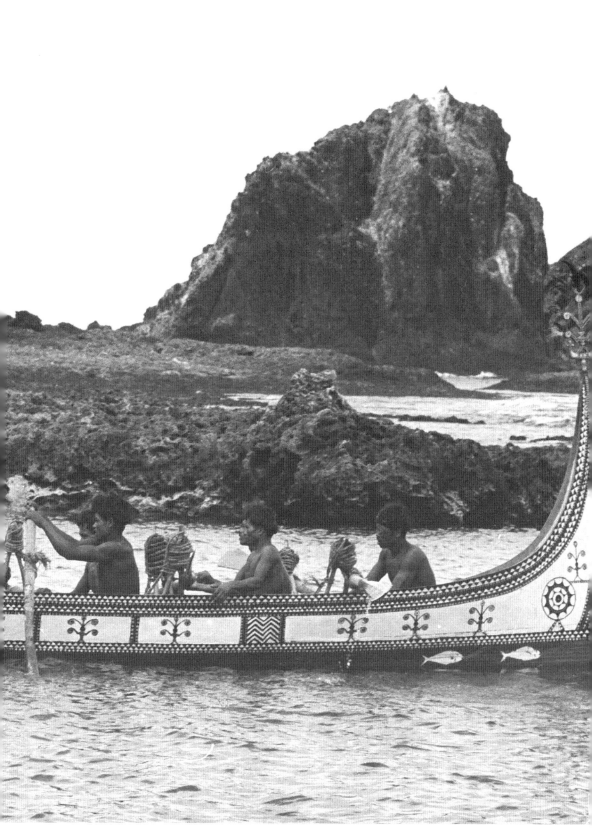

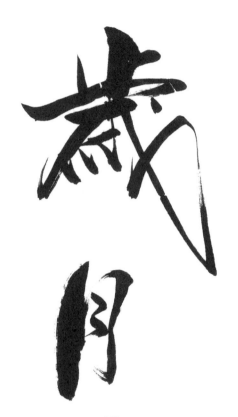

歲月

Time

歲月

當年和蘭嶼居民相聚的時間雖然只有五十八天，我卻有幸參與島上的大事，例如颱風天、豐年祭等。相片中每個人的神情呈現出真實與誠懇，也能從中看見上一輩族人的樣貌與精神。

Time

Even though I only spent fifty-eight days with the islanders, I was able to take part in some unforgettable events such as the typhoon days and the harvest festival. The expression on each face captured by the cameras was so honest and real, and revealed to us the character and the soul of the older generation of Orchid Island.

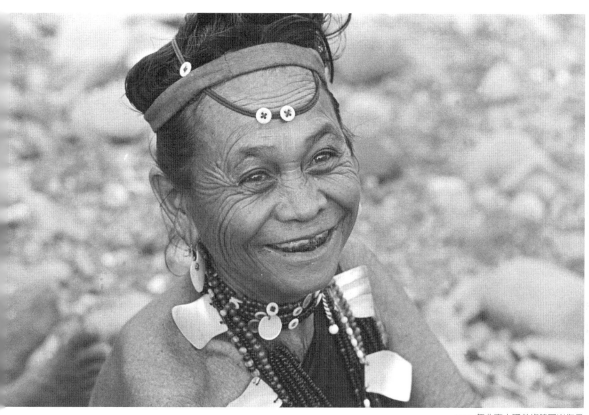

2001 年北京中國美術館展出作品
Beijing National Art Museum of China, 2001

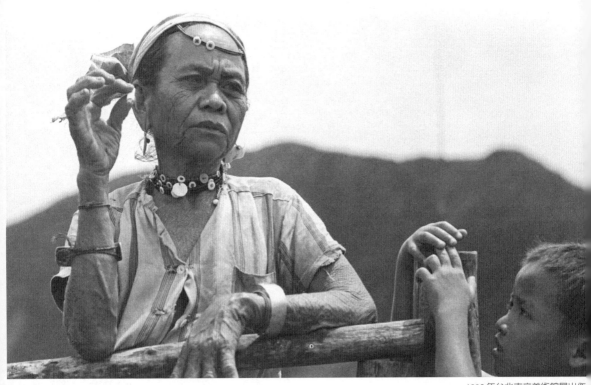

1995 年台北市立美術館展出作
1997 年國立台灣美術館作
2001 年北京中國美術館展出作
Taipei Fine Arts Museum, 19
National Taiwan Museum of Fine Arts, 19
Beijing National Art Museum of China, 20

照片中那個孩子不一定是老婆婆的孫子，但是他看老婆婆抽菸的樣子吸引我的注意。那時，我純粹想拍下孩子好奇的神態，以及老婆婆看海的心情，構成一張代表歲月主題，又能相呼應的有趣畫面。

The boy in the photo might not be the old lady's grandson, but the way he looked at the smoking grandma was really charming. I simply wanted to catch the inquisitive look on the child's face, and the mood of the old grandma looking at the sea. It is a photo about time and of contrasting and interesting elements.

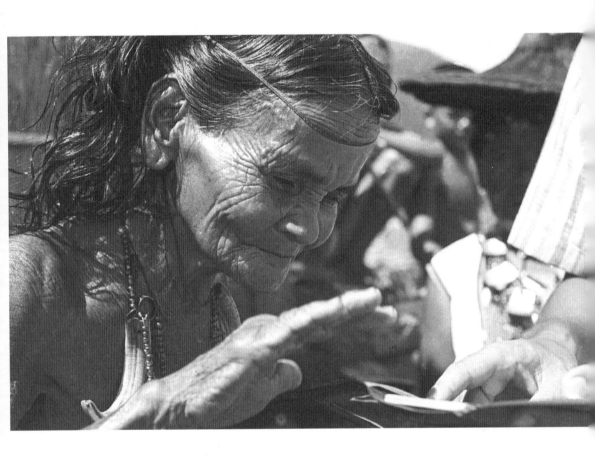

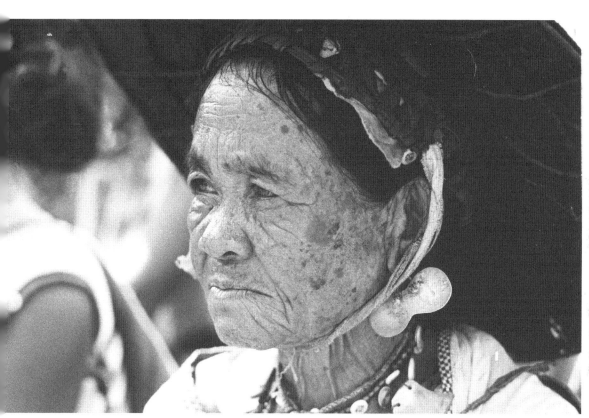

1965 日本富士攝影比賽得獎作品
Japan Fuji Photography, Contest 1965

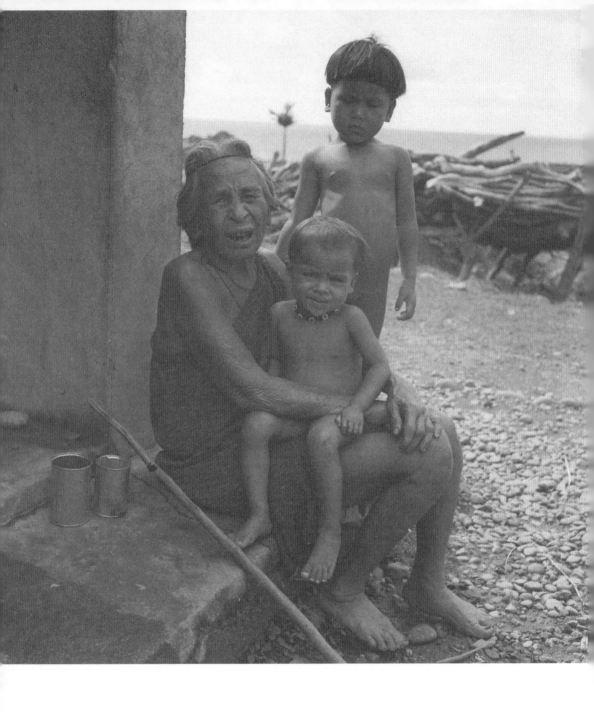

1995 年台北市立美術館展出作
1997 年國立台灣美術館作
2001 年北京中國美術館展出作
Taipei Fine Arts Museum, 19
National Taiwan Museum of Fine Arts, 19
Beijing National Art Museum of China, 20

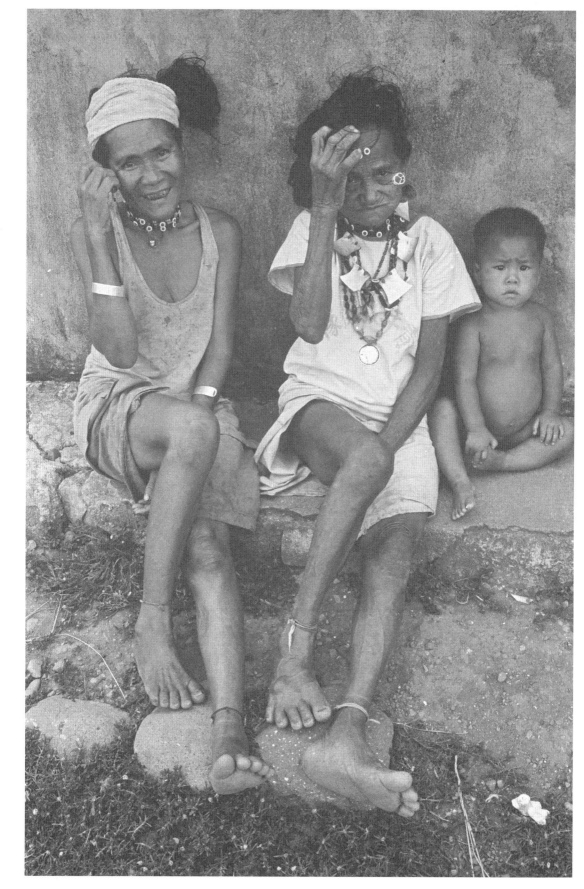

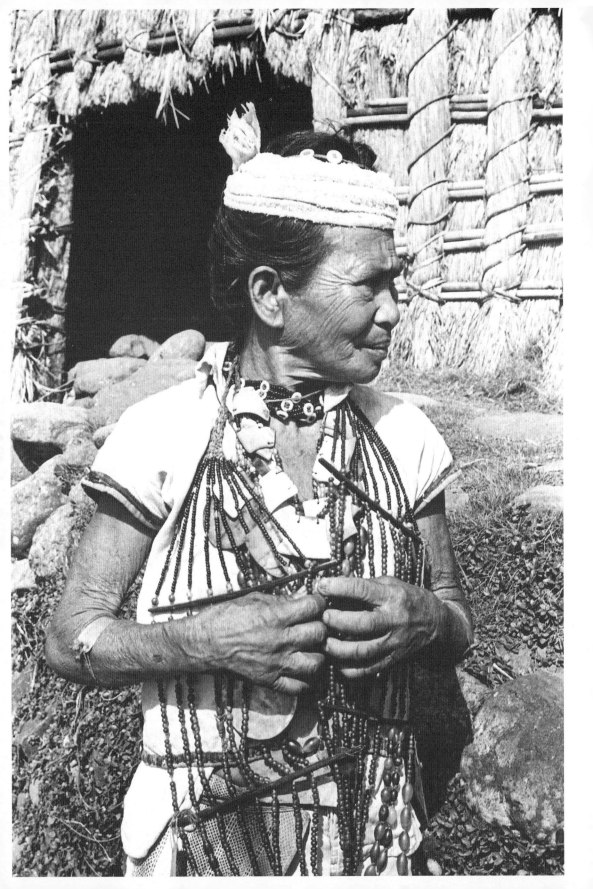

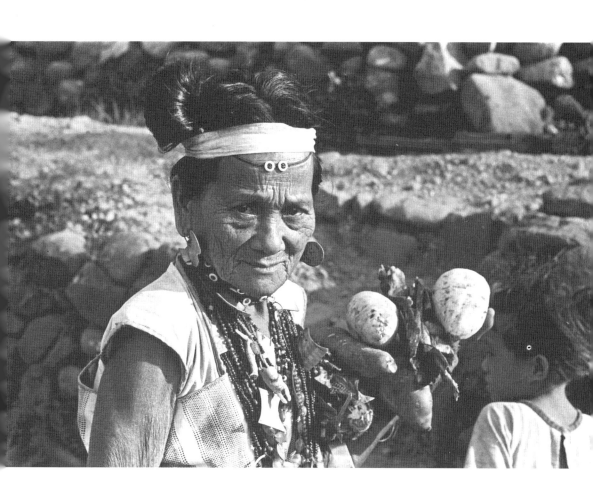

相傳，蘭嶼島上很多老人家的晚年，都是自己「處理」的。當他們年紀大了以後，知道自己來日不多，就會請孩子揹自己到安靜的地方，等待死亡降臨。這樣的風俗，類似日本早年電影《楢山節考》的劇情，似乎有些宿命的感覺。

According to the tradition, old people on Orchid Island would "take care" of themselves when they were about to pass away. When they knew their time left was short, they would ask their children to carry them to a quiet place to wait for death to come. This custom seemed to resemble the scenario in the Japanese classical film *The Ballad of Narayama* and might be perceived as a bit fatalistic.

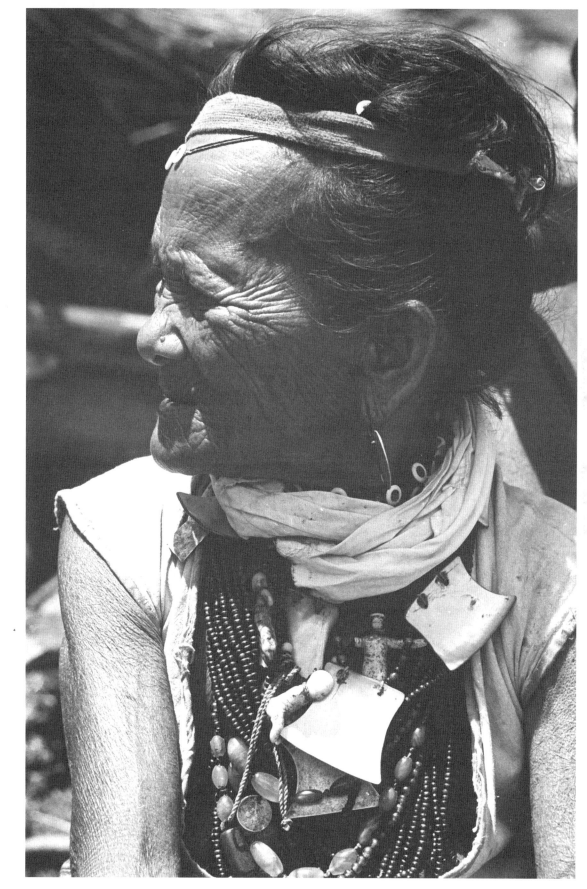

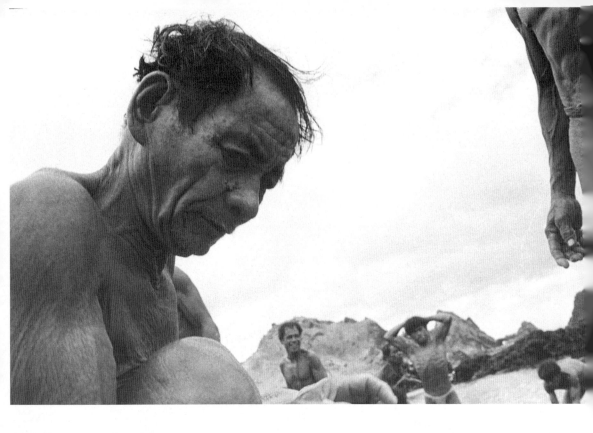
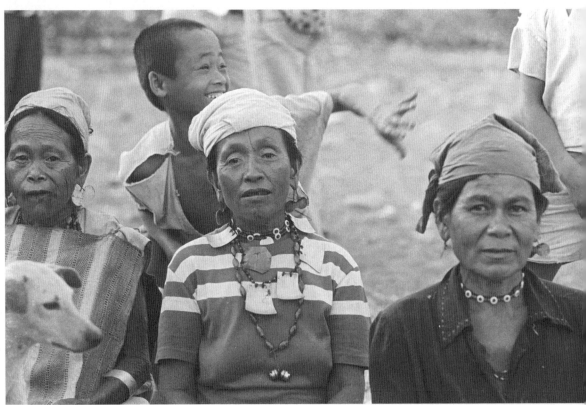

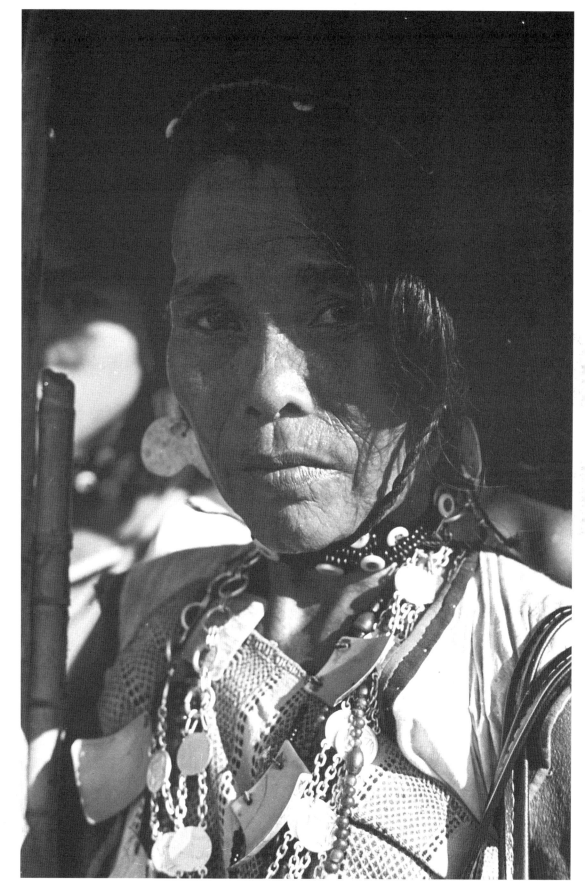

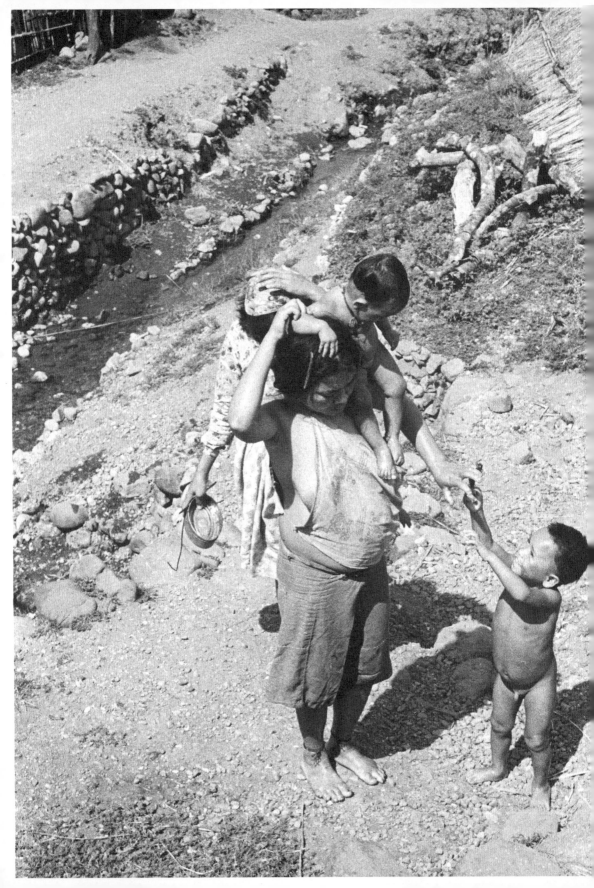

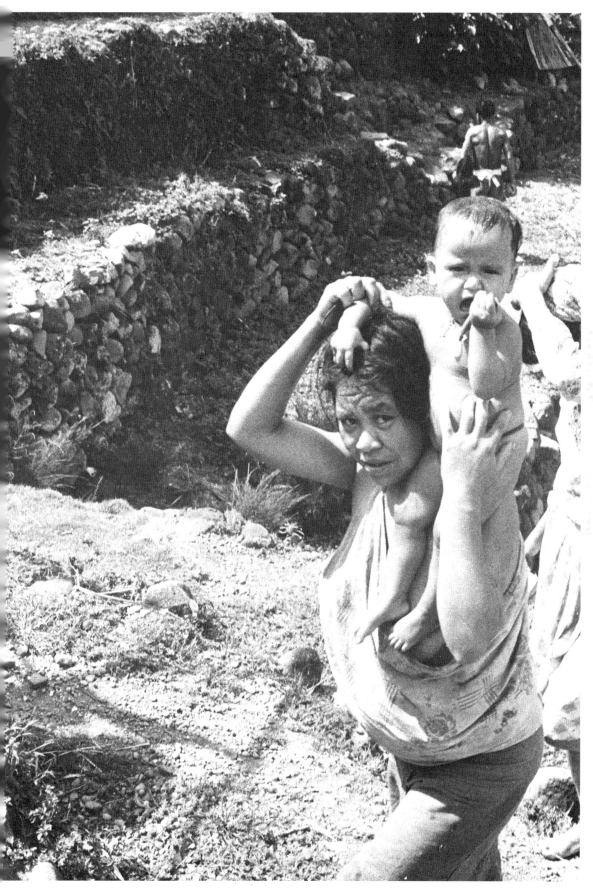

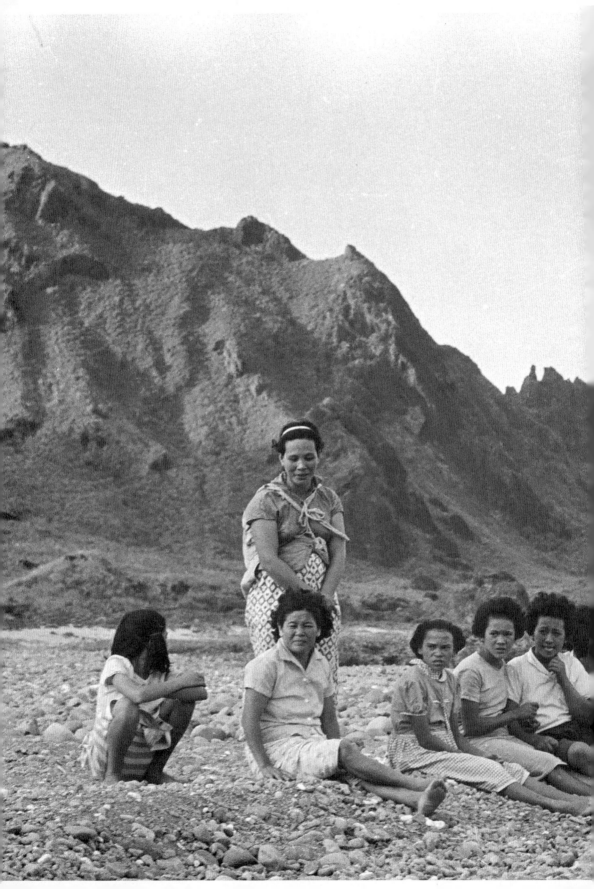

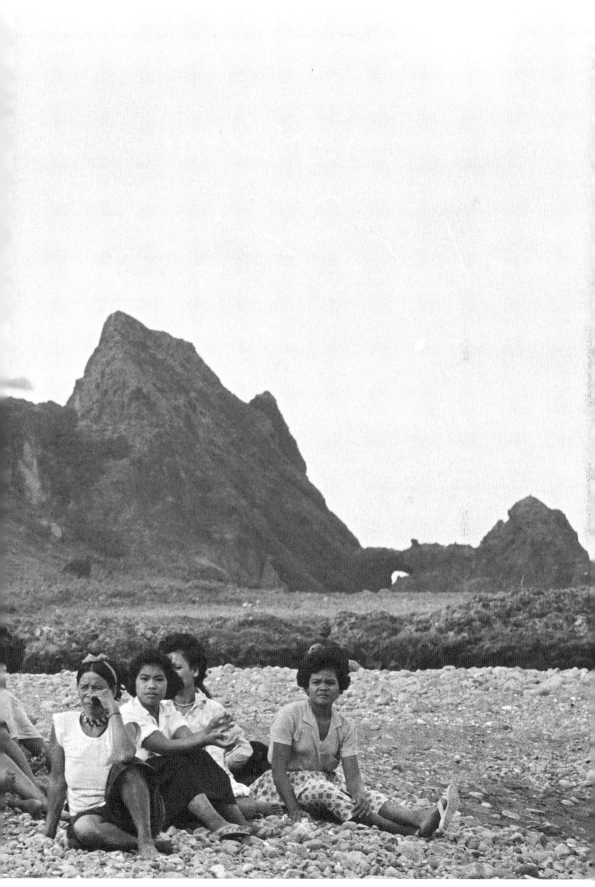

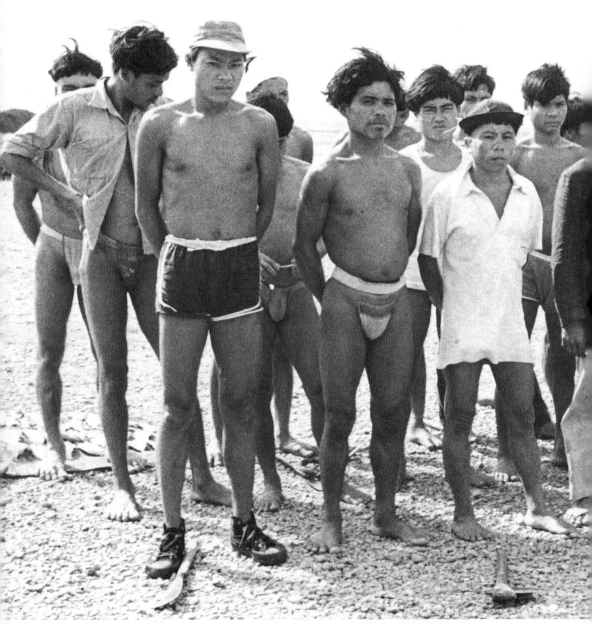

如果有蘭嶼的朋友從這本書中，看見回憶中的自己時，會有一些連結與珍惜的感覺，這真是各自
生命歷程中非常喜樂的一件事。

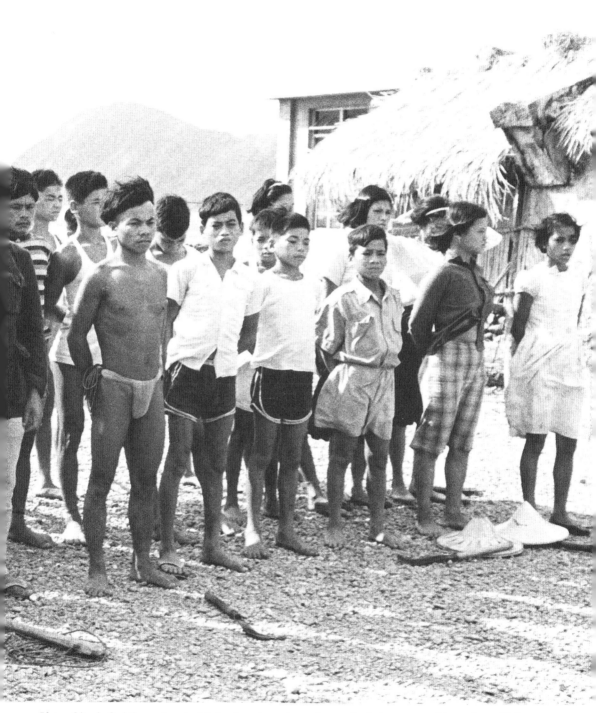

If any friends find themselves in this book and see themselves as in their memory, I hope they will feel a special connection and a sense of endearment – it will truly be a joyful thing in their life and mine too!

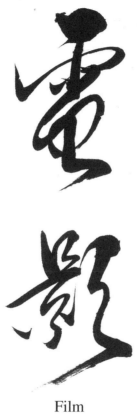

Film

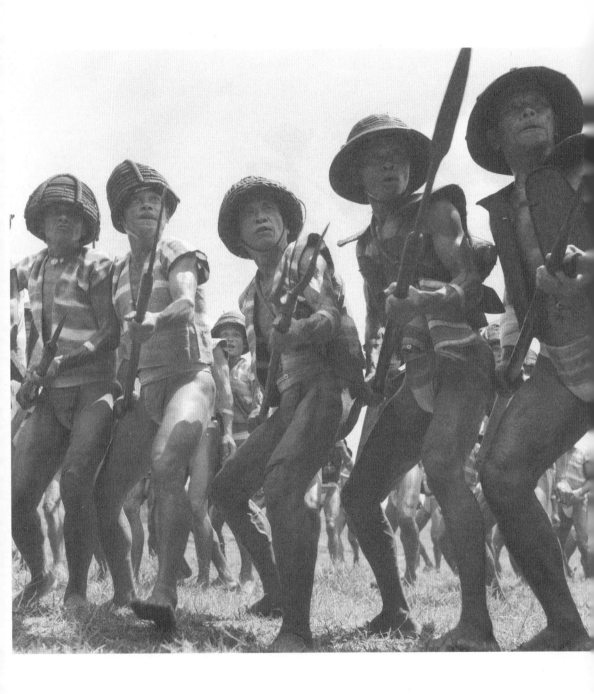

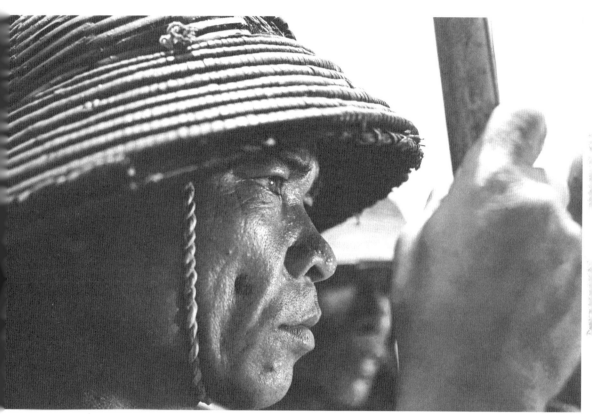

1999 南北六人展出作品
2001 年北京中國美術館展出作品
South-North Six-Person Show, 1999
Beijing National Art Museum of China, 2001

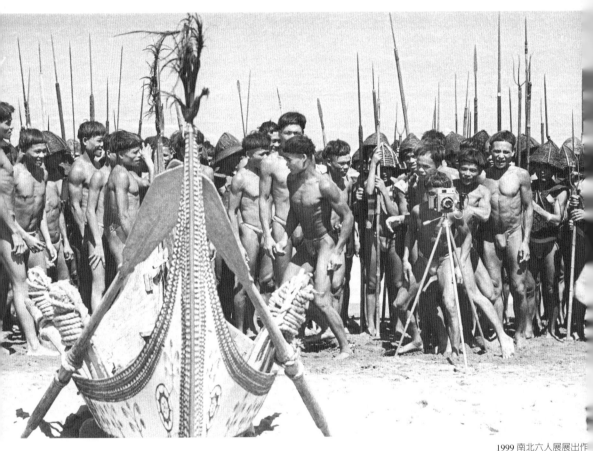

1999 南北六人展展出作
South-North Six-Person Show, 19

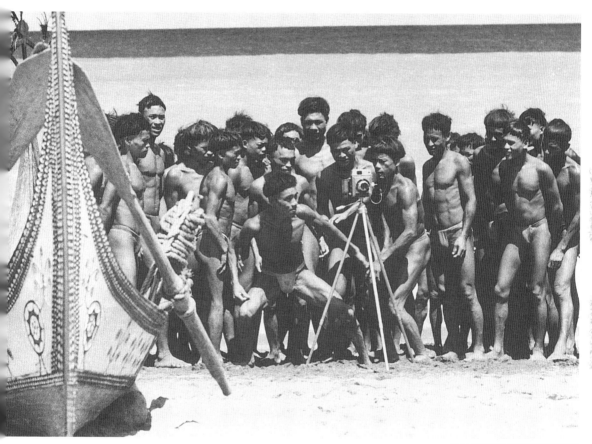

2001 年北京中國美術館展出作品
Beijing National Art Museum of China, 2001

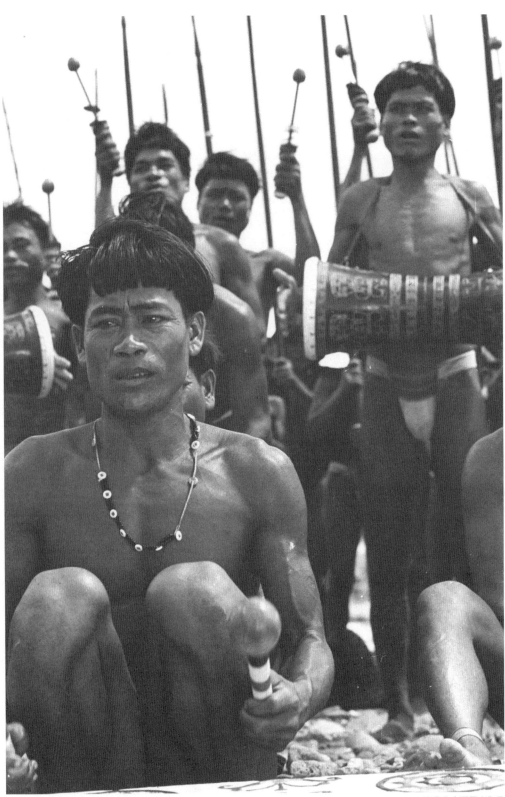

1999 南北六人展展出作品
South-North Six-Person Show, 1999

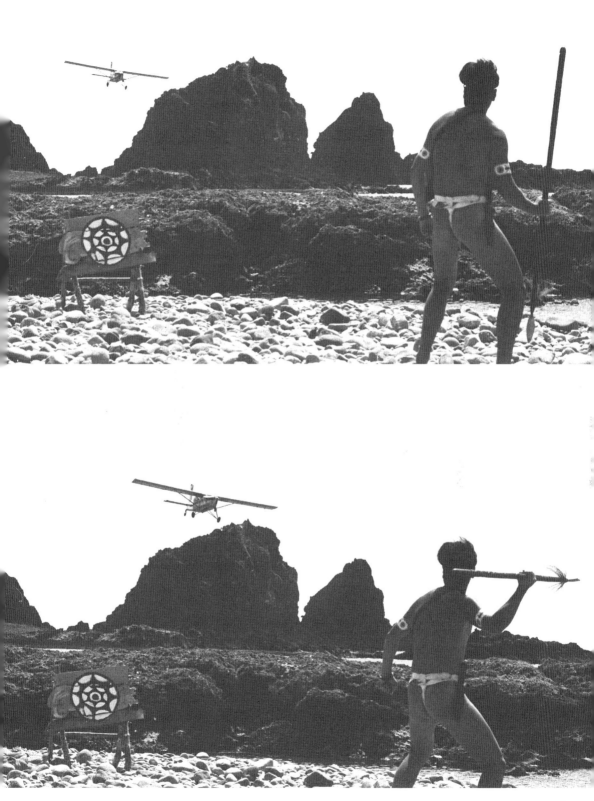

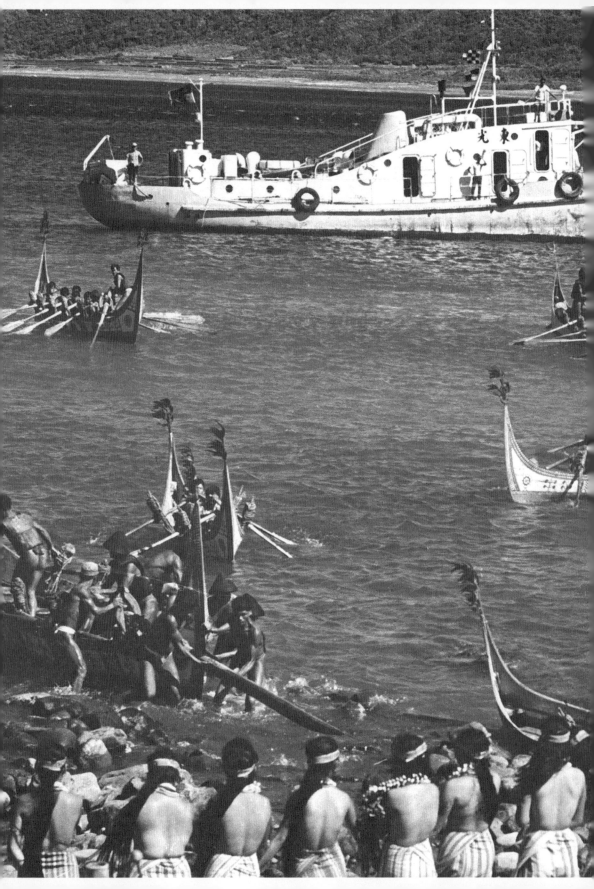

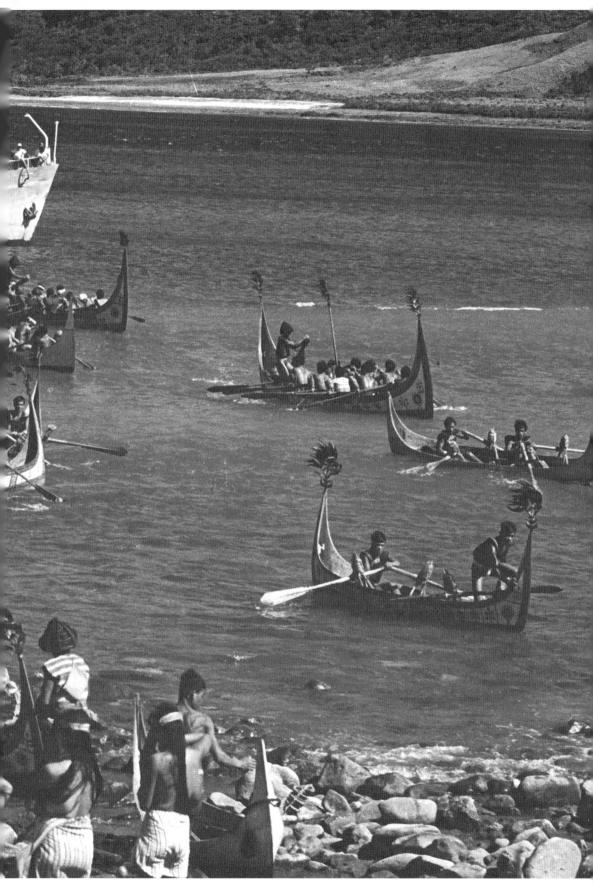

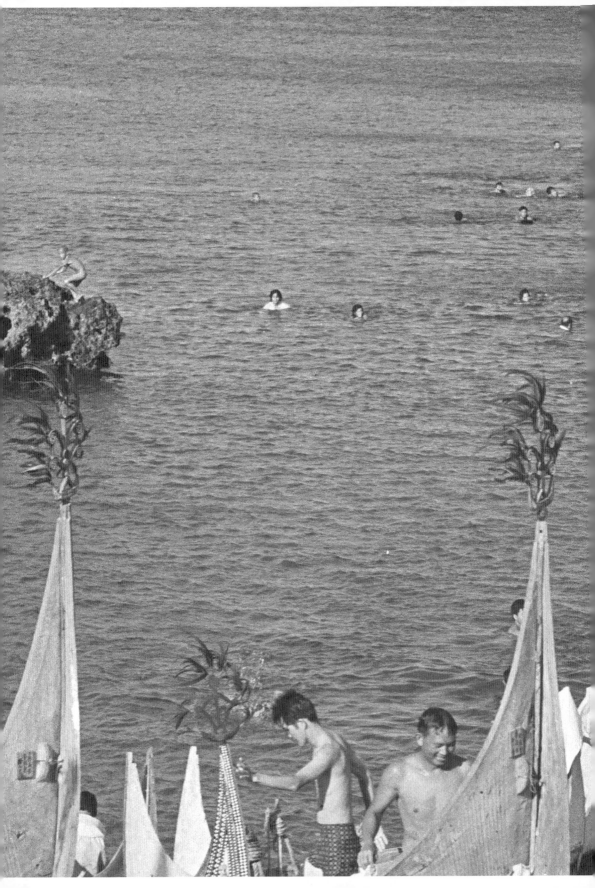

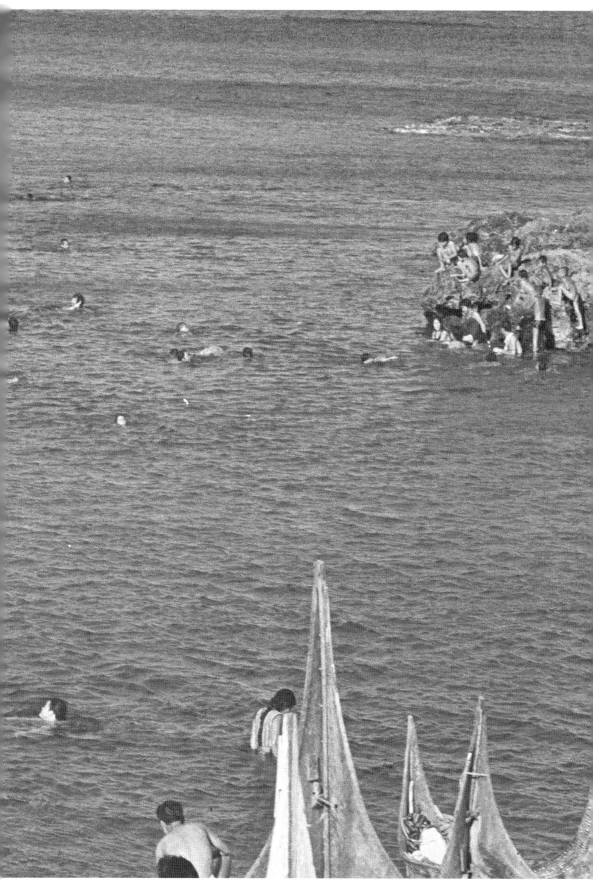

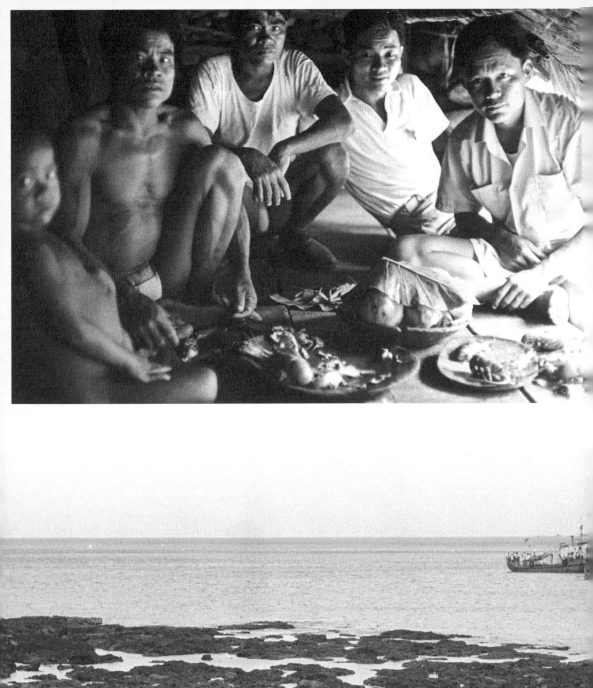
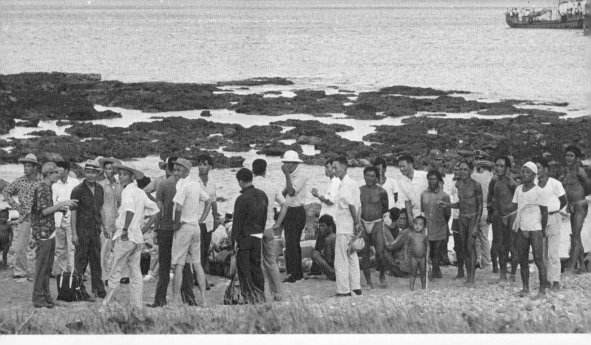

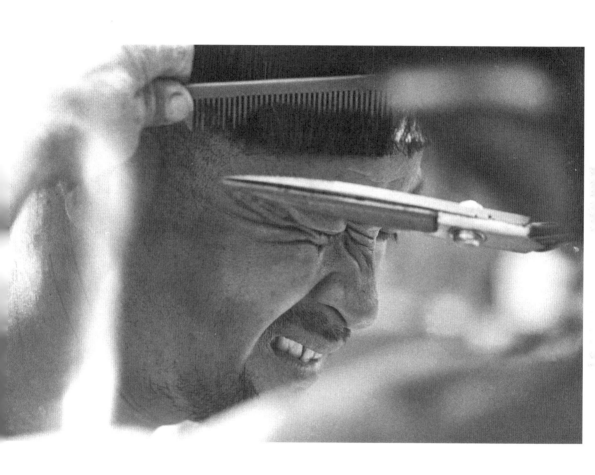

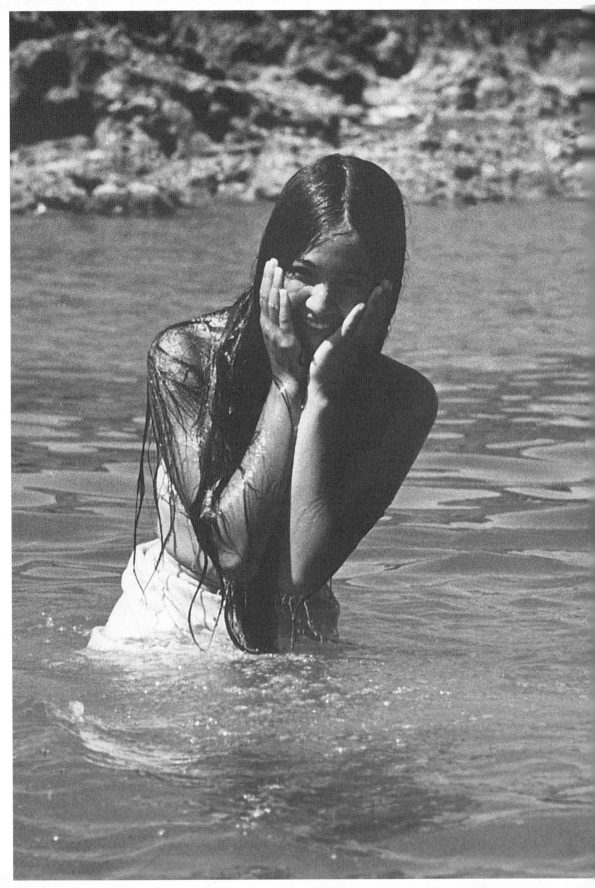

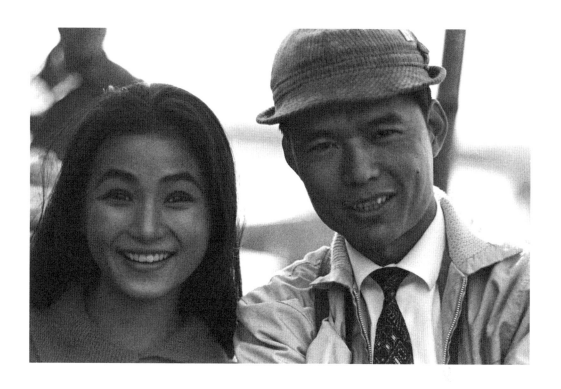

國際影星鄭佩佩小姐，年輕時擔任《蘭嶼之歌》女主角，在拍片後收工時，躍入海中，讓我有機會以望遠鏡頭為她留下美麗的倩影。

International star Cheng Pei-Pei was the leading actress for *Song of Orchid Island*. After filming, she dived into the ocean and I had the opportunities to capture her beauty and youth with my telephoto lens.

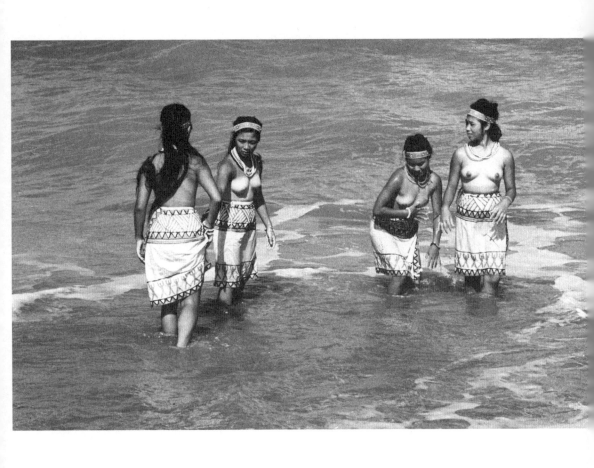

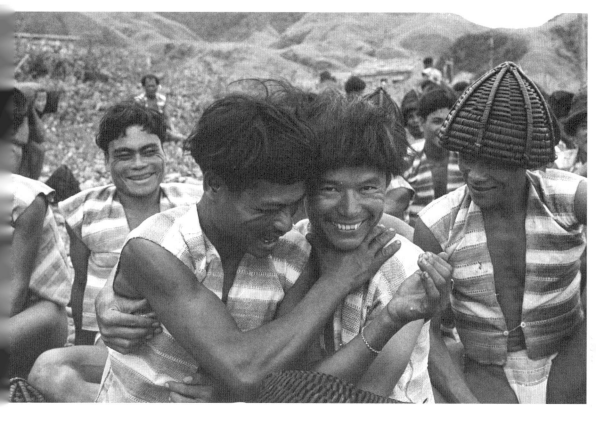

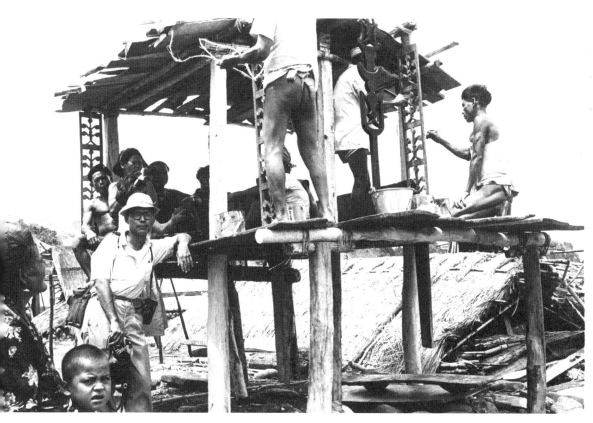

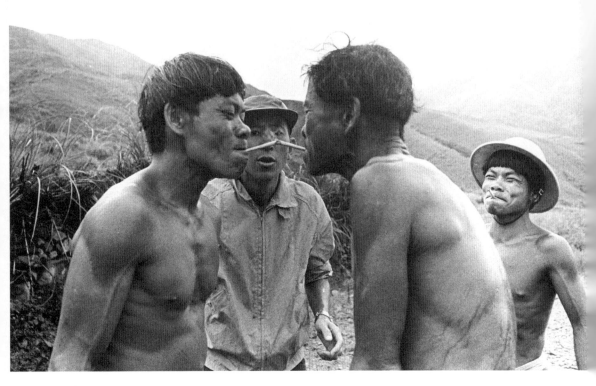

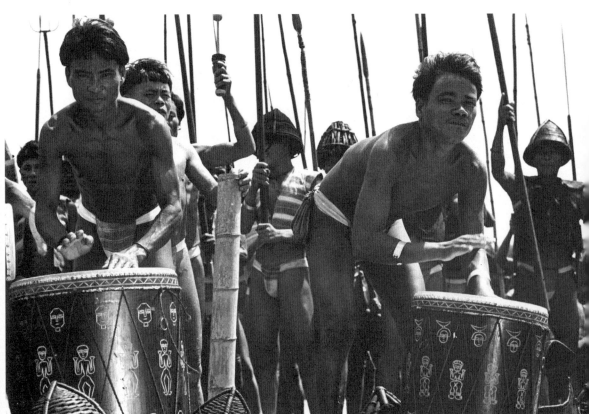

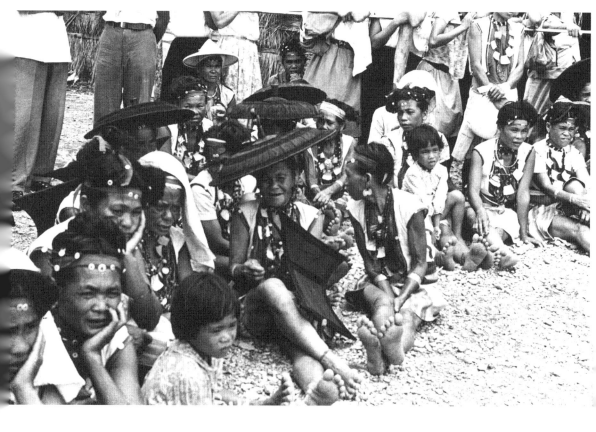

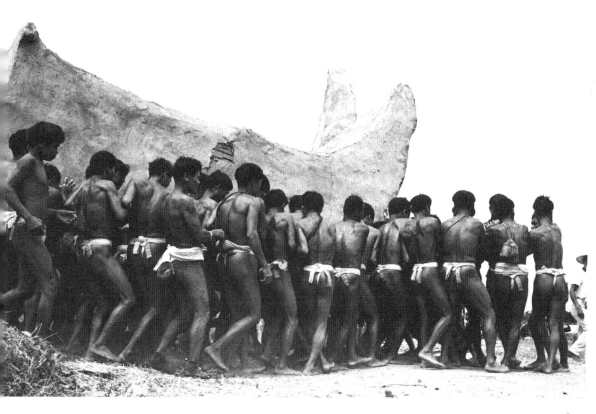

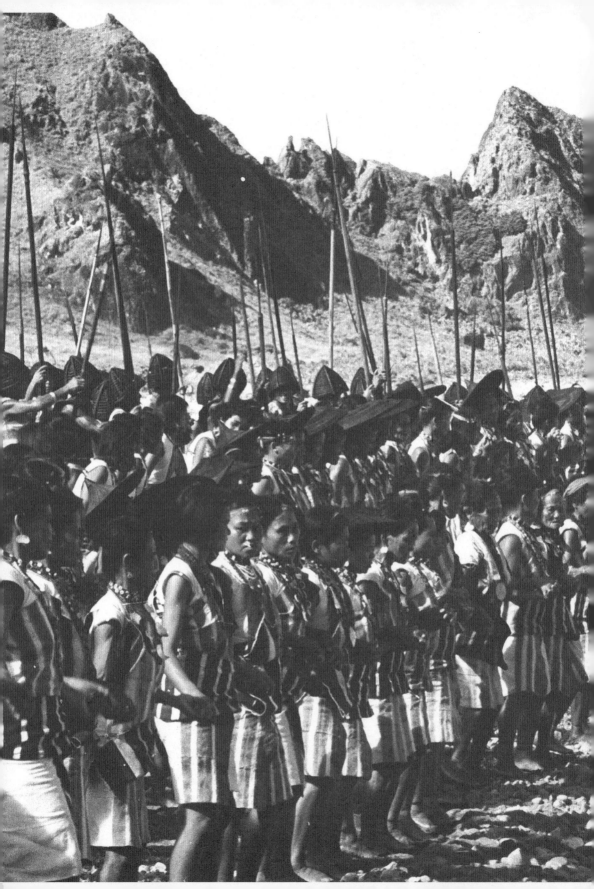

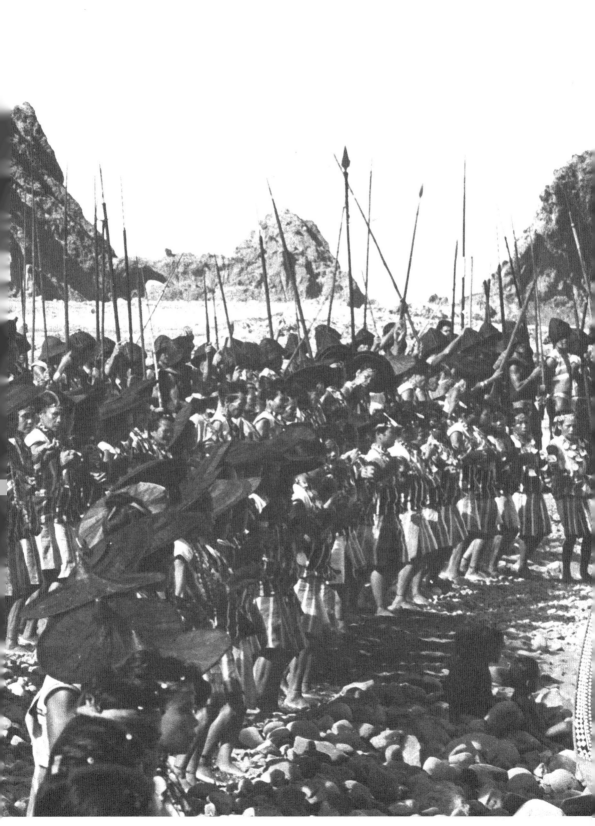

Appendix

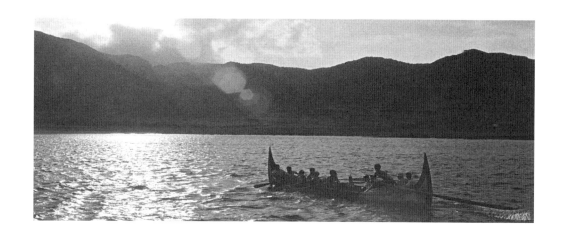

與大師的對話
Conversation with a Master

與謝震隆老師對談拍攝花絮與建議
Hsieh on behind-the-scene stories and advices for the readers

撰文 / 許豐明　By Hsu Fong-Ming

許：請談談拍攝《映像蘭嶼》的時代背景和緣起？

Hsu: Please share with us the historical background and origin of the photo series *Images of Orchid Island.*

謝：1963 年拍攝這一系列作品之前，我在台南西門路開設照相沖洗店。有一天，邵氏公司的製片拿當時在台灣安平港附近拍的電影劇照來我店裡沖洗，我對這些照片並不滿意，既死板又毫無生命力。如果是我來拍，可能會有不同的視覺效果。製片臨走前，我告訴他，明天我抽空幫他們拍幾張照片讓他看看。

Hsieh: It was 1963. I was running a photo shop on Western Gate Road in Tainan when the opportunity arose. One day a producer from Shaw Brothers Studio came to my shop to process some movie stills taken near An-Ping Harbor. I looked at those pictures and thought they were dull and lifeless. So I told the producer, if I had taken the stills, they would have had a very different visual impact. Before he left, I said I would a few stills to show him the next day.

就這樣，第二天我單獨一人，帶著相機去現場跟拍。你知道嗎？早期的劇照師拍照都是拿 4×5 大型相機拍攝「呆」照，在導演完成一場戲後，集合相關演員，安排好位置，讓劇照師來拍「呆」照。我去現場可不是這樣，他們拍他們的，我拿起我的相機，拍我所觀察的影像，我希望人們看見我拍的每一張照片，就像看見電影最精采的片段一樣。

So the next day I took my camera and went to the filming location by myself. You would not believe how the movie stills were taken in the early days. The still photographers only had to do some set-up shots of the actors with 4×5 cameras. They waited for the directors to finish shooting a scene, then gathered all the actors involved in the action, arranged their position, and finally took the "still" shots. However, when I went on the set, I took a very different approach. I took pictures right in the middle of their action. I wanted each picture to represent the most dramatic moment of the scene.

後來，我用機動性較佳的 135 相機拍的照片，引起當年邵氏知名導演潘壘先生的注意。就這樣因緣際會下，我受邀跟導演一起到蘭嶼拍攝電影《蘭嶼之歌》，這一待，就是五十八天。

I used 135 cameras that had great mobility to take those stills and they caught the attention of Mr. Pan Lei, who was a renowned director with Shaws Studio at that time. That was how I got invited to go to Orchid Island to shoot stills for the film *Song of Orchid Island*. We were there for a total of fifty-eight days.

我憑著一股對攝影的衝勁，把攝影沖洗店交給同樣研究攝影多年的弟弟，自己整裝待發，隨著潘壘導演的攝影隊伍，踏上夢寐以求又充滿神祕感的蘭嶼島。這是我第一次擔任專業電影劇照師，也是我第一次有機會踏上蘭嶼這座美麗的島嶼。

Leaving the photo shop to my brother who had also studied photography for years, I packed up and joined director Pan's film crew for the dream trip to the mysterious island. This was my first assignment as a still photographer, and my first time ever to visit Orchid Island.

許：對蘭嶼這塊土地的第一印象是什麼？

Hsu: What was your first impression of the island?

謝：那時候的蘭嶼人煙稀少，除了島上達悟族（或稱雅美族）的原住民，很少有外人會到島上。我們從台灣搭船要花很長的時間，大夥兒飽受暈船的痛苦，在甲板上很多人都吐了，然而說也奇怪，當人們站在船頭遠遠望見陸地時，映入眼簾的南方風情小島，以及海邊的清風徐徐，便讓船上的人們精神大振。那時的蘭嶼沒有人工建設的港口，我們必須先乘坐大船到岸邊，換搭小木筏，再撩起褲管或裙襬踏進海水，才能順利踏上這片土地。

Hsieh: The population on the island was rather small. Few outsiders came over except the native Tao people (or Yami people). The journey by cruise from Taiwan was long and many of us were seasick and throwing up on the deck. Yet as soon as the sight of the island emerged on the horizon, we were

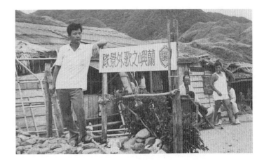

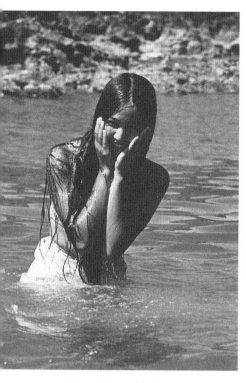

immediately refreshed by its tropical scenery and gentle breeze. There was no man-made harbor for the cruise to land. We had to transfer into small wooden rafts first, and then treaded the water with our pants or skirts pulled up before we stepped on the island.

許：如何在拍劇照與拍攝自己要的照片之間取捨？

Hsu: How did you balance between taking the stills for the film and shooting your own photos?

在受邀前往蘭嶼之前，我和潘壘導演有個默契，就是他拍他的電影，我從旁自己構思劇照畫面。我從第三者的角度觀察，用參加比賽般的專注和投入拍照。

Before accepting the invitation to go to Orchid Island, I made an agreement with Director Pan: I would have the liberty to frame the movie stills on my own while he was filming the scenes. I would be a third person observing what was happening. And the pictures would be taken with the same focus and involvement as if I were attending photography contests.

我拍的往往是導演未曾發現的精采畫面，他也對我的作品充滿信心。後來這些照片的寫實風格，著實影響了香港攝影界拍攝劇照的方式，我將劇照拍攝手法翻新的理念也獲得認同。

The stills I took often employed some incredible angles that the director never thought of, so he grew very confident in my works. Later on the realistic style of these stills was brought back to Hong Kong and completely changed the way the photographers shot movie stills from then on. They started to identify with my new concepts and techniques.

當然，除了拍攝劇照之外，大多數時間，我會帶著自己的三部相機，走遍蘭嶼全島，到處逛逛、到處看看，當我感受到影像背後呈現出故事時，便按下快門。這本攝影集的最大特色，除了少數幾張照片確實是劇照之外，其他都是我自己一個人在蘭嶼全島留下的足跡。

Of course, besides taking stills on the set, most of the time I carried my three cameras and wandered around the whole island. Whenever I sensed a story behind an image I would push the button. That is the uniqueness about this book: only a few photos in the series are movie stills; the rest of them are all records of my personal journey on the island.

就像這張鄭佩佩小姐年輕時的照片，攝於電影收工後，她跳進海水裡沖洗一天疲憊時的剎那，留下這幅在電影中沒有的畫面。我喜歡從自然與真實當中創作，這張照片可說是最好的例子之一。

For example, the shot of the young Cheng Pei Pei was taken right after a day's filming. She jumped into the sea to bathe away the fatigue. It was not a scene in the film, but the photo perfectly demonstrated my creative approach to photography based on nature and reality.

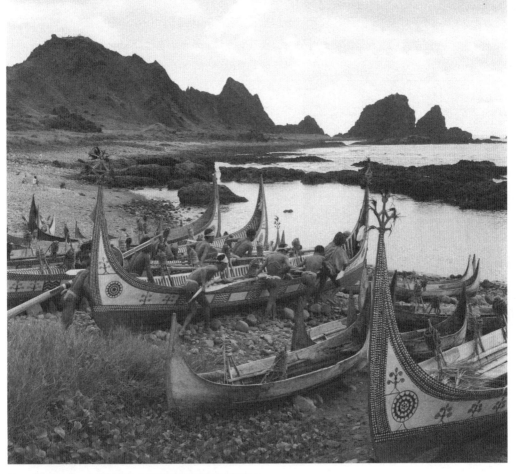

許：旅行途中，拍攝當地人物的溝通訣竅有哪些？

Hsu: What were your communication secrets with the local people during your travel?

謝：說起在蘭嶼的拍攝方式，我的習慣是一面聊天，一面以廣角鏡頭從不同角度拍攝，被攝者處於不知情的狀態，我不會先徵求對方同意。

Hsieh: For the series of Orchid Island, I usually just chatted with them and at the same time took pictures of them from different angles with wide-angle shots. I didn't ask their permission so they would not be on guard.

當然，我的拍攝原則是，拍攝被攝者最好的一面，而不是故意拍攝穿幫畫面或是醜化被攝者的照片。如果徵求同意後才拍攝，照片中的人物，往往會失去最自然的一面。當然，如果對方不願意，我不會勉強；不過通常當他發現我在拍攝時，我已經拍攝完畢。

Of course, one principle I adhered to was that I always presented the best side of my characters and I never scandalized or belittled them. If I asked permission before taking the shot, usually the photo would not appear natural. However, if people didn't want to be photographed, I would never force them. But usually before they realized I was shooting them, I had already finished the shot.

舉例來說，蘭嶼人的習俗是穿著丁字褲，我與他們談及這件事時，想看他們時而微笑、時而尷尬的反應。這些珍貴的表情，不論是喜是悲，都是我獵取鏡頭時，最想要的自然表現。

For example, the men on the island were accustomed to wearing G-strings, and I liked to chat with them on this subject. Their responses were sometimes smiling and sometimes embarrassment. To me, these expressions–whether joy or sorrow–were most precious. I loved to capture these types of natural emotions.

許：旅行途中拍攝人物的攝影器材準備訣竅有哪些？

Hsu: What tips will you offer to those who want to do portrait photography during a trip concerning preparing camera equipment?

謝：拍攝前，裝備必須齊全才能出發。當年的我習慣使用定焦鏡頭，三部相機掛在身上：廣角、標準、望遠鏡頭各掛在不同的機身上。這是為了因應不同的場景，以及避免因為底片不夠，錯失拍照良機。

現在的學生在旅行時，喜歡使用變焦鏡頭，可以輕易調整廣角與望遠的效果。其實，我們都應該了解鏡頭的原理，變焦的焦段越多，表示鏡頭裡面的鏡片數增加，光線的折射度相對複雜了，這樣一來，拍攝出來的光影其細緻度和品質就會打折扣。舉例來說，同樣是標準鏡頭的 50mm，在變焦的鏡頭裡，還有其他的鏡片干擾光線進入傳統相機的底片，或是現在數位相機的感光元件。但定焦的鏡頭卻不會產生這樣的問題。

Hsieh: Many students like to use zoom lenses during traveling so they can easily switch from wide angle to long shots. However, we need to understand how the lenses are made. The more ranges of focal length a lens has, the more glasses there are inside and the more complicated the refractive index becomes. The result is degrading of the details and quality of the light and shadows in the photos. For instance, a 50 mm lens in a long lens will allow distracting light reaching the film inside a traditional camera or the image sensor of a digital camera, while a prime lens with 50 mm focal length won't have the same problem at all.

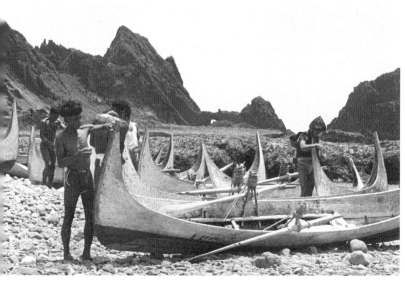

如果，我們在旅行途中只有變焦鏡頭時，可將定焦鏡頭的思維，應用在變焦鏡頭的使用上。例如站在距離二十公尺和距離五公尺拍攝特寫畫面時，使用廣角或望遠鏡頭，和被攝者之間的距離一定有所不同。如果只為了方便，因而站在原地使用變焦鏡頭，拍出來的照片會少了人與人之間的距離感，以及照片本身應有的景深。

If we only have a zoom lens available for traveling, we can also apply the concept of shooting with a prime lens. For instance, if you are taking a close up shot of a person, the distance between you and the subject should differ depending on whether you are using a wide-angle lens or a zoom lens. If you simply don't want to move for the sake of convenience and use the zoom lens, the photo will lack the real sense of distance between people and the proper depth of field.

所以，我平常都會帶三顆鏡頭，將他們裝在固定的相機上。拍廣角或是第一時間搶拍人物時，基本上我不對焦。再者，三台相機的性能也有所差異。望遠鏡頭的機身我使用最新機型，這是因為望遠鏡頭的機身必須最好且穩定性最佳。拍攝一般人物畫面時，只要我自己能移動，我會選擇廣角或望遠鏡頭。我反而較少使用標準鏡頭，這是因為它拍出來的視覺效果和眼睛所見的太接近，畫面缺少變化，除非光線實在太暗了，需要較大光圈值調整焦距，我才會使用。至於廣角鏡頭，一般是為了畫面效果和快速取景，不需要太講究它的機身性能。

Therefore I usually carry three lenses, each fixed on one particular camera. For a wide-angle shot or time sensitive portrait shots, I usually won't focus. The three cameras are of different types. To accommodate a zoom lens I will use the latest model, because it needs to have the best and most steady body. For portraits, I usually choose a wide-angle lens or a zoom lens and adjust the distance by moving my position. Seldom do I use the prime lens because the result is too close to what you see with natural eyes and lacks variation. I only use it when it is too dark and I need larger aperture to adjust focus. As for the camera for the wide-angle lens, it can be a simple and inexpensive model, because I mainly use it for certain visual look and speed, so it does not need to be extravagant.

在當年，使用 200mm 望遠鏡頭算是非常不得了的事。拍人像時，我常喜歡用 85mm 或 105mm 定焦鏡頭，勝過使用標準鏡頭，它的景深和光圈是主要的考量因素。

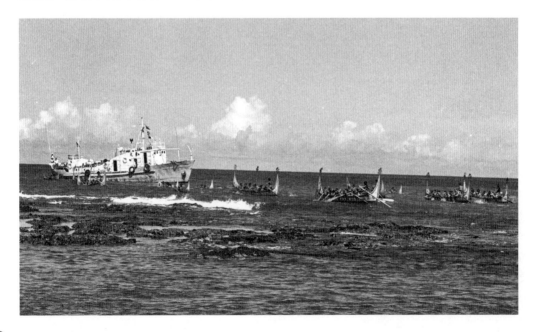

A 200 mm long lens was quite a big deal in the past. For portrait photography, I like 85 mm or 105 mm prime lenses instead of 50 mm because of the depth of field and aperture factors.

許：最後一次拍攝蘭嶼是什麼時候？您有沒有可能再回去拍攝呢？

Hsu: When was the last time you photographed Orchid Island? Will you go back again to do more photography?

謝：我最後一次去蘭嶼拍攝帶了一班學生，原計畫在當地停留五天，但是到了第三天我就拍不下去，自己一個人落寞地回到台灣，因為我發現蘭嶼的風貌完全改變了，不再是我當年所見深具南洋風情的小島。現在的蘭嶼，不只是環境存在核能廢料的問題，當地的年輕一輩，也受到台灣或外地朋友的金錢誘惑，對自己文化保存陷入迷思：原住民一見觀光客總是無理由地伸手要錢；此外，「示威」儀式中不見肅穆表情卻見嬉笑，也令人感到榮景不再，傳統文化日漸萎靡。

Hsieh: The last time I went to Orchid Island was with a class of students. Originally we scheduled a five day photography trip, but I quit on the third day and came back to Taiwan alone in a very low spirit. The landscape had completely changed. It was no longer the romantic southern pacific island. The island suffered environmentally because of the nuclear waste problem. The younger generation had been barraged by outside temptations and lost perspective of their own culture. They only asked for money when they met the tourists. No longer could we find the solemn expression in the demonstration ceremony as I witnessed. The traditional native culture was slowly disintegrating.

如果有機會，我希望這本書出版時，能在蘭嶼當地辦一次小型個人作品展。我希望展出四十年前的蘭嶼影像，相信當地的原住民朋友，若從我的照片中看見四十年前年輕喜悅的自己，一定感觸良多。

If I have the opportunity to hold another exhibition, perhaps in conjunction with the publication of this book, I would like to have a small solo exhibition on Orchid Island. I would like to present to people the images of Orchid Island forty years ago. I believe if any native friends see in my photos the happy jolly faces of themselves forty years ago, they will be much moved.

如果有當地的朋友從我的照片中，看見過去的自己，我願意將那張照片或是這本書，送給他們當作「傳家之寶」。如此連結與珍惜的感覺，真是各自生命歷程中非常喜樂的一件事。

If any native friends see themselves in my photos, I would like to give them the photos or this book as a "family heirloom." I hope they will feel a special connection and a sense of endearment – it will truly be a joyful thing in their life and mine too!

許：最後，您希望讀者用什麼樣的心情看待這本書？

Hsu: How would you like the readers to appreciate this book?

謝：我拍這些照片的目的，就是希望我們臺灣人，應該珍惜上帝賜予的美麗環境，包括原住民的族群與文化，尤其是四十多年前，未曾經過人工或外來文化感染的這片土地。我所拍攝這一系列蘭嶼的風光與人物，是最好的見證。

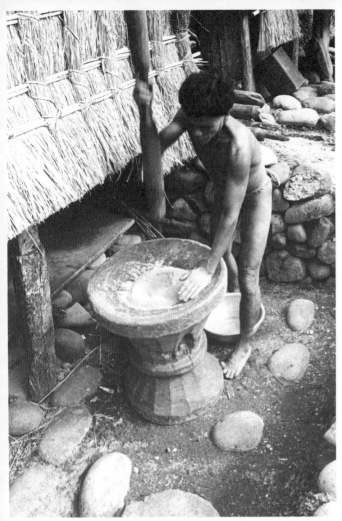

Hsieh: I took these pictures in the hope that we Taiwanese would cherish such beautiful places as Orchid Island as given by God, including its native people and culture. These pictures show what the place was really like forty years ago, before it was influenced by artificial or outside cultures. The sceneries and people in the series of photos are the best witness of the beauty of the island.

我個人希望這一系列作品，可以讓台灣或世界各地的朋友，了解四十多年前未受外來文化感染的蘭嶼文化，是多麼讓人感到驕傲。

Personally, I hope this series will help Taiwanese and friends from all over the world to understand the culture of Orchid Island forty years ago, and how magnificent it was before it got polluted by outside influences.

另一方面，我也希望幫助當地的下一代認識自己的土地，瞭解它的美好，在尋根的影像之旅後，有所啓發與迴響，並能認真思考，如何保護蘭嶼的自然資源。這就是我五十多年來，身為台灣影像工作者對本書最大的期許了。

On the other hand, I hope the younger generation of Orchid Island will get to know its own land and its beauty. Perhaps after searching for the root and journeying through the images, the young people will be inspired and earnestly think about how to protect the natural resources of the island. As a Taiwanese photographer who has worked over half a century, I think this will be the highest expectation I can have for this book!

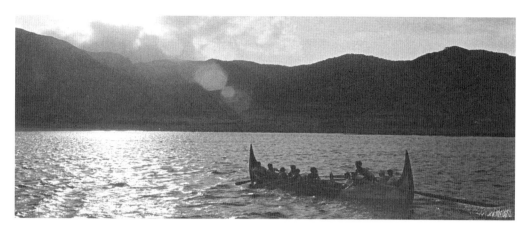

主要作品評審與講座
Jury and Lecture

謝震隆　Hsieh Chen-Lung

經歷：

1933 年生於台灣，曾獲日本攝影藝術月刊（PHOTO ART）主辦月例攝影比賽年度計分最高獎：全日本第一名（BEST-1），並獲得獎學金赴日專修暗房技術。曾任香港邵氏電影公司劇照攝影師及嘉禾電影公司首席電影攝影師。在海內外舉行過攝影個展十四次、參展十三次，共計二十七次的攝影展記錄。

Experience:

Hsieh was born in 1933. He won the first place of the annual award of Monthly Photography Contest hosted by Photo Art in Japan and received scholarship to study darkroom techniques in Japan. He was a still photographer for Shaw Brothers Studio and the chief cinematographer for Golden Harvest Films in Hong Kong. He had a total of 27 photography exhibitions including 14 solo exhibitions and 13 group exhibitions in Taiwan and overseas.

現任：

中華民國電影攝影協會理事 / 攝影指導
中華攝影學會 / 作品評審委員
台灣鄉土文化攝影群 / 攝影作家
財團法人耕莘文教基金會攝影研習班 / 授課老師
台北縣新店崇光社區大學 / 講師
台灣獵影學會 / 會長

Current positions:

Chinese Society of Cinematographers / director and photography instructor

Chinese Society of Photography / jury member

Taiwanese Indigenous Cultural Photographers / member

Cardinal Tien Cultural Foundation photography camp /instructor

Hsintien Chungkuang Community College / lecturer

Taiwanese Society of Scenic Photographers/ chairman

國際性攝影比賽主要獲獎紀錄（按年分排）：

Awards from major international photography contests (In chronological order):

1962 年 法國國際攝影展（BORDEAUX XIIE SALON INTERNATIONAL D' ART PHOTOGRAPHI）
入選賞「農夫出耕」

Finalist of Bordeaux Xile Salon International D' Art Photographi - Farmer Going to Work

1963 年 日本攝影藝術月刊（PHOTO ART）主辦年度獎月例攝影比賽 BEST 10（前 10 名）獲得
全年累積得獎分數最高第一名（BEST-1）

First place in Japan Photo Art Annual Contest

1963 年 日本 OLYMPUS PHOTO SALON（首獎）特選賞「三位農婦」

First Prize in Japan Olympus Photo Salon – Three Farm Women

1963 年 日本 NIPPON CAMERA 月例賽（首獎）入選第一名「豬」

First Prize in Japan Nippon Camera Monthly Contest – The Pig

1963 年 日本 ASAHI CAMERA 月例賽（首獎）入選第一名「閒聊中的信徒」

First Prize in Japan Asahi Camera Monthly Contest – The Chitchatting Pilgrims

1963 年 日本光學專業年度攝影比賽 NIKKOR PHOTO CONTEST（《1963/1964 年鑑》收藏）入選
賞「養鴨人家的小孩」

Finalist of Japan Nikkor Photo Contest (*1963/1964 Photo Annual Collection*) – Children of the
Duck Farming Family

1965 年 日本 ASAHIPENTAX 國際性攝影比賽入選賞「上街」

Finalist of Japan Asahipentax International Photo Contest - Strolling the Street

1967 年 日本光學專業年度攝影比賽 NIKKOR PHOTO CONTEST（《1967/1968 年鑑》收藏）入選
賞「煩惱」

Finalist of Japan Nikkor Photo Contest (*1967/1968 Photo Annual Collection*) - Worry

1972 年 日本光學專業年度攝影比賽 NIKKOR PHOTO CONTEST（《1972/1973 年鑑》收藏）入選
賞「怒漢」

Finalist of Japan Nikkor Photo Contest (*1972/1973 Photo Annual Collection*) – The Angry Man

1973 年 NIKKOR SALON 入選賞「洗濯」

Finalist of Nikkor Salon - Washing

2005 年　日本東京電視網舉辦世紀攝影大展，主題「世上的孩子們，明日的見證者」，主辦單位自
　　　　全球挑選出從十九世紀末至今，最傑出的兩百位攝影家參展，為兩岸三地唯一代表。

One of the 200 photographers to exhibit in the "Century Photography Exhibition" sponsored by TV Tokyo Network with the theme "children of the world, witnesses of tomorrow," the only photographer selected from the region of China, Hong Kong and Taiwan.

攝影作品集：

《台灣鄉鎮獵影》（1992 年）

《巴黎，我愛！》（1994 年）

《台灣鄉土風情獵影》（2001 年，中國：台海出版社出版）

Published Photographic Work:

Realistic Shots from Country Towns (1992)

Paris, je t'aime (1994)

Realistic Shots from Rural Taiwan (2001, Published by China's Taihai Publishing House)

作品典藏：（合計共二十八件作品）

國立台灣美術館典藏

高雄市立美術館典藏

台北市立美術館典藏

國立歷史博物館典藏

Photographs in the collection of: (A total of 28 works)

National Taiwan Museum of Fine Arts

Kaohsiung Fine Arts Museum

Taipei Fine Arts Museum

National Museum of History of Taiwan

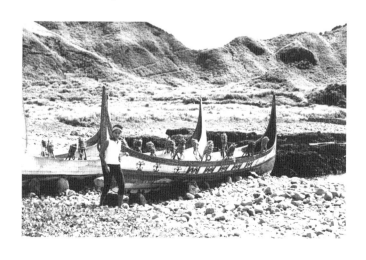

感謝誌

以下名單依本書影像中人物之先後順序排列

孩子篇
李秀娟
鄭新友的妻子
黃秀玉
謝富甘
謝振山
張爾霧
蔡寶士
張福妹
黃正雄
謝乃古
邱玉蘭
林秀娟（阿美族）
邱素妹
黃加莫
謝龍義
賴秀珠（阿美族）
周進花
鄭金鳳
馬秋英
張銀玉
謝秀英
胡美花

生活篇
江石頭
鄭農坤
謝秀英的母親
馬元讚
陳珍秀
江美娟的父親
黃玉蘭的母親
張清長的母親
邱素藍
邱素藍的母親
周月條
施花梅
江仁義
江仁義的母親
江仁義的姊姊
鍾國華
陳岡遙
謝振林的父親
江夢坤的母親

張謝芹蓉
張雪雲
張白雲的母親
鄭東城的母親
謝老梅
謝馬來的弟弟
謝福義
施池立的母親
沈海峰的母親
施翠美
阿　雄
江靖男
王翠蓮
黃清路的母親
黃玉秀
董海同的父親
周黨興的父親
周朝德的外祖父
紀守長神父
馬金龍的母親
陳珍秀的母親
鄭框婆的母親
謝國基的母親
陳清水的祖母
邱阿蘭、邱丁山的母親
夏本媽希任
施麗玉的母親
郭碧娥

示威篇
馬義打
黃武吉的父親
張海嶼的父親
黃野茂
張錦普
謝振霖
謝多國
陳金發
黃清路
謝德全
黃馬語
鍾夯龍
施智津
江碧蓮

張馬恩
謝老梅
黃馬安的父親
張馬恩的父親
邱丁山的父親
施學正的父親
張錦普
江秀玉的父親
黃秀珠的父親
謝秀英的父親
黃金發的父親
謝再明
謝福生的祖父
陳清水的父親
陳榮宗的父親
張玉秀的父親
蔡武雄的父親
黃馬安的父親
黃　野的父親
謝慶明的父親

青春篇
周里花
胡玉琴
江良妹
謝秀玉
楊文花
謝蘭青
顏文華
江秀玉
張月枝
張寶霞
黃玉金
謝靜美

成年篇
曾順吉的祖父
張錦宗的祖父
張銀玉的母親
黃秀英的父親
黃多賜的母親
黃金發的母親
施太滿的堂叔
陳榮龍的父親

徐達三的父親
邱加郎

歲月篇
曾馬如的母親
廖福財的祖母
謝秀英的母親
謝國基的母親
陳清水的祖母
李路農的母親
黃金發的外祖母
謝振南的祖父
謝南海的外祖母
馬元贊
江夢坤的母親
李金福的母親
邱玉蘭的母親
邱玉蘭的姊姊
江靖里
江秀玉
謝玉屏
邱賜女
黃堅里
鄭玉珠
黃碧珠的外祖母
謝福在的父親
曾之光的父親
張新發的父親
施伯義
林定新
張清長
施金龍

電影篇
邱丁山、邱國建的父親
張錦商的父親
江文志的父親
羅加立的父親
呂智祥
邱黃馬古
董新發的父親
謝文進

Touch 系列 004

映像蘭嶼：謝震隆攝影作品集

· ·

作　　　者：謝震隆

企劃·撰稿：許豐明

譯　　　者：楊偉珊

編　　　輯：許玉青、洪懿諄

封 面 設 計：井十二設計研究室

發　行　人：鄭超睿

出 版 發 行：主流出版有限公司 Lordway Publishing Co. Ltd.

地　　　址：台北市南京東路五段 **123** 巷 **4** 弄 **24** 號 **2** 樓

電　　　話：**03-9371001**

傳　　　真：**03-9371007**

電 子 信 箱：**lord.way@msa.hinet.net**

郵 撥 帳 號：**50027271**

網　　　址：**http://mypaper.pchome.com.tw/news/lordway/**

經　　　銷：

紅螞蟻圖書有限公司

地址：台北市內湖區舊宗路二段 **121** 巷 **19** 號

電話：**02-2795-3656**　傳真：**02-2795-4100**

Images of Orchid Island

By Hsieh Chen-Lung

Copyright 2008, by Lordway Publishing Co. Ltd.

All rights reserved

2008 年 **10** 月　初版 **1** 刷

2014 年 **8** 月　二版 **1** 刷

書號：**L0805**

ISBN：**978-986-83433-7-5**（平裝）

Printed in Taiwan

映像蘭嶼：謝震隆攝影作品集／謝震隆著

初版 . － 臺北縣新店市：主流，2008.10

面； 公分 . －（Touch 系列；4）

ISBN 978-986-83433-7-5（平裝）

1. 攝影集

957　　　　　　　97014339